Camille Pissarro

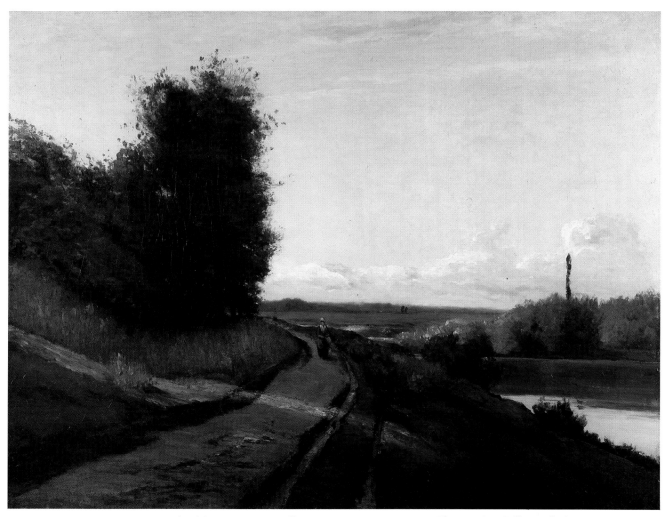

1. C. PISSARRO, *Banks of the Marne*, 1864. Oil on canvas. 81.9 × 107.9 cm. Glasgow Art Gallery and Museum.

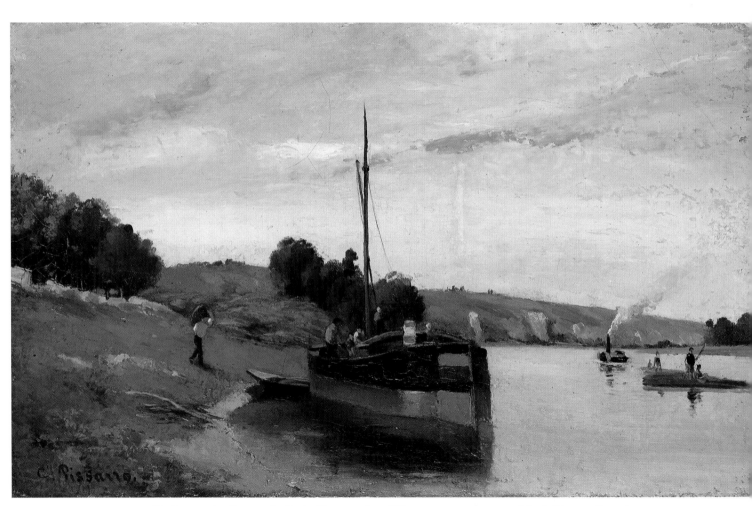

4. C. PISSARRO, *Barges at La Roche-Guyon*, *c.*1865. Oil on canvas. 46 × 72 cm. Musée Pissarro, Pontoise.

Richard Thomson

Camille Pissarro
Impressionism, Landscape and Rural Labour

New Amsterdam
New York

First published in the United States of America, 1990,
by New Amsterdam Books by arrangement with
The Herbert Press Limited, London.

Designed by Pauline Harrison
House Editor: Julia MacKenzie

Set in Poliphilus
Printed and bound in Great Britain.

New Amsterdam Books
171 Madison Avenue
New York, N.Y. 10016

ISBN 0-941533-90-5

Contents

Preface
to Exhibition Catalogue

In 1980, to celebrate the 150th anniversary of Camille Pissarro's birth, the Arts Council organized a retrospective exhibition at the Hayward Gallery in London. The present exhibition, the first major show of Pissarro's work to be mounted in Britain outside London, has a more specific focus and reflects developments and changes of emphasis in Impressionist studies in the past decade. Richard Thomson has selected groups of works, many not included in the earlier exhibition and some not seen together since they left the artist's studio, to show how complex were Pissarro's attitudes to nature, landscape traditions and issues of politics and modernity.

We are grateful to Richard Thomson for the imagination and thoroughness with which he has pursued this project, and to the lenders, whose co-operation has made it possible. We are indebted to The Royal Bank of Scotland for their generous sponsorship. They were the sponsors of an Arts Council exhibition, *Impressionist Drawings*, of which Richard Thomson was a co-selector, in 1986, and we are delighted to have the opportunity to work in partnership with them again. In Glasgow the exhibition is one of the principal contributions to the city's year as the Cultural Capital of Europe.

JOANNA DREW
Director, Hayward and Regional Exhibitions

ROGER MALBERT
Exhibition Organizer

Acknowledgements

In the preparation of *Camille Pissarro: Impressionism, Landscape and Rural Labour* I have benefited greatly from the generous advice and assistance of many scholars, curators, collectors and dealers, to whom I offer grateful thanks.

I must single out the staff of the Department of Western Art at the Ashmolean Museum in Oxford. The Ashmolean has the largest single holding of Pissarro's work as well as archival material essential to the study of the artist. Not only has the Museum contributed impressive loans to the exhibition, but I have also received much kind support from the staff: Nicholas Penny (Keeper), Jon Whiteley, Judith Chantrey, Noëlle Brown, and Anne Thorold, whose organization and scholarship have made the Pissarro Archive a model of its kind. I thank them all.

I am also indebted to Christian Geelhaar, Kunstmuseum, Basel; Laura Luckey and Cathie Zusy, Bennington Museum, Vermont; Jane Farrington and Evelyn Silber, Birmingham City Art Gallery; Hamish Miles and Paul Spencer-Longhurst, Barber Institute of Fine Arts, Birmingham; Philip Conisbee, Roy Perkinson, Barbara Shapiro and Peter Sutton, Museum of Fine Arts, Boston; Sarah Faunce, Brooklyn Museum; Timothy Stevens, National Museum of Wales, Cardiff; Douglas Druick and James Wood, Art Institute of Chicago; Michael Clarke, National Gallery of Scotland, Edinburgh; Vivienne Hamilton and Rosemary Watt, Burrell Collection, Glasgow; Anne Donald, Glasgow Art Gallery;

Chris Allan and Martin Hopkinson, Hunterian Museum, Glasgow; Chloe Bennett, Ipswich Museums; John Leighton, National Gallery, London; Jennifer Harris, Sarah Hyde and Greg Smith, Whitworth Art Gallery, University of Manchester; Julian Treuherz, Manchester City Art Gallery; Richard Field and Sasha Newman, Yale University Art Gallery, New Haven; Gary Tinterow, Metropolitan Museum of Art, New York; Michael Pantazzi and Shirley Thomson, National Gallery of Canada; Françoise Cachin, Musée d'Orsay, Paris; Catherine Legrand and Arlette Sérullaz, Cabinet des Dessins, Musée du Louvre, Paris; Anne d'Harnoncourt, Larry Nichols and Joseph Rishel, Philadelphia Museum of Art; Christophe Duvivier, Edda Maillet and Jérôme Serri, Musée de Pontoise; David Alston, Sheffield City Art Galleries; Christian von Holst, Staatsgalerie, Stuttgart; Katherine Lochnan and David McTavish, Art Gallery of Ontario, Toronto; David Brooke, Sterling and Francine Clark Art Institute, Williamstown, Mass.

My thanks go also to Marianne and Walter Feilchenfeldt, Zürich; Jean Edmonson, Acquavella Galleries, New York; Jack Baer and Stephanie Maison, Hazlitt, Gooden and Fox; Christian Neffe, J.P.L. Fine Arts; Desmond Corcoran, Lefevre Gallery; V. Beston, Marlborough Fine Art; John Whately, Noortman (London); Melanie Clore, Sotheby's; John L. Tancock, Sotheby's New York.

I am particularly grateful to the private collectors who have so kindly agreed to lend to the exhibition. I would also like to express my thanks to Alexandra Murphy, who told me of the ceramics lurking in Vermont, Matthew Braddock, Peter Burton, Barbara

Divver, Peter Ferriday, Craig Hartley, Kelvyn Lilley, Huw and Amy McGill, Gerry and Peggy Needham, Michael Pollard and Chris Yaneff. In France Mme Hulot of the *S.H.G.B.E.* and M. Pierre de Pontavice, Mayor of Melleray, were most helpful, and the calvados at Montfoucault was very welcome. Liz Allen tirelessly pursued the photographs and Rosemary Watt forgave George's vandalism. I am indebted to the Committee for Staff Travel Funds for Research in the Humanities at the University of Manchester for a grant enabling me to visit North America in July 1988.

Finally I must convey my gratitude to and respect for my friends in Pissarro scholarship, though none should be held responsible for this contribution. Within the family, Joachim Pissarro has helped with loans, and conversation with John Bensusan-Butt is always a pleasure. I have learnt much from John House, John Rewald, Barbara Shapiro, Anne Thorold and others, not least my wife Belinda, whose advice and support are always invaluable. The first three volumes of the complete edition of Pissarro's correspondence, currently being edited by Janine Bailly-Herzberg, have been an essential aid, and I have also gleaned much from the work of Richard Brettell, whose fascinating doctoral thesis on Pissarro at Pontoise is to be published shortly (Yale University Press). My greatest debt is to my friend Christopher Lloyd. The last decade's spate of publications and exhibitions on Pissarro has been stimulated by Christopher's scholarship or encouragement; *Camille Pissarro: Impressionism, Landscape and Rural Labour* is no exception. 'Ce fut un de mes maîtres et je ne le renie pas', one might say.

RICHARD THOMSON
Heaton Moor, October 1989.

Introduction

We usually link Camille Pissarro's name closely to Impressionism. He was the only artist to show at all eight exhibitions held by the Impressionist group between 1874 and 1886; within the Impressionist circle he formed a bridge between landscape painters such as Monet and the figure painters around Degas; and he introduced new talent into the exhibitions, not least Gauguin and Seurat. His own painting, it has been argued, was consistently concerned with landscape and the transcription of natural effects by Impressionist means, and was – apart from an aberrant Neo-Impressionist phase in the later 1880s – more unswervingly 'Impressionist' than any other painter except Sisley.

However, recent writers have come to question and redefine both Impressionism and Pissarro's career. The idea of a unified movement, comprising both landscape and figure painters, determined to introduce modern subjects, usually of a carefree bourgeois world, and freer, more spontaneous handling is difficult to sustain. Rather, we now recognize a more shifting constellation of artists, acknowledging differences of social background, studio practice and perception of the modern world. We question assumptions about notions of 'immediacy' and 'accuracy' which used to be central to accounts of Impressionism, and by contrast emphasize that Impressionist images are fictions, the result of choice, editing and often careful preparatory work, the product of the individual artist's ideology and the pressures of the art market. Instead of charting Impressionism from the 1860s to the 1890s in terms of the stylistic development of an autonomous avant-garde, we situate it within the fluctuating social, political and economic patterns of the Second Empire and early Third Republic.[1]

Pissarro's work has played a key role in this reassessment and over the last dozen years his career has undergone extensive scrutiny. With the staging of an important retrospective exhibition, and the publication of biographies, a thorough study of his drawings and three fully annotated volumes of his extensive correspondence,[2] Pissarro has emerged as an artist of greater diversity and complexity, a figure rich in paradox.

The purpose of this book and exhibition is to explore the artist's work in the light of such developments. The text attempts to assess Pissarro's relationship not only to Impressionism but also to the broader patterns of late-nineteenth-century French art, and to place his work within the context of contemporary social and political developments and his own ideological commitments. In addressing such questions the text follows the structure of the exhibition. This is not a retrospective, and makes no claims to be exhaustive. The exhibition has been selected to illuminate and analyse specific themes in Pissarro's work. These include his images of rural labour and of markets during the 1880s and 1890s, for example, and his treatment of certain locations, such as Pontoise, Montfoucault and Rouen. Inevitably this has meant certain omissions; thus there are no works made at the outset of his career in Venezuela, or in London, Le Havre, or central Paris. By the same token, however, important aspects of Pissarro's work which have been rather overlooked – his representations of the Parisian suburbs, say, or of female bathers – can be brought into focus.

The polarities of figure and landscape, country and city, form the underlying structure of this study. Seen as a whole, Pissarro's career appears as a dialogue between city and country.[3] Since classical times the rural and urban worlds have been set up as opposed cultural polarities, open to multiple readings. The country can be construed as natural, calm and healthy, the city artificial, hectic and decadent; yet alternatively, the former might stand for the savage and backward, the latter for sophistication and enlightenment.[4] Placing Pissarro's work within such polarities can only be a simple basis for an account of his career, but it serves as a convenient framework to question his choice of motif, medium and method, his assumptions and rhetoric about his own work, its negotiation of a place within past and contemporary art production, and the reception of his pictures by critics, dealers and collectors. Above all, exhibition and book seek to demonstrate how with Pissarro making – selecting a subject, preparing and executing a composition – and meaning – the intentions and reception of the image – exist in intricate and fascinating interrelationship.

Camille Pissarro: *Impressionism, Landscape and Rural Labour*

AMILLE PISSARRO'S activity as an artist was inextricably enmeshed with both his own social and cultural formation and the momentum and tensions of the French society in which he elected to work. Born in the West Indies in 1830, Pissarro came from a Jewish family of Danish citizenship. The Pissarros were middle-class business people making the most of the mid-century colonial trade; they were well enough off, and sufficiently aware of their transitory commercial commitment to the Caribbean, to send the teenage Camille to school in Paris. Not long after his return, in 1852, Pissarro threw up a commercial career and set off to Venezuela with the Danish painter Fritz Melbye. By 1855 this bohemian gesture had matured into a determination to become a professional artist, and Pissarro settled in France, attending classes held by such academically reputable painters as François Picot and Henri Lehmann.[5] During the later 1850s and 1860s Pissarro made a gradual transition from the now somewhat musty neo-classical conventions of historical landscape, compiling ordered, planar compositions peopled with figures from the Antique,[6] to the increasingly dominant, and more 'modern', forms of landscape developed by the so-called Barbizon School. These painters — Théodore Rousseau, Jean-François Millet, Charles Jacque and, in certain moods, Camille Corot — focussed on the native French countryside, depicting it with a subtle balance between the wild and threatening and the detailed and banal. This transition was nothing new (Charles Daubigny had made it two decades before), and Pissarro's development received the financial support of his family, despite their strong objections to his relationship with his mother's maid Julie Vellay, which resulted in the birth of their first son, Lucien, in 1863. By his mid thirties, Pissarro's life and work were founded on paradoxes. He had rejected a conventional business career and set up house with a Gentile servant, yet relied on his bourgeois parents for maintenance. He repudiated historical landscape, yet carried with him its sense of structure and lessons of craft. He came from a peripatetic merchant family, yet was making images of rural France.

Pissarro worked through half a century of remarkable changes in French political life. He fled Paris as Prussian armies precipitated the collapse of the Second Empire and its replacement by the Third Republic. Although Pissarro was in London during the bloody repression of the radical Paris Commune in May 1871, he returned to witness the rebuilding of France in the aftermath of defeat and civil war. By the 1880s he was acutely aware of the Republic's failures to introduce significant social reforms, and in the 1890s saw friends tried for their anarchist activities and the powerful anti-semitism and political polarization caused by the Dreyfus Affair. But the France in which Pissarro made his career was formed not only by fluid and combative politics but also broader social and economic changes. The later nineteenth century saw what has been called the 'modernization' of rural France. Throughout the nineteenth century French agriculture and country life underwent changes brought about largely by external factors; even in the first decade the ease of transportation afforded by new canals forced crop changes on farmers.[7] The railway revolution of mid century greatly speeded such processes. In 1848 there were less than 2,000 kilometres of track in the whole of France; by 1870 this had increased ninefold.[8] It has been argued that a variety of factors combined between 1870 and the First World War to break down local and regional differences and create a more coherent and 'modern' France: the growth of the railway system, facilitating the transport of goods, people and ideas across the country; the spread of effective primary education, which helped break down the use of regional *patois*; and the imposition in 1872 of conscription, after which young men returned to their villages with broader horizons.[9]

However, the pattern of change was extremely complex, not least because different areas, even closely located communities, responded to change in differing ways. There had been a widely and anxiously acknowledged awareness of rural depopulation since mid century; the number of agricultural labourers declined from 4.5 to 3 million between 1860 and the 1900s, the span of Pissarro's career in France.[10] The reasons for this were manifold, among them the lure of work in the newly industrialized cities

and larger towns and the critical depression in French agriculture brought upon largely by foreign competition and the failure adequately to modernize farming techniques. Thus between 1870 and 1895 cereal prices dropped by 27%.[11] Tariffs introduced in 1881 and 1892 were protective but not progressive, for they tended to encourage the continuation of traditional smallholdings rather than their consolidation into more competitive units.[12] The Paris basin, where Pissarro chiefly worked, raised livestock, grew cereal and root crops, and served the metropolis with market-garden produce; such areas of polyculture generally held up better than those of monoculture, for instance the vine-dominated Hérault.[13] External forces could impose abrupt local differences, as in the case of two communes on facing banks of the Seine some 45 kilometres west of Paris. Bennecourt, where both Monet and Cézanne painted in the 1860s, saw its population halved between 1820 and 1890, falling most sharply in mid century. Neighbouring Bonnières flourished, the result of having a station on the Paris-Rouen line built in 1843 and of forward-looking local entrepreneurs who pioneered more commercial agriculture and introduced small industries.[14] And local produce could hold up against the odds; in the mid 1870s many Parisians preferred to buy local milk at twice the price of that brought by train from the provinces.[15]

Such complex movements of rapid progress and reluctant, gradual change contributed to the shape and identity of Pissarro's work. They touched him personally, in his day-to-day life. The railway came to the market town of Pontoise in 1863;[16] easing access to Paris, his colleagues and markets, the new station may have encouraged his decision to settle there three years later. The hamlet of

Eragny, where Pissarro lived from 1884, only got a halt in July 1891; previously he had to make the inconvenient three-kilometre journey to the station at Gisors.[17] And if in 1898 Mme Pissarro was complaining that telephone wires had been put up on their house without permission, just six years previously their Breton maid had only been able to speak her regional dialect and not a word of French.[18]

But how was an artist going to find ways to make images which in some way could articulate a set of values about this changing world? This question is central to any account of Pissarro's work, and no single answer or interpretation can be given precisely because Pissarro's artistic practice itself was in constant tension and metamorphosis. During the 1860s Pissarro's major exhibition paintings would have been made in the studio from preparatory studies, and even in the 1870s, the decade of 'high' Impressionist *plein air* painting, he probably never entirely relinquished working on certain canvases in the studio.[19] Although in the early 1890s he boasted to Lucien about his exertions twenty years before – 'I did my painting no matter where; in all seasons, in heatwaves, rain, terrible cold, I found the means to work with enthusiasm'[20] – Pissarro's *plein air* rhetoric should not disguise the diversity of his practice. He came to find it difficult to respond to the summer, 'with its fat green monotony', saying that for him 'the *sensations* revive in September and October'.[21] *Sensation* was a key word for Pissarro and his colleagues, but it is clear from his letters that it had several meanings. For instance, it might refer to his response to, or emotions in front of, nature, as in his affection for autumn. However, he also talked about leaving large finished figure paintings, made in the studio, hanging around there 'in

order to find, suddenly, the final *sensation* which should give life to the ensemble';[22] here *sensation* implies a response, and the ability to transcribe it, which will harmonize an existing artificial representation. In the early 1880s, at a time when he began to draw much more, especially producing preparatory studies and reprises of existing motifs, the term *synthesis* came to play an important part in Pissarro's working vocabulary. *Synthesis*, for Pissarro, involved spare, uncluttered representation of form – qualities he appreciated in the Parthenon Frieze – and also the artist's own personal handling of the process of reduction and simplification; criticizing a drawing of Lucien's in 1886 he wrote, 'it must be a *synthesis* of the thing, . . . let it go, a little craziness, again you're timid'.[23] What linked these two terms and allowed them to coexist in Pissarro's aesthetic were their shared distance from 'real' nature, and their emphasis on the individuality of the artist.

Pissarro's political ideology was also determinedly individualistic, in common with many vanguard artists of the period. No doubt it was partly formed in reaction against his family's avowal of stock bourgeois attitudes. His mother never accepted Julie, treating her as a servant even after her marriage to Pissarro. He greatly resented this, and he did not get on with his brother Alfred, who owned a sweatshop in Paris making children's clothes. His anti-bourgeois position embraced medical matters – he and his immediate family were devotees of homeopathy – and political ideology. The development of Pissarro's political ideas is impossible to trace exactly. Certainly by 1865 he was corresponding with the painter Antoine Guillemet about Proudhon's *On the Principles of Art and its Social Use*, and it is possible that during the following decade his

politics became gradually more radicalized along with those of his friend Ludovic Piette, a small landowner in the Mayenne. In 1871 Piette had been elected a municipal councillor on a liberal-conservative platform. However, by mid decade, perhaps stimulated by his disgust at the Versaillais troops' brutal suppression of the Commune in 1871, Piette's politics appear to have shifted to radical republicanism.[25] Certainly by the early 1880s his correspondence reveals Pissarro reading such socialist newspapers as *Le Libertaire* and *Le Prolétaire*, and being highly critical of politicians like Clemenceau, whom he considered insincere in his attitude to social reform.[26]

A decade later Pissarro's ideology had crystalized in a commitment to anarchism. Anarchism is based on a belief in the innate goodness of human nature, which is corrupted by overbearing social organization. Capitalism was held to be corrupt, and central government to represent the interests of the bourgeoisie to the detriment of the people. Cities were pernicious, huge workhouses in which the proletariat lost their identities in the service of bourgeois capitalism. Anarchist writers such as Pierre Kropotkin and Elisée Reclus favoured a decentralized society, based on rural communities of free individuals, subject to no centralized authority.[27] Pissarro realized that such ideas were utopian; as he wrote to the novelist and critic Octave Mirbeau in 1892, having read Kropotkin's *The Conquest of Bread*, 'in any case, it's a beautiful dream and . . . nothing prevents us from believing that it will be possible one day, at least if man doesn't sink and return to complete barbarism'.[28] The previous year Mirbeau had published an article praising Pissarro in anarchist terms, reporting the painter's belief that the artist was on a par with 'the poet, farmer, doctor, blacksmith, chemist, [or] industrial worker . . . Like all the latter, who produce something useful and beautiful, he plays a part in that general effort towards harmony, which consists in finding expression for the universe [by] following the individual aptitudes granted us by nature, education and environment'.[29] One of Pissarro's last reported remarks made the same point: 'everyone . . . must paint according to their own vision'.[30] Whether expressed in terms of *sensation* or anarchism, Pissarro's most fundamental belief was in the individual, and in this respect it is crucial to interlock the trajectories of his work and ideology.

From the 1850s Pissarro determined to make a career as a painter of landscape (*paysage*) and rural subjects (*la vie agreste*). These genres had established themselves at the Paris Universal Exhibitions of 1855 and 1867 as major forces in modern French art, a dominance that increased with the gradual decline of the painting of mythological and historical subjects on a large scale. A new middle-class public favoured images within their own experience or imagination. The urban bourgeoisie of the second half of the century were often city dwellers of the first or second generation, anxious about the metropolitan phenomenon, with its uncertain social hierarchies, its rapid physical growth, its proletarian unrest. Images of the countryside provided a welcome sense of relief from the modern world, nostalgia for an ostensibly changeless rural existence.[31] Pissarro's work could be read as meeting such demands. As Georges Lecomte put it in 1892, in his images 'we find the peace of flowered fields, vast expanses of tranquillity. These natural harmonies sound a gentle note on office walls. Like a bay window opening onto rural spaces.'[32] Landscape painting in various forms provided surrogate nature for the city dweller. There was a hierarchy of different categories of painting, which Pissarro himself acknowledged,[33] ranging from the modestly sized, rapidly executed *étude*, intended to put down a transitory natural observation (*effet*), to the resolved *tableau*, a highly worked canvas of exhibition status and usually of a significant motif, which often incorporated figurative elements. And in terms of motif late-nineteenth-century landscape included views of famous or picturesque sites, either abroad or in the French provinces, topographical townscapes, stormy marines or fashionable beach scenes, meadows with grazing animals or ethnographical images of disappearing peasant traditions. Broadly speaking, the unifying element in such diversity was that the landscape genre was used to construct some ideal, a set of values: perhaps nature's grandeur and changelessness, or the fecundity of French soil, or the ability of the land to absorb progress. Pissarro's career was a constant reassessment of how his images of landscape and rural life articulated a changing France; resolved tensions between the modern and traditional; balanced a progressive execution against market demands; and remained sincere to his developing ideology.

Convention and Change in the 1860s

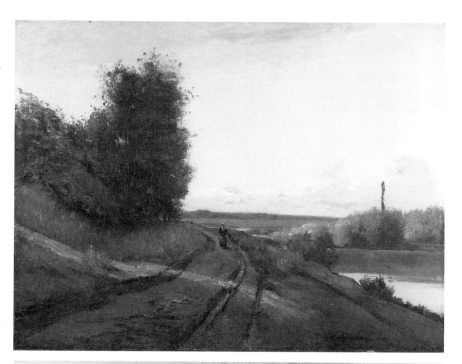

Although only a fraction of Pissarro's work from the 1860s survives, and is often considered tentative, gradually freeing itself from the influences of the older generation of landscape painters, it does in fact bring into play Pissarro's concern not merely with *how* to represent the landscape but also with *what* the landscape should represent. His pictures fit into different categories of *paysage*, varying in execution, motif and status.

It now seems likely that the large canvas formerly known as *The Towpath* (fig. 1) is the painting exhibited at the Salon of 1864 as *Banks of the Marne*.[34] This important *tableau* was prepared in the conventional way, Pissarro starting with a small preparatory oil sketch (*esquisse*) made on site (fig. 2), and using it as the basis for the exhibition picture, which would have been painted in the studio. Following convention again, he did not rely slavishly on his oil sketch. The clouds that mass in the distance of the sketch were subdued in the final canvas, and the two countrywomen who walk away from us were replaced by one moving towards us. These adjustments calmed the mood and allowed the spectator greater access into the fiction of the landscape; they were decisions to alter

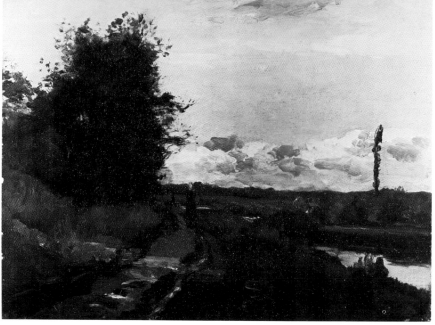

1. ABOVE: C. PISSARRO, *Banks of the Marne*, 1864. Oil on canvas. 81.9 × 107.9 cm. Glasgow Art Gallery and Museum. Reproduced in colour on page 1.

2. BELOW: C. PISSARRO, Sketch for *Banks of the Marne*, c.1863–4. Oil on canvas. 24.4 × 32.4 cm. Fitzwilliam Museum, Cambridge.

the way the picture was received and read. Pissarro retained the fundamental structure from the sketch and, like his preparatory procedure, it accepts conventions. The disciplined recession of planes from a dark foreground, through a lit middleground to calm horizon, and the use of dark *repoussoir* trees were all requirements of the neo-classical landscape (fig. 3), and in submitting a painting to the Salon, to the critics, public and potential buyers, Pissarro was attentive to their expectations. The painting consequently has a timeless quality; landscape and figure could belong to any century, and a major river is reduced to the size and tranquillity of a pond.

the design is based not on horizontal planes but on the thrust of river and bank which drive deeply into the picture space. This is no image of tranquillity; the Seine is envisaged as a commercial route, carrying long-distance traffic up and down the river, and local transport across. Other artists were painting river

traffic at the time, but an older artist like Daubigny tended not to paint the more modern steamboats, and when they do appear in his work they are generally disguised in the distance, their contemporaneity dominated by the timeless calm of the riverside village (fig. 5). There was a market for such pictures,

4. C. PISSARRO, *Barges at La Roche-Guyon*, c.1865. Oil on canvas. 46 × 72 cm. Musée Pissarro, Pontoise. Reproduced in colour on page 2.

3. N.-D. BOGUET, *View of Lake Nemi*, 1811. Oil on canvas. 57.5 × 99.7 cm. Private collection, France.

A river scene probably painted the following year at La Roche-Guyon provides a distinct contrast (fig. 4).[35] A canvas of significant size, Pissarro does not seem to have submitted it for exhibition. If elements in the *Banks of the Marne* echoed Corot's silvery tonalities, the *Barges at La Roche-Guyon* has a harsher surface, for it is one of a number of canvases made in the mid 1860s in which Pissarro, like Cézanne, essayed Courbet's use of the palette knife.[36] No preparatory oil sketch for it has survived, although a pastel (P&V 1507) shows the same distant cliff beyond the river as the *Barges* and *Donkey Ride at La Roche-Guyon* (1865; P&V 45). In the *Barges*

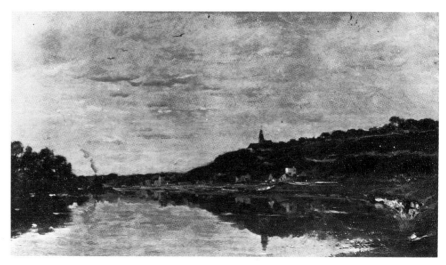

5. C. DAUBIGNY, *La Frette*, 1869. Oil on canvas. 37.8 × 66.4 cm. National Gallery of Scotland, Edinburgh.

and between 1859 and 1878 Daubigny made no less than nine versions of *The Banks of the Oise, Ile de Vaux*, with a barge set between wooded banks.[37] Pissarro's painting is not so reassuring; despite centring on the barge and its mast, it features the newer technology, the steamboats which were threatening the bargees' livelihoods.[38] The *Barge at La Roche-Guyon* matches making and meaning, with its harsh, knifed surface and thrusting composition, its antipicturesque image of progressive river transport.

The Small Factory (fig. 6), which also dates from mid decade, has the status of an *étude*. Its main motif is locked comfortably into the balanced composition, ensconced in the Corotesque tonalities. But this little mill or workshop, typical of the modest and probably unmechanized *fabriques* erected around Paris before the massive industrialization of mid century, has an unemphatic presence.[39] Its chimney does not smoke, and its modest size is indicated by the scale of the figures. Although apparently in bourgeois costume, they appear to be in no relation – proprietorial or inquisitive – to the factory, the purpose of which is not apparent. There seems to be a disjunction, possibly willed, between harmony of execution and articulation of meaning.

For Pissarro's career in the 1860s was more than the search for a personal style. He seems to have consciously essayed various possibilities within the landscape genre. This involved negotiating a position for himself between the traditional and the modern at every level of his practice: preparatory work, composition, finish, subject. On the other hand lay the pressures of absorbed, acceptable convention and market demands, on the other the sincerity to *sensation* and the articulation of developing values within a changing world.

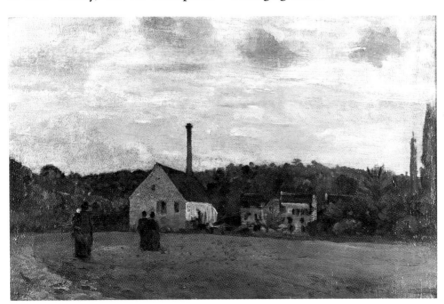

6. C. PISSARRO, *The Small Factory, c.*1862–5. Oil on canvas. 26.5 × 40.2 cm. Musée d'Art Moderne, Strasbourg.

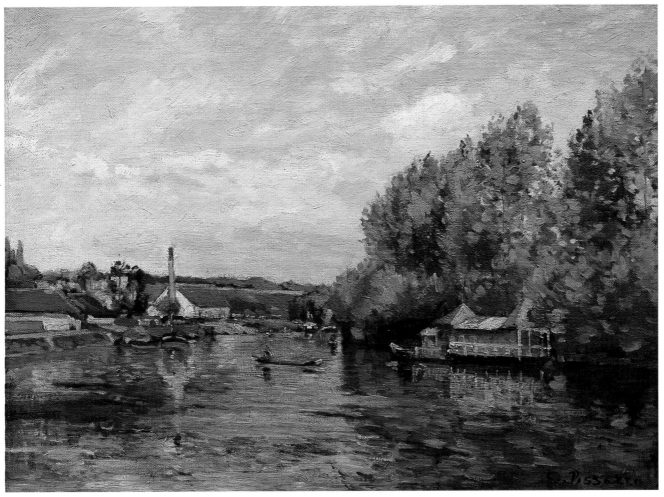

18. C. PISSARRO, *La Grenouillère at Bougival, c.*1869. Oil on canvas. 35 × 46 cm. From the Collection of the Earl of Jersey.

19. C. PISSARRO, *Wash-House at Bougival*, 1872. Oil on canvas. 46.5 × 56 cm. Musée d'Orsay, Paris.

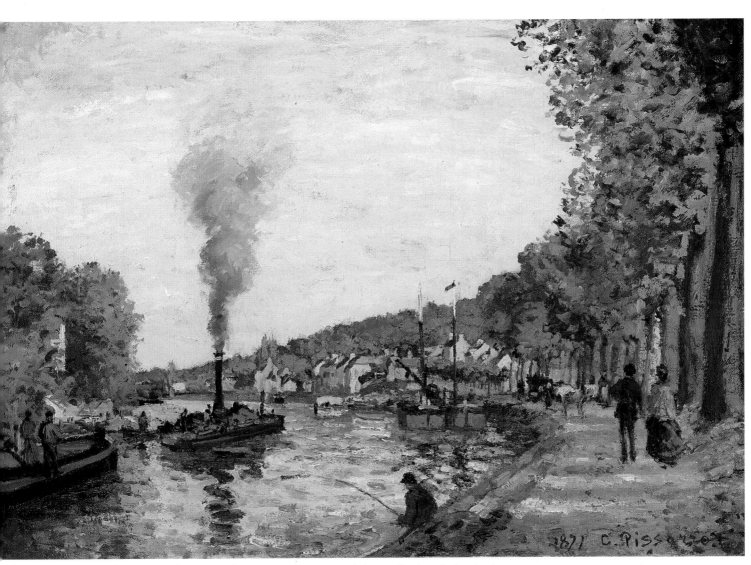

20. C. PISSARRO, *The Seine at Marly*, 1871. Oil on canvas. 44 × 60 cm. Private collection, Switzerland.

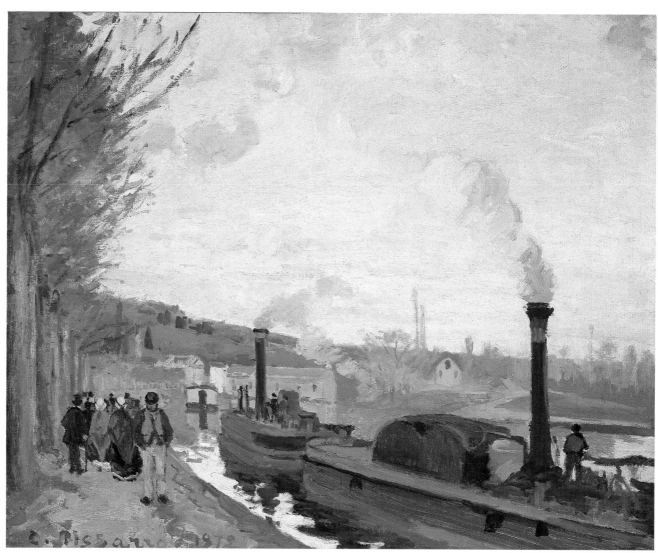

21. C. PISSARRO, *The Seine at Port-Marly*, 1872. Oil on canvas. 46 × 55.8 cm. Staatsgalerie, Stuttgart.

Representing the Parisian Suburbs

Pissarro's career between 1866 and 1872 was fragmented, due to a combination of external circumstances and, it seems, a search for new locations to paint. Based in Pontoise from early 1866, he had moved to Louveciennes, in the western suburbs of Paris, by spring 1869 (*see* map; fig.7). However, at the beginning of September 1870 the Prussian advance on Paris forced him to evacuate his family to Montfoucault, from where they travelled on to London by the end of the year. They were back in Louveciennes by late 1871, but only stayed nine months, settling back in Pontoise in August 1872.[40] We tend to think of Monet, Renoir and Sisley as the painters of the Parisian suburbs at this time, but Pissarro's two short spells should not be overlooked. Apart from a few earlier studies of picturesque parts of Montmartre,[41] the Louveciennes and Marly paintings of 1869–72 add up to Pissarro's first concerted efforts to represent aspects of city life.

In the 1860s and 1870s the extension of the Parisian suburbs was rapid. Villages to the west of the capital – such as Louveciennes and Voisins on the ridge overlooking the Seine, Bougival and Marly down by the river – had been gradually changing their identities since the arrival of the railways thirty years before. Only a dozen kilometres from the centre of Paris and a few minutes by rail from the Gare Saint-Lazare, they provided the metropolitan bourgeoisie with convenient and still quasi-rural accommodation from which to commute and the day-tripper with riverside pastimes and promenades.[42] The extent to which

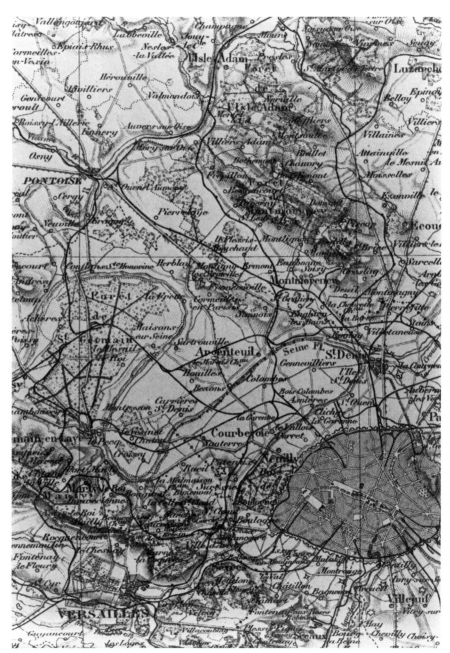

7. Map of the Paris region; from L. BARRON, *Les Environs de Paris*, Paris, 1886, between pp. 18–19.

8. C. PISSARRO, *View from Louveciennes*, c.1869. Oil on canvas. 52.5 × 82 cm. National Gallery, London.

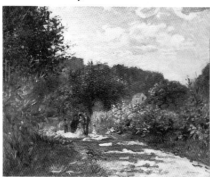

9. A. RENOIR, *A Road in Louveciennes*, c.1870. Oil on canvas. 38.1 × 46.4 cm. Metropolitan Museum of Art, New York.
10. C. TROYON, *Grape Harvest at Suresnes*, c.1860. Oil on canvas. 138 × 96 cm. Musée d'Orsay, Paris.

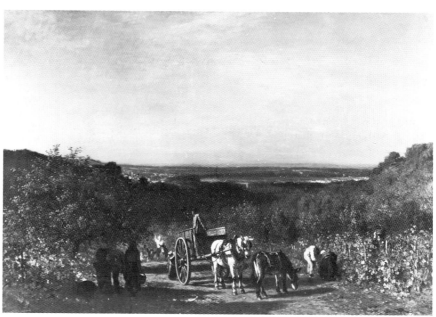

their populations were new and transitory is apparent from the Saint-Lazare terminus's passenger statistics for 1869; of 13,250,000 passengers, suburban traffic comprised some 11 million.[43] The old village communities still existed, but they were being swamped by the city's overspill.

Painters had worked in the western suburbs for decades, among them artists such as Célestin Nanteuil, François Français and Paul Huet; Corot had property at nearby Ville d'Avray, and painted at Marly in 1872. Strolling round Bougival in 1855, the Goncourt brothers joked how 'that's been done by X, that's been drawn by Y, Z painted that'.[44] For artists the attractions were evident. The area provided a variety of motifs – river, hills and woods, picturesque villages and historic sites – with cheaper accommodation than Paris but still within easy distance for the city and the support systems it provided: dealers, critics, framers, collectors. However, by the late 1870s the essentially placid, escapist motifs which the elder generation had sought, existed in shifting, threatened balance with the intrusion of the new: the riverside restaurant, the raucous bathing place, the crowded regattas. The younger landscapists were drawn to this precarious balance.

Pissarro's paintings made at Louveciennes, both before and after the Franco-Prussian War, tend to construct an image of rural village life. At least thirty take as their central motifs the roads linking these suburban villages with each other and nearby Versailles. *View from Louveciennes* (fig. 8), probably dating from 1869,[45] is a slow-paced and apparently agricultural image, with apple trees in blossom and carefully tended vines or soft-fruit bushes; only the discreetly silhouetted Marly aqueduct gives any point of geographical reference.

Renoir painted the same road a few months later (fig. 9). His account of the motif further disguises the village of Voisins in the middle distance, makes the landscape appear more wild than cultivated, and all but effaces the aqueduct. But whereas Pissarro's figures are country people, Renoir juxtaposes his blue-clad peasant with a bourgeois family, giving us a fiction of a promenade in deep countryside. A painting of about a decade earlier, Troyon's *Grape Harvest at Suresnes* (fig. 10), although

taking a more distant, panoramic view and stressing the agricultural scene in the foreground, nevertheless showed the Marly aqueduct on the far left horizon and carefully lit the suburban agglomerations in the distant river valley, though these could easily be misread as country villages. Three painters of different generations constructed images equivocal about the metropolis's tentacular advance into agricultural land.

Returning to the area after the War, Pissarro largely retained the same fiction

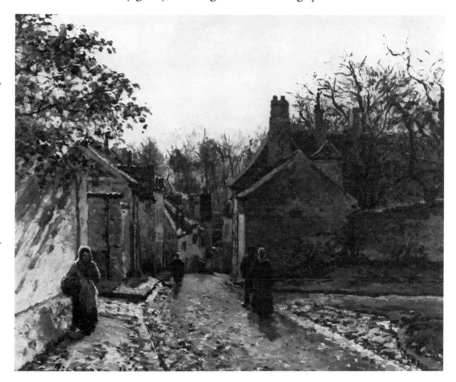

11. C. PISSARRO, *Rue de Voisins, Louveciennes*, 1871. Oil on canvas. 46 × 55.5 cm. Manchester City Art Gallery.

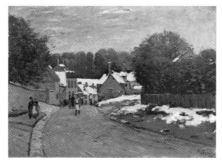

12. A. SISLEY, *Early Snow, Rue de Voisins, Louveciennes*, c.1871. Oil on canvas. 54.8 × 73.8 cm. Museum of Fine Arts, Boston.

about Louveciennes. Both he and Sisley painted the rue de Voisins in Louveciennes in 1871, Pissarro in the autumn and his colleague a little later, under snow (figs 11, 12). The images differ in their *effet*, of course, and in their position. But Sisley showed a newly tiled roof to the left, and specified more closely the types who populate his street: an aproned maid on the pavement, to the centre a baker carrying on his head a tray of bread, and behind him a bourgeois couple. If Sisley was prepared to suggest renovation and class mixture, Pissarro selected a viewpoint that narrowed the street, a warm yet sombre tonality that implied age, and a staffage humbly dressed. One of the first Impressionist paintings to enter a British collection, Pissarro's *Rue de Voisins, Louveciennes* was sold to a Lancashire industrialist, probably in 1872.[46] Perhaps its immediate appeal was due to Pissarro's success in contriving to represent increasingly suburbanized Louveciennes as changeless country village.

The Franco-Prussian War had a marked effect on Pissarro. Despite his Danish citizenship, in November 1870 he was prepared to fight for the newly proclaimed Republic, but his mother urged him to put his family first.[47] The worst blow fell in March 1871, after the French surrender had raised the Prussian siege of Paris and post could reach Pissarro in London. Julie's sister, Félicie Estruc, reported that the Pissarros' rented house in Louveciennes had been used as a stable and billet by the Prussians for four months and was unrecognizable. Pissarro had lost twenty years' work; he reckoned that over 1200 paintings, *études* and drawings had disappeared or been destroyed.[48] Louveciennes had been occupied throughout the siege by the Prussian V Army Corps. From the heights to the west of Paris, their

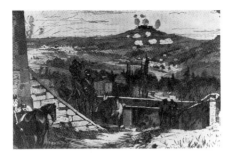

13. ANON., *Mont Valérian during the Siege.* Wood engraving. From E. Ollier (ed.), *Cassell's History of the War between France and Germany, 1870–1*, London, n.d., vol. I, p. 360.

entrenchments offered a commanding view of the city and that flank's lone outlying fort on Mont Valérian, and there had been regular artillery engagements between the positions throughout the siege (fig. 13). King Wilhelm of Prussia even had a belvedere built on the end of the Marly aqueduct from which he could watch the bombardment of the French defences.[49] The devastation in Louveciennes that Félicie Estruc reported – 'the houses are burned; windowpanes, shutters, doors, stairs, parapets, they've all disappeared' – was the combination of four months of Prussian investment and French return of fire.

Returning to work around Paris in 1871–2 the Impressionist painters seem to have been remarkably discreet about the ravages, preferring to produce images of untroubled calm or at least confident retrenchment.[50] The evidence of their *Rue de Voisins* paintings suggests that Sisley was prepared to hint at repairs which Pissarro edited out. But a contrast of two paintings from the same viewpoint and of almost identical size, both dated 1870, intimates another approach by Pissarro (figs 14, 15). One painting

14. C. PISSARRO, *Louveciennes*, 1870. Oil on canvas. 45.8 × 55.7 cm. Southampton Art Gallery.

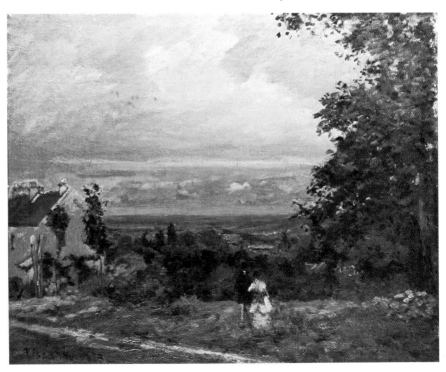

22

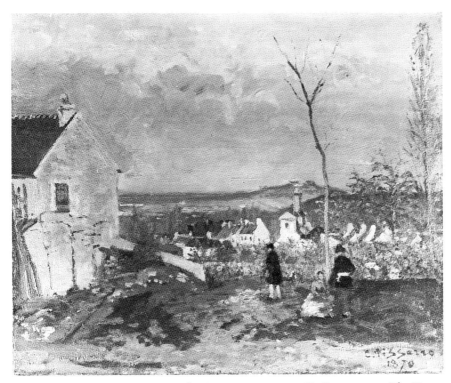

ground shattered, the earth turned over, branches stripped from the trees, Mont Valérian exposed. It is an autumnal scene, but Pissarro was at Montfoucault in the autumn of 1870. Perhaps he inadvertently misdated the picture, and with its devastation and reoccupation by a soldier in French uniform, it might be construed as an image of the aftermath of war, a poignant, if informal, pair to the charming summer scene.[51] Other artists recorded the war damage. Georges Jeanniot, for example, drew a similar vista in 1871, ironically framing the Arc de Triomphe with ruins above Suresnes (fig. 17). Pissarro rather preferred polar

15. C. PISSARRO, *Louveciennes with Mont Valérian in the Background*, 1870 (?or 1871). Oil on canvas. 45 × 53 cm. Nationalgalerie, Berlin.

16. C. COROT, *Landscape with Mont Valérian*, c.1865–70. Oil on panel. 24.5 × 34.2 cm. Leeds City Art Gallery.

17. RIGHT: G. JEANNIOT, *The Devastation of Suresnes*, 1871. Pencil and watercolour. 20.3 × 29.2 cm. Colnaghi, New York.

shows the view from outside Pissarro's house on the route de Versailles, with a bourgeois couple gazing towards distant Paris and Mont Valérian just masked by the branches to the centre right. Probably painted in the summer of 1870, before the War broke out, it is a steady, ordered picture, with a bucolic character not unlike a contemporary view of Mont Valérian by Corot, in which the great fort appears like an Italian hilltop town (fig. 16). The other painting, however, shows this fore-

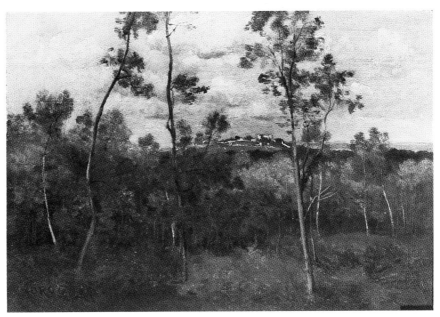

opposites in his images of before and after the conflict.

Pissarro also painted the riverside suburbs before and after the War. These pictures seem to lack the polarization just discussed, although they do make important internal contrasts. Indeed, the fact that with six of his seven riverside motifs Pissarro repeated the same motif or composition suggests a conscious charting of varied possibilities, even the creation of deliberate pairs.[52] His first riverside painting seems to have been *La Grenouillère at Bougival* (fig. 18). This modest-sized but important canvas probably dates from the summer of 1869; stylistically it incorporates both silvery Corotesque trees and a richly hued and textured handling of the water close to the current work of Monet, who was painting with Renoir at La Grenouillère that summer. But unlike his colleagues, Pissarro, while including at the right of his composition the wooden structure of the fashionable bathing place, did not paint 'the packed and mixed crowd' observed by contemporary commentators at this 'indecent and refined' venue.[53] Instead he used a small factory on the opposite bank as a counterweight, constructing a tacit dichotomy between industry and leisure. In 1872 he painted the same view, but ignored La Grenouillère to focus on the near bank and the river traffic (fig. 19). The landscape is scarcely natural, with its regimented row of saplings, smoking factory chimney, busy barge traffic, and women laundering clothes at the floating wash-house. An emphatic image of labour, *Wash-House at Bougival* makes a sharp contrast with the fiction of carefree bourgeois leisure composed by Monet and Renoir in their images of La Grenouillère.

Pissarro continued to explore tensions between leisure and labour in his other

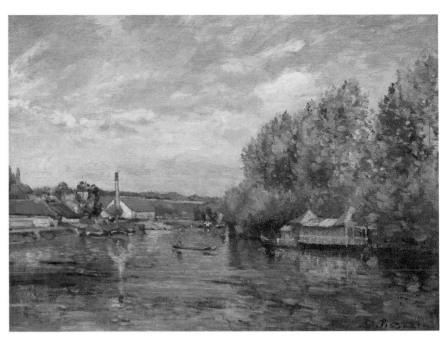

18. C. PISSARRO, *La Grenouillère at Bougival,* c.1869. Oil on canvas. 35 × 46 cm. From the Collection of the Earl of Jersey. Reproduced in colour on page 15.

19. C. PISSARRO, *Wash-House at Bougival,* 1872. Oil on canvas. 46.5 × 56 cm. Musée d'Orsay, Paris. Reproduced in colour on page 16.

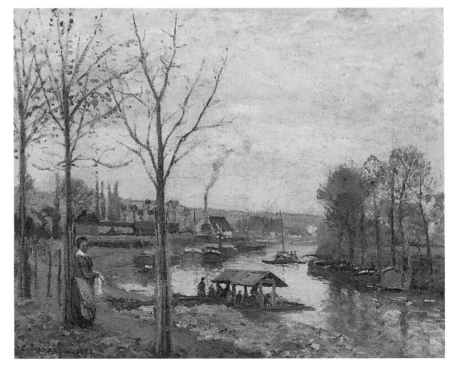

riverside paintings. There are two views of the Seine at Marly, one painted in the late summer of 1871, the other early the following year (figs 20, 21). The earlier painting has its ancestry in the imagery of prints of a previous generation, representing Parisians taking steamboats on excursions to the suburbs (fig. 22). But Pissarro's painting is a 'modern' picture in twin respects: its combination of

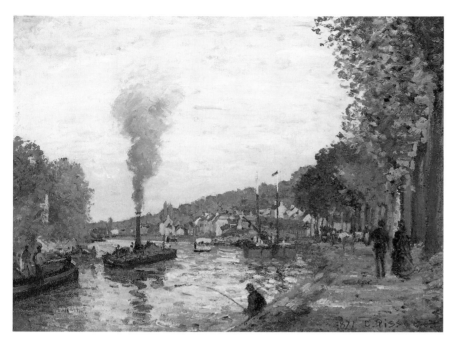

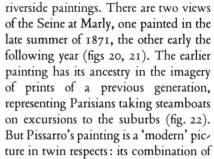

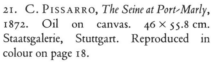

20. C. PISSARRO, *The Seine at Marly*, 1871. Oil on canvas. 44 × 60 cm. Private collection, Switzerland. Reproduced in colour on page 17.

21. C. PISSARRO, *The Seine at Port-Marly*, 1872. Oil on canvas. 46 × 55.8 cm. Staatsgalerie, Stuttgart. Reproduced in colour on page 18.

22. V. ADAM, *The Trip to Saint-Cloud by Steamboat*, 1830. Lithograph. 16.6 × 19.4 cm. Library of Congress, Washington DC.

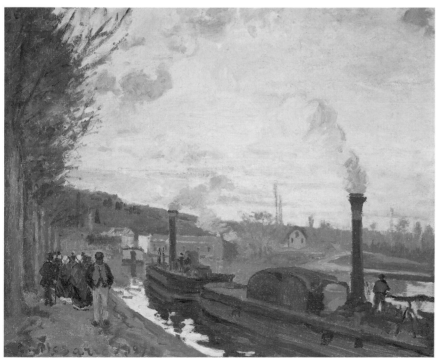

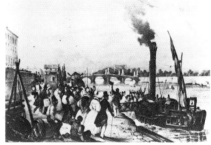

his new assurance with broken brush-work and complementary contrasts, and his harmonious balancing of the commercial traffic on the river and the leisurely bourgeois strollers on the bank. Making and meaning act in confident synchronization to construct a balanced, thriving suburban world untouched by war. The 1872 canvas used a similar design, held by trees filling a vertical edge and the river curving into the picture space, and was taken from about the same place. But whereas the 1871 canvas looks eastwards towards Bougival, with La Grenouillère behind the trees to the left, the 1872 painting faces westwards, showing the sun setting behind Port-Marly. In this strong, sombre, broadly painted picture, the river is presented as a commercial artery, crammed with steamers, their decks cluttered with pumps and winches. The Machine de

Marly looms in the background, a pumping station rebuilt in 1858 and, being capable of forcing through 12,000 cubic metres of water per day, one of the technological marvels of the era.[54] On the bank figures in middle-class costume walk away while towards us stomps a pipe-smoking labourer. In explicitly identifying these types, Pissarro surely planned them to count in the reading of the painting, and here the working aspects of this riverside suburb predominate. The same stretch of river could be given different identities by altering the balance of its constituent elements in tandem with a change of palette, touch and *effet*.

Pissarro's work in the Parisian suburbs was not a challenging concentration on the contemporary. Like Monet, Renoir and Sisley, he juggled several categories of 'suburb', sometimes contrasting them from canvas to canvas, sometimes within the same painting. From his base at Louveciennes Pissarro spent two brief but intense periods working out his positions *vis-à-vis* the encroachment of Paris, the migrations of the bourgeoisie, the industrialization of the suburbs, and the devastation of war in a diverse and even contradictory group of paintings.

Pissarro at Pontoise: Modernity and Equivocation

Because of the war damage at Louveciennes we have only a partial overview of Pissarro's activity at Pontoise between 1866 and 1868. As far as we can judge, he concentrated on major exhibition *tableaux* — both his works at the Salon of 1868 were large Pontoise canvases — and drew subjects from two aspects of the area: the town itself and the adjacent, heavily cultivated L'Hermitage.

Produced in the spring of 1866, *The House of Père Gallien* (fig. 23, p. 32) is a substantial canvas painted 'near the remains of the 16th century fortifications called "la Citadelle"'.[55] But there are no picturesque ruins in this verdant landscape under a showery sky. Its subject is the edge of the town, for our eye travels through the picture space to be abruptly halted by the back walls of properties abutting cultivated land. A bourgeois couple, clichéd enough in their attentive flirtation under the blossom, seem out of place strolling on what appears to be a ploughed smallholding rather than a path. Just as they form a contrast with the two lace-capped countrywomen behind, so the house to the right, with its jauntily angled slate roof and pale blue shutters, appears newer, more prim, than the stocky building on the left, roofed with tiles, its green shutters faded.[56]

A similar friction can be found in *The Côte de Jallais, Pontoise* (fig. 24), painted in 1867 and one of the pictures shown at the Salon the next year.[57] It appears to belong within a family of strongly composed valley motifs painted by Corot, Courbet and Daubigny,[58] and to use their formulae for a close-valued representation of the smallhold-

ings and market gardens of L'Hermitage, a community adjoining the town to the north. Reviewing the Salon, Zola admired the 'ridge divided by strip cultivation into green and brown bands. That's the modern countryside. One feels that man has passed by, digging the soil, carving it up, saddening the horizon.'[59] For Zola, the landscape's modernity lay in Pissarro's ability to give grandeur to the banal. He ignored the two women just coming into view. Their dresses and parasol identify them as bourgeois, infiltrating — and, it seems, gently disrupting the character of — this pastoral scene. Daubigny's *View of Butry, near Valmondois* (fig. 25) has a similar composition, represents a nearby site, and was painted only shortly before, but it is constructed very differently. Daubigny's irregular farm buildings, haphazard plantings and laden haycart create an image of traditional agriculture, while Pissarro's regular plots, walls and ditches, his four-square structures and strolling women, suggest a recognition and articulation of change.

The pace of change in Pontoise in mid century was gradual but tangible. Twenty-five kilometres to the northwest of Paris and perched on a commanding site above the Oise not far from its confluence with the Seine (*see* map; fig. 7), Pontoise's identity was shaped by its location. It served as a market town for the fertile lands around it, a place of transit and exchange, and was far enough from Paris to retain an independence. The sale of Pontoise's many ecclesiastical properties after the French Revolution increased the number of smallholdings surrounding the town.[60] Pontoise had

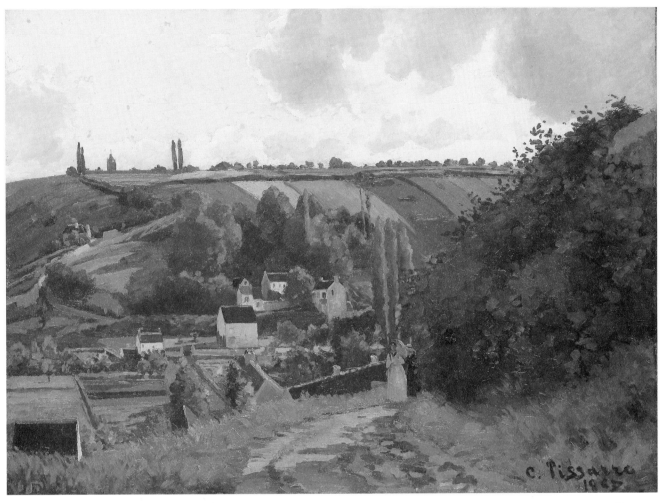

24. C. PISSARRO, *The Côte de Jallais, Pontoise*, 1867. Oil on canvas. 87 × 114.9 cm. Metropolitan Museum of Art, New York.

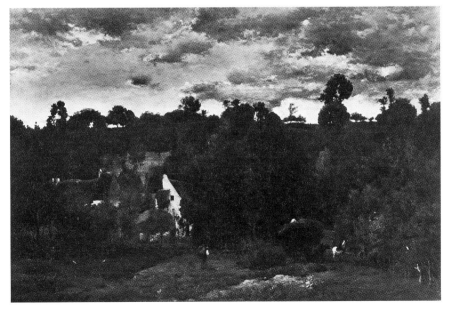

25. C. DAUBIGNY, *View of Butry, near Valmondois*, 1866. Oil on canvas. 112 × 161.5 cm. Kunsthalle, Bremen.

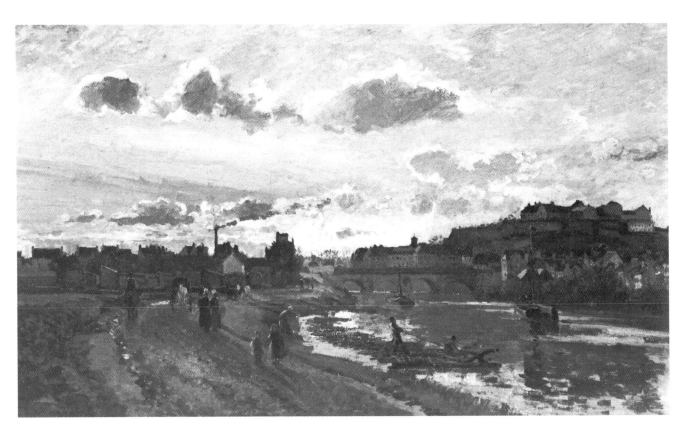

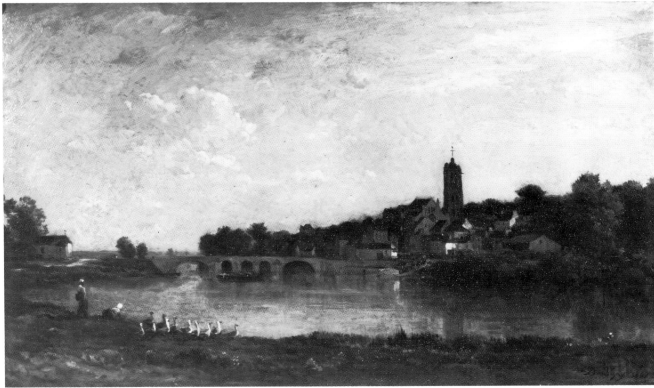

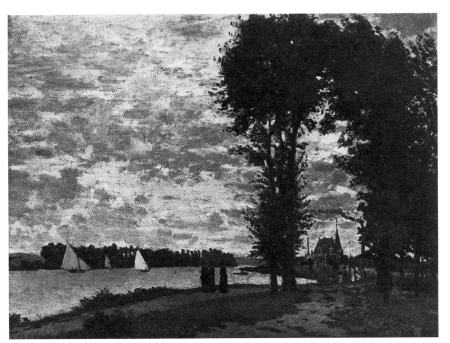

always served as a centre for the rich cornfields of the Vexin, lying to the northwest. Distribution of the region's grain was facilitated by the construction in 1843 of a stone bridge and quays.[61] The railway arrived at Saint-Ouen-L'Aumone, on the opposite bank of the river, three years later, and was extended to Pontoise, over an iron bridge, in 1863.[62] The expansion of the French railway network undermined the monopoly in providing fresh produce for the metropolis which the towns around Paris had enjoyed; in November 1871 fresh flowers from the Côte d'Azur were first sold in Paris.[63] The pace of economic life was speeding up, and Pontoise responded, not atypically, with a slow-paced pattern of specialization and diversification. Its agriculture was a complex, even overlapping, mixture of large cereal farms on the Vexin plain, small holdings such as those at L'Hermitage, *jardins potagers* or market gardens, and orchards. The growth of Pontoise's markets, with the rise of the metropolitan population, and the pressure of competition had essentially transformed local agriculture from subsistence farming to a market economy by Pissarro's time.[64] Industrial developments occurred also, but mainly in Saint-Ouen. In the early 1870s Chalon et Cie built two factories

for distilling alcohol from potatoes and beets, and a modest paint factory was erected in 1873, but these were small employers with little impact on the local economy.[65]

Returning to Pontoise in 1872 Pissarro was electing to work in a community where the tensions and polarizations produced by economic change were less acute than in the Parisian suburbs. A *View of Pontoise* made in 1872 shows a sunset, like the *Seine at Port-Marly* of earlier that year (figs 26, 21). But whereas the suburban motif was packed with the machinery, buildings and even the workforce of the modern conurbation, Pissarro constructed Pontoise as a more open, freer place. He did not go quite so far as Daubigny, who in his 1867 *Bridge between Persan and Beaumont-sur-Oise* (fig. 27) had ignored the railway and industrialized Persan on the left to focus on the church and village of bucolic Beaumont. But his little girls and lace-capped countrywomen exude an air of innocence like Daubigny's

goose-girl, and the new iron railway bridge is hidden around the bend in the Oise. The lone factory chimney does not disturb the harmony, and its smoke elides effortlessly with the clouds. Nevertheless, chimney and barges admit modernity and commerce, but in a discreet, balanced manner similar to Monet's contemporary paintings of Argenteuil (fig. 28), a town between Pontoise and Paris.[66] Pissarro's *View of Pontoise* seems contradictory, ambivalent. There is little hint here that Pontoise was slowly becoming a satellite of the city; it is represented essentially as a country town.

Pissarro's images of agriculture around Pontoise are also partial and ambivalent. He produced only about ten canvases of the cornfields of the *Vexin français*, despite their local importance, and these mostly date from his first months in the region.[67] *Landscape near Pontoise* (fig. 29) took up the pictorial challenge of close-valued terrain unrolling in a dipping rhythm into space. It uses a structure still loosely

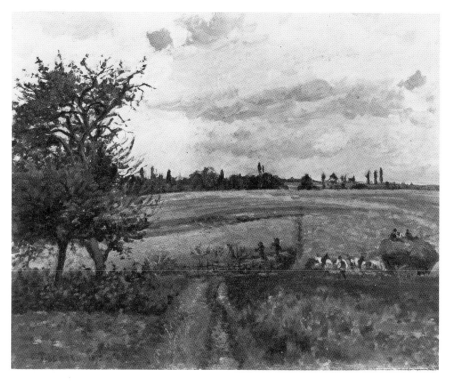

29. C. PISSARRO, *Landscape near Pontoise*, 1872. Oil on canvas. 46 × 55 cm. Ashmolean Museum, Oxford.

following neo-classical regulation, a darker foreground, recession by planes, and a *repoussoir* tree, much as Corot did in his *The Cart. Souvenir of Saintry* (fig. 30). But whereas Corot placed his static cart centrally and in relation to the village, Pissarro arranged his landscape more dynamically; his hay waggon with its male and female labourers is placed off-centre, giving a sense of passage, of implied distance. And while in the Corot agriculture is only generalized, Pissarro shows variety. There are apple trees in a cultivated plot with fallow opposite; a new plantation of saplings in the middleground; and despite its expansiveness even the corn appears divided into plots. Paintings like this and *Misty Morning at Creil* (fig. 31), a vista subtly closed to us by the *effet* of the fog, present an agricultural momentum unthreatened by change. Although a Société d'agriculture et d'horticulture de Pontoise had been founded in 1854 to promote more 'scientific' production, the pace of mechanization in the region was slow. A. M. Laroche at Saint-Ouen constructed a mechanical thresher in 1868, but destroyed it the following year! The next did not appear in the neighbourhood for a decade.[68]

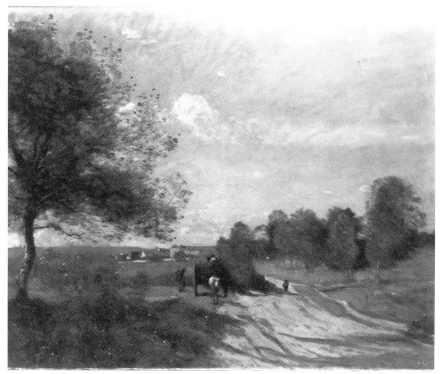

30. C. COROT, *The Cart. Souvenir of Saintry*, 1874. Oil on canvas. 47 × 56.8 cm. National Gallery, London.

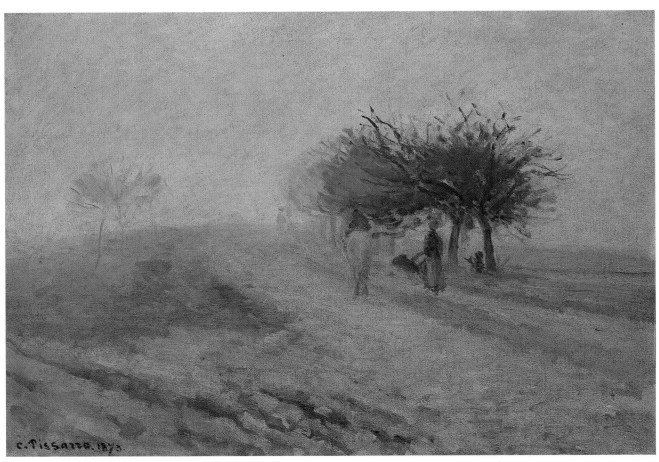

31. C. PISSARRO, *Misty Morning at Creil*, 1873. Oil on canvas. 38 × 56.5 cm. Frau Marianne and Dr Walter Feilchenfeldt, Zurich.

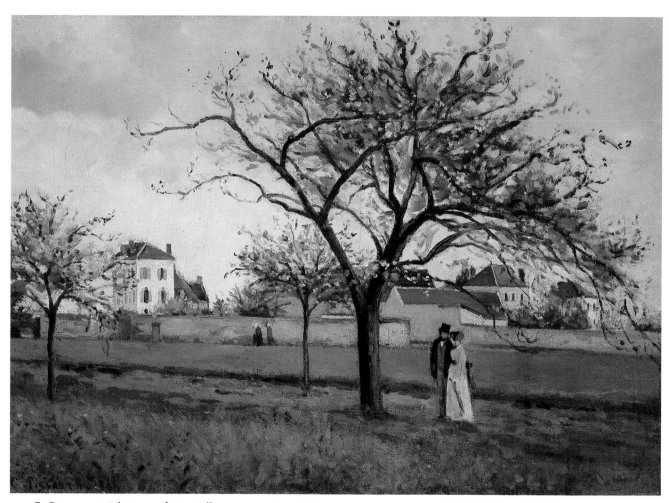

23. C. PISSARRO, *The House of Père Gallien, Pontoise*, 1866. Oil on canvas. 40 × 55 cm. Ipswich Museums and Galleries.

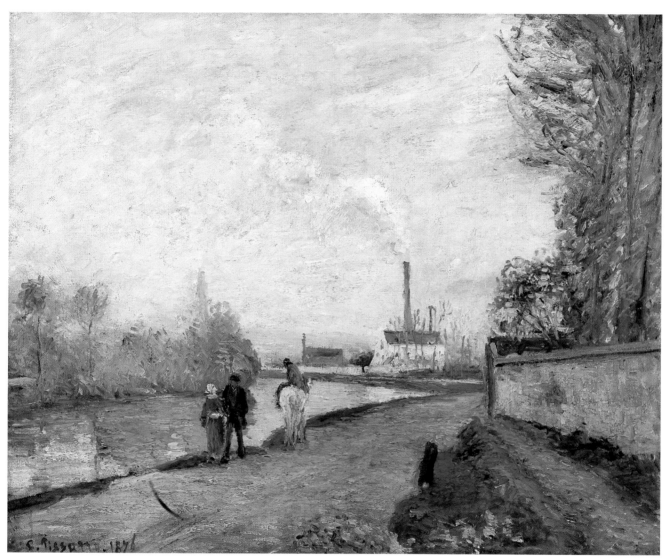

34. C. PISSARRO, *The Oise at Pontoise, grey weather*, 1876. Oil on canvas. 53.5 × 64 cm. Boymans-van Beuningen Museum, Rotterdam.

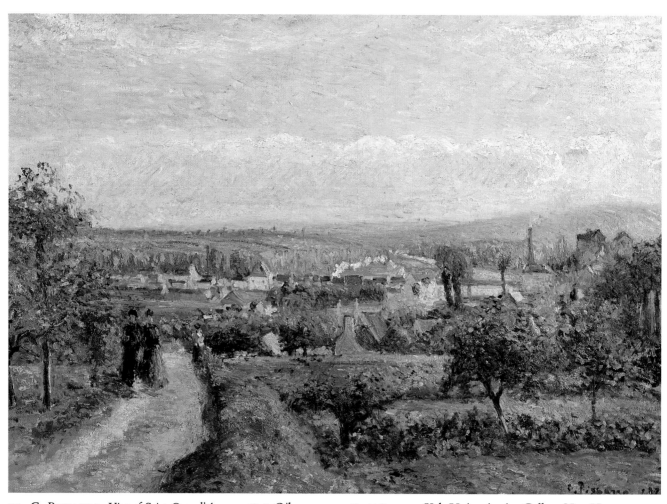

37. C. Pissarro, *View of Saint-Ouen-l'Aumone*, 1876. Oil on canvas. 58.5 × 80.5 cm. Yale University Art Gallery, New Haven.

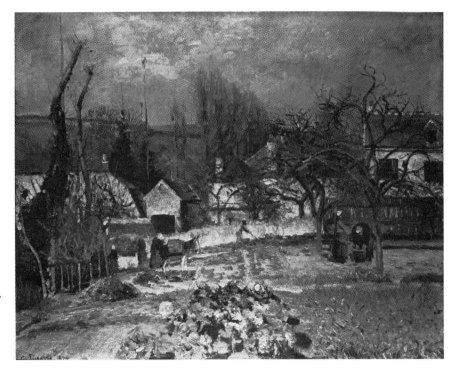

32. C. PISSARRO, *Kitchen Gardens at L'Hermitage*, 1874. Oil on canvas. 54 × 65.1 cm. National Gallery of Scotland, Edinburgh.

The majority of Pissarro's paintings made at Pontoise represent L'Hermitage, where the family lived during the 1870s in a sequence of rented houses. L'Hermitage had an equivocal identity. Packed into a confined space between ridges were numerous smallholdings and *jardins potagers*. These restricted and sloping properties were labour intensive, and little adaptable to mechanization.[69] During the 1860s the rue de l'Hermitage had been run through the valley, bringing with it new amenities such as cafés and gas lighting.[70] In a letter to Monet of 1882 Pissarro described the new houses on the Côte de Jallais, 'a couple of steps from the fields', as 'thrown up like . . . the villas in the Paris suburbs'.[71] Something of this fluid identity emerges in Pissarro's paintings. *Kitchen Gardens at L'Hermitage* (fig. 32) of 1874 apparently represents men and women bringing in the final autumn crops, the cabbages and onions, from their *jardins potagers*. But behind this image of intense, traditional field work, behind a green-painted fence, lurks a neat, shuttered house, not unlike the architecture of the Parisian suburbs, which contrasts with the more disordered buildings to the left. Either a new structure or an old stone property freshly plastered,[72] it indicates Pissarro's perhaps rather reluctant awareness of transition. This equivocation, apparent in the *Côte de Jallais* of 1867 (fig. 24), runs as a tacit theme in Pissarro's

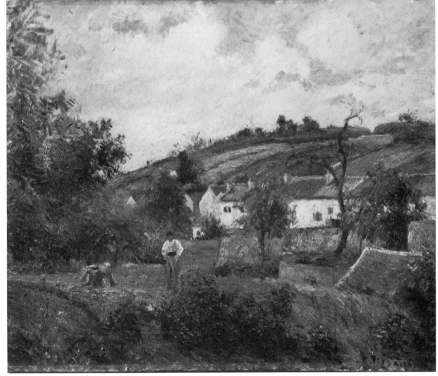

33. C. PISSARRO, *Village near Pontoise*, 1878. Oil on canvas. 55 × 65.5 cm. Öffentliche Kunstsammlung, Basel.

L'Hermitage motifs. An ambiguity haunts *Village near Pontoise* of 1878 (fig. 33). Like *Kitchen Gardens* of four years earlier, it shows work in a *jardin potager*, and appears to read like a rural motif. But are the differences in the rooves — tiles and slates — to be understood in terms of simple local variety, the budgets of the householders, or the intrusion of new properties, the infill between traditional cottages?

Pissarro's responses to the modest industrialization of the river were also equivocal. In 1873 he made three paintings of the Chalon distillery and the surrounding buildings, which faced L'Hermitage across the Oise.[73] They are determined motifs, with the factory dominating the canvases, and yet cautious, for we are distanced from it by the river. Such direct representations of industry were uncommon, and were usually the result of commissions, as was Corot's *House and Factory of M. Henry at Soissons* (1833; Philadelphia Museum of Art). Perhaps because none of these three paintings found ready buyers, Pissarro later favoured compositions which, if they include factory chimneys, place them discreetly in the distance or mask them with trees, and these occur with some consistency throughout the 1870s. In 1876 he produced another group of the Chalon factory: two canvases of size 15 and two size 10.[74] The larger were painted from the Saint-Ouen side of the river (fig. 34), stressing the towpath and the horses used for hauling barges. They have a more 'industrial' identity than the smaller paintings, viewed from the Quai de Pothuis looking across the Oise (fig. 35). Edouard Béliard, who exhibited with the Impressionists in the mid 1870s, had painted this view the year before (fig. 36). Like Pissarro he centred his landscape on a lone gaslight, which acted in combination with the

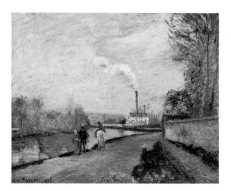

34. C. PISSARRO, *The Oise at Pontoise, grey weather*, 1876. Oil on canvas. 53.5 × 64 cm. Boymans-van Beuningen Museum, Rotterdam. Reproduced in colour on page 33.

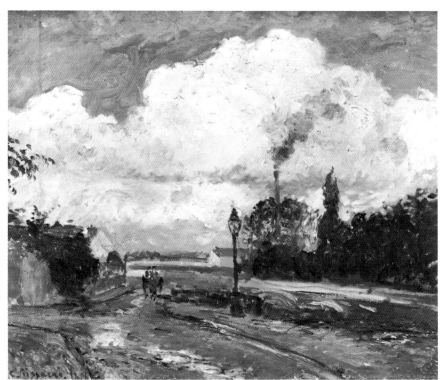

35. C. PISSARRO, *Quay at Pontoise, after rain*, 1876. Oil on canvas. 46 × 55 cm. Private collection, on loan to Whitworth Art Gallery, Manchester.

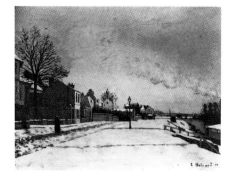

36. E. BÉLIARD, *Quai de Pothuis at Pontoise*, 1875. Oil on canvas. 78 × 110 cm. Musée Municipal, Etampes.

37. C. PISSARRO, *View of Saint-Ouen-l'Aumone*, 1876. Oil on canvas. 58.5 × 80.5 cm. Yale University Art Gallery, New Haven. Reproduced in colour on page 34.

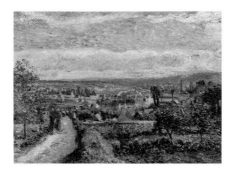

38. BELOW: C. PISSARRO, *The Plain of Epluches (rainbow)*, 1877. Oil on canvas. 53 × 81 cm. Rijksmuseum Kröller-Müller, Otterlo.

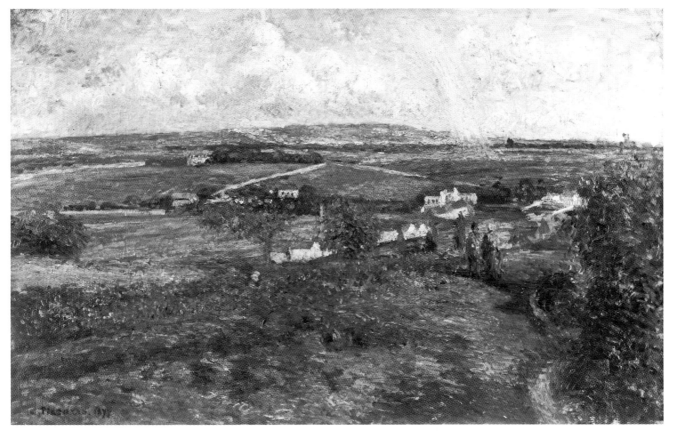

expanse of quayside – in Béliard's painting – and the smoking chimney – in Pissarro's – as a symbol of the modernization of the Pontoise riverbank. But Pissarro's 1876 group has an offhand quality in its execution and a cautious attitude to the industrial motif. Unlike Béliard, who had a *Factories on the Banks of the Oise* at the 1876 Impressionist exhibition,[75] Pissarro kept these paintings back in the studio.

At the 1877 Impressionist exhibition Pissarro showed *View of Saint-Ouen-l'Aumone* and *The Plain of Epluches (rainbow)* (figs 37, 38), two of the rare panoramic views he painted at Pontoise, or indeed elsewhere.[76] Later he felt the panorama format did not fit his talents.

Although admiring the famous view of Rouen from the heights of Canteleu, he never painted it, and in 1899 rejected the possibility of working at Arques: 'the countryside doesn't suit me; it's particularly panoramic, whereas I look for corners [*coins*]'.[77] The panoramic landscape typically uses its wide view to include a great deal of information, more than

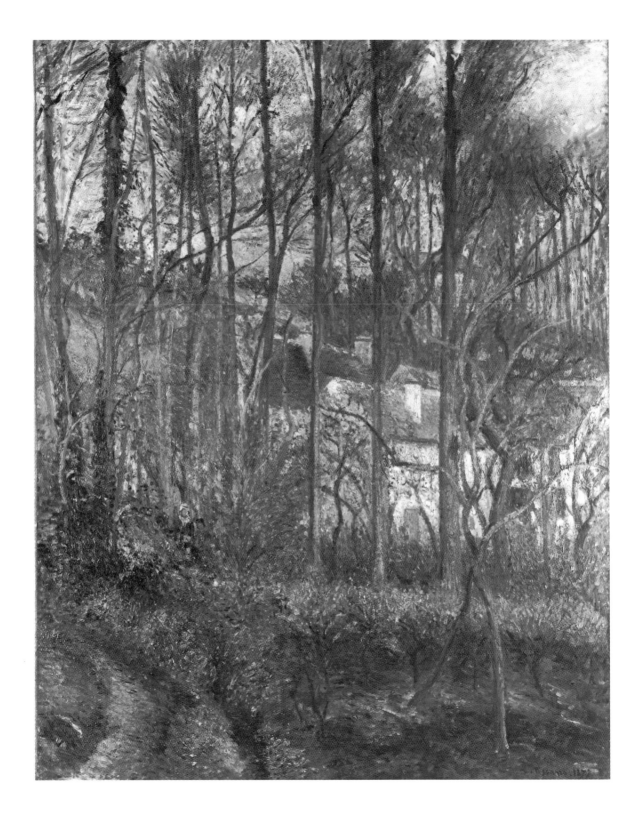

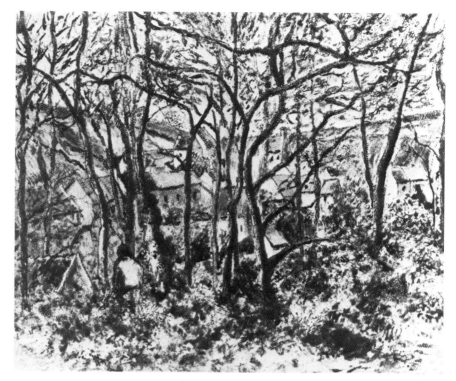

the eye could take in at once; it is synoptic, all inclusive, and essentially artificial. Nevertheless, with these two paintings Pissarro exploited those very characteristics. The *View of Saint-Ouen* is an integrated demonstration of the 'modernization of rural France'. It provides a pictorial list of 'natural' and 'modern' elements: on the one hand the apple trees, the strip cultivation and the squat old farmhouses, on the other the iron bridge, the factory chimney, the train puffing across the middleground. The intrusion of the modern elements is mollified by the pinks and yellows of the evening sky, just as the *Plain of Epluches* has the natural effect of the rainbow as a diversion. Nevertheless, this panorama too is dense with information, here about local agriculture. If the fore- and middle-ground are made up of smallholdings, with clustered farmbuildings, to the rear is a large, manorial property set in large fields and enclosed by walls. Pissarro thus charted some of the different types and scales of local agriculture, as he did on other rare occasions;[78] and he also discreetly inserted a small factory. The bourgeoises promenading in the *View of Saint-Ouen* and the peasants conversing in *Plain of Epluches* also help to give each landscape a different reading. But in both these panoramas, with their striking accents of colour, Pissarro systematically acknowledged the diversity and fluidity of the communities and their means of production in the Pontoise region.

As the decade drew to a close Pissarro transferred his ambitions from 'modern' or synoptic motifs to developing a more unified surface and systematic brushwork, while his representations of L'Hermitage increasingly promoted the fiction of a rural community. At Argenteuil Monet was once again working to a similar pattern, no longer sustaining a harmony between nature and modernity but reducing elements in his landscapes which were too pressingly contemporaneous.[79] One of Pissarro's most important paintings of this period is the *Côte des Boeufs, L'Hermitage*, made in 1877 (fig. 39). Pissarro himself was pleased with it, and hung it in his bedroom for many years; at his one-man show in 1892 a substantial 2,000 francs was asked for the canvas.[80] The wooded *sous-bois* motifs which so fascinated Pissarro in the late 1870s are a polar opposite to his panoramas: confined in space and subject, restricted in colour and touch. A *sous-bois* itself has particular character-

istics, notably an insistently patterned surface. In order to achieve an effect beyond it of receding pictorial space the artist has to control value – relative lightness and darkness – as Pissarro did with such subtlety in the daring prints he made at this period, experimenting with etching and aquatint (figs 40, 41). In the *Côte des Boeufs* values are again used with great delicacy, but in alliance with hue, as reds advance and greens recede to give a visual oscillation which animates the rather cloying textures which Pissarro built up. For the *Côte des Boeufs* is far from an improvised 'impression'; Pissarro himself told Sickert it had cost him 'the work of a Benedictine'.[81] Critics writing about Pissarro at this time frequently commented on the textures. 'His facture is doughy, fleecy, tormented; his figures, with their melancholy character, are treated with the same methods as the trees, grass, walls and houses', complained Charles Ephrussi in 1880.[82] Ephrussi equated mood and surface in a way which might be related to *Côte des Boeufs*. For this is not an easy painting to read. The breezy sky, rising sap and blossoming soft-fruit bushes are almost submerged in the marks Pissarro required to build up his *effet*. Matter and motif become nearly indivisible, so the figures and the houses are not just cramped between the 'natural' ridges and trees but also by the 'made' surface of the painting. The *Côte des Boeufs* brings fictions into play, most importantly the 'pure' rurality of L'Hermitage and the 'spontaneity' of the Impressionist touch, and tries to marry them. These were issues that had come closely into focus at Montfoucault.

Montfoucault: Fictions of the 'True Countryside'

In late October 1874 Pissarro wrote to the businessman, critic and collector Théodore Duret: 'I'm letting you know that I'm departing for my friend Piette's locality; I won't be back before January. I'm going there to study the figures and animals of the true countryside.'[83] This was the first of a series of extensive campaigns at Montfoucault which Pissarro made during the mid 1870s. He had worked there in the previous decade,[84] but his letter reveals that there were new ramifications in 1874. His intention was to concentrate on figurative motifs rather than landscape, and his reference to the Montfoucault region as 'the true countryside' suggests that he recognized the equivocal, quasi-rural character of the L'Hermitage *jardins potagers*.

Montfoucault is in the Mayenne, some 225 kilometres to the west of Paris, thus further from the orbit of the capital than Pissarro had been used to working. The gently undulating landscape, with its woods and hedgerows, is neither as expansive as the Vexin nor as compressed as L'Hermitage, and agricultural production was mixed, with cereals and livestock, orchards and vegetables. Montfoucault is remote, set well back from a lane linking the local villages like Melleray and the market town of Lassay, and it centres on a large farmhouse with a walled garden in front and behind a yard flanked by outbuildings. Alongside is a larger farmyard, irregularly enclosed by barns and a couple of labourers' cottages. The property belonged to Ludovic Piette, whose close friendship with Pissarro seems to have begun about 1860. His family were local notables,

and in the Melleray archives for 1870 Piette is referred to as 'Le Sieur Piette-Montfoucault'. However, his Montfoucault property of 18 hectares was not extensive, and in the region even the 'aristocrats' were said to 'have finished their dinner when they had finished their soup'.[85] Piette also drew income from an apartment block built on a plot bought in Paris in 1859, in which he retained a *pied-à-terre*. Capitalizing on the Second Empire property boom, Piette subsidized a career as a painter from Parisian rents and rural cultivation, exhibiting at the Salon during the 1860s but thereafter preferring to sell via regular auctions of his work staged in Paris by the dealer *père* Martin, who also handled Pissarro.[86]

The Mayenne retained many conservative characteristics. In 1875 Piette tried to find a maid for the Pissarros, writing that the girl he was sending could be recognized by 'a large black veil attached to her bonnet in the regional tradition' and that, given the strong local Catholicism, she would expect to attend mass regularly.[87] (The maid never arrived, deterred perhaps by the distance of alien Pontoise.) Such provincialism coexisted with the typical new pressures of urban industrialization with high wages and concomitant rural depopulation; Piette himself found it hard to get a maid because local women with skills in the manufacture of cotton were being lured by Paris.[88]

Despite these modern pressures coming gradually to bear on rural Mayenne, Pissarro's Montfoucault motifs generally have an unchanging character. But then this was consistent with his attitude to

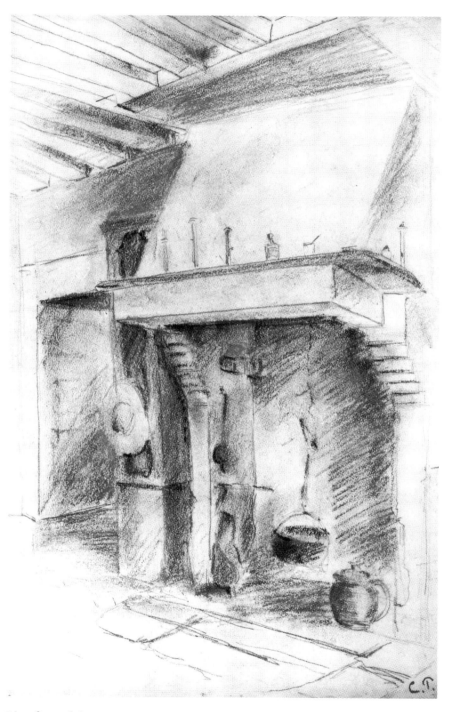

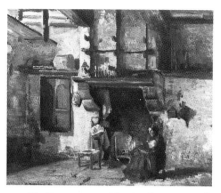

42. C. PISSARRO, *The Fireplace*. Study for *The Kitchen at Piette's House, Montfoucault*, 1874. Pastel and black chalk. 50 × 32.3 cm. JPL Fine Arts, London.

43. C. PISSARRO, *The Kitchen at Piette's House, Montfoucault*, 1874. Oil on canvas. 46 × 55 cm. Detroit Institute of Arts.

artists of the first rank.'[89] Duret replied with encouragement three days later: 'Are you painting two- and four-legged beasts? Pure landscape is invaded from so many sides, but here is a gap to fill and continue in the line of Paul Potter, Cuyp, Troyon, [and] Millet, while of course being modern and different.'[90] Pissarro's 1874 paintings are predominantly of the main house, the farmyard, and the immediate vicinity such as the pond; there are only two images of the further pastures.[91] There are also two interiors,[92] unusual for Pissarro in their almost ethnographical detail, for one of which he made a large, considered preparatory drawing (figs 42, 43). He evidently worked *en plein air* in winter conditions. The view of the rear of the farmhouse (fig. 44) and a motif of the outer farmyard are densely painted, but the canvases are by no means entirely covered. This may in part have been due to the difficulties of working in cold conditions, but Pissarro probably intended the dull pink priming to emerge through

Montfoucault in 1874. On 11 December, he reported back to Duret: 'I'm not working badly here, and I've set myself

figures and animals. I've several genre paintings, [but] I'm starting timidly on that branch of art, so distinguished by

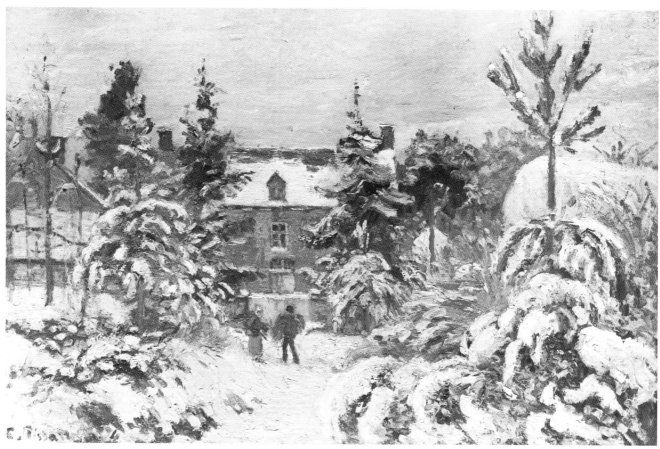

the paint surfaces in order to give a 'col-oured' quality to the snow; neither can-vas employs much pure white.[93] As he had written in 1873: 'there is nothing more *cold* than full summer sun; ... nature is coloured in winter and cold in summer'.[94]

Representing two distinct aspects of Montfoucault, these paintings are more than winter *effets*. *Piette's House* (fig. 44) shows the landowner's residence almost symmetrically, and the eye is led straight to it. The iron gates of the yard are closed, and outside stand two farm labourers; there seems to be a hierarchy implicit in the painting. Both man and woman carry substantial loads. Her faggots are presumably for firewood, while his hay is perhaps for feeding stock. This would

44. C. PISSARRO, *Piette's House at Mont-foucault, snow*, 1874. Oil on canvas. 45.9 × 67.6 cm. Sterling and Francine Clark Art Institute, Williamstown, Mass.

45. C. PISSARRO, *Farm at Montfoucault; snow effect*, 1874. Oil on canvas. 54 × 65 cm. Ashmolean Museum, Oxford. Reproduced in colour on page 47.

fit a typical rural pattern of division of labour, in which women were usually charged with the domestic work and farmyard tasks such as feeding poultry and fetching water, while the men did the heavier and more far-flung jobs, including tending the stock.[95] Thus in *Farm at Montfoucault: snow effect* (fig. 45) the load of hay is probably not for the single sheep but to be taken in the cart to animals kept distant from the farmyard. Such paintings should neither be read as systematic records of rural life – Pissarro selected and excluded possible motifs at Montfoucault as much as he did at Pontoise – nor as straightforward *effets*. In them Pissarro seems to have been trying to elide his means of represen-tation with his subject. Images of the

hard, winter conditions of rural life required, it appears, an appropriately solid, rough handling, closer to Millet or Courbet than his Impressionist colleagues.

At Montfoucault the following year Pissarro's practice changed. He began to draw more, as figures became more emphasized in his compositions. Some of these drawings are on quite large sheets, and may have been intended as studies to be worked up later, perhaps even at Pontoise, into finished paintings. *Female Peasant carrying a Load of Hay* (fig. 46), for instance, relates to no known painting but, used in conjunction with a figureless pastel of the motif,[96] could have served as the basis for one. An impressive painting of a sower (fig. 53) was worked up via an oil sketch,[97] and a large, important painting of *The Pond at Montfoucault* (fig. 47) seems to have been made in conjunction with two smaller landscapes of the motif, a squarer variant of the composition with two figures,[98] and at least one drawing (fig. 48). Their exact interrelationships and sequence cannot be reconstructed with accuracy, though it is possible that the drawing, a very finished sheet in which the poses of the woman and cow correspond closely to the large painting but whose placement in the composition does not, was not a preliminary study but an independent work, made after the picture, for separate sale. *The Pond at Montfoucault* itself, with its rich medley of autumn hues, is a heavily worked painting with complicated textures created by both palette knife and brush. Its arresting *effet* of sunlight, shafting momentarily through passing cloud to glance off the surface of the pond, seems to have been an accident substantially contrived in the studio. Such motifs of women tending animals increased

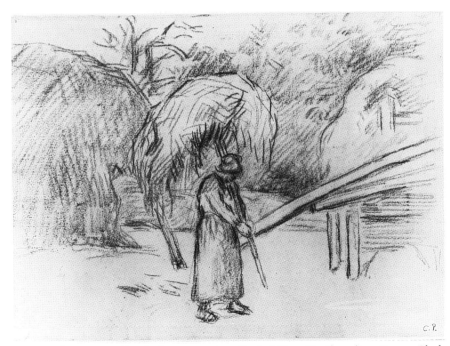

46. C. PISSARRO, *Female Peasant carrying a Load of Hay, Montfoucault, c.1874–5.* Black chalk. 23.9 × 30.5 cm. Ashmolean Museum, Oxford.

47. C. PISSARRO, *The Pond at Montfoucault*, 1875. Oil on canvas. 73.6 × 92.7 cm. Barber Institute of Fine Arts, University of Birmingham. Reproduced in colour on page 48.

48. C. PISSARRO, *The Pond at Montfoucault*, 1875. Charcoal heightened with white chalk. 29 × 23 cm. Arkansas Art Centre.

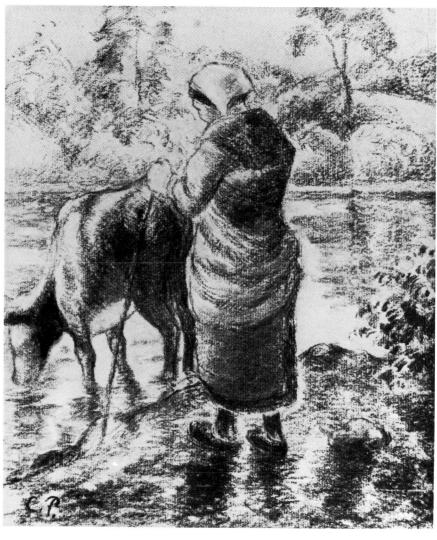

during Pissarro's 1875 Montfoucault campaign, while interiors were dropped from the repertoire.[99]

The 1876 campaign was Pissarro's last at Montfoucault before the early death of Piette in April 1878. The late summer visit resulted in scenes of the harvest in the fields and the farmyard. Two of the farmyard motifs show the communal labour of men and women as they work a mechanical thresher.[100] Mid- and even late-nineteenth-century artists are usually reckoned to have edited

machinery out of their representations of rural life. Daubigny illustrated a threshing machine in an etching for a scientific magazine, but would not have done so in his painting, while Lhermitte kept emphatically to pre-modern tools. As late as 1890, the British critic P. G. Hamerton was surprised to see an image of an iron plough at the Salon.[101] Pissarro, it has been argued,[102] sustained the myth of changelessness, but in fact farm machinery occurs in four paintings, two pastels and a number of drawings.[103]

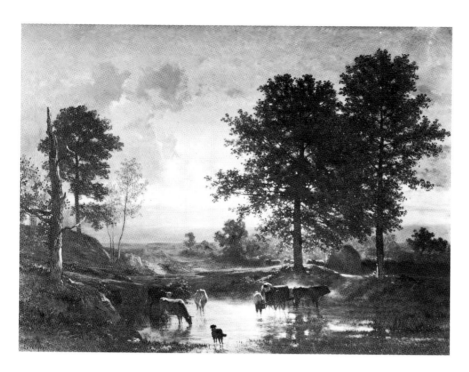

49. C. TROYON, *Watering Cattle, c.*1850–5. Oil on canvas. 122.3 × 162.5 cm. Wallace Collection, London.

The *Threshing Machine* (fig. 50, p. 49) was painted rapidly, *sur le motif*, with roughly handled paint building up the chaotic texture of the vibrantly coloured straw. The bright green machine itself stands out against the stack; it is important, time-saving, progressive, even if it is powered by horse rather than steam, and the harvest is still labour intensive.

Pissarro's work at Montfoucault thus has its contradictions and ambivalences. His increasing use of preparatory drawings and oil sketches suggests a retreat to more conventional practices, yet this active reversion to the palette knife and a very varied range of textures infers a challenging ambition to find a handling appropriate to subjects from 'the true countryside'. That handling, however, is quite distinct from the smoother and more gestural strokes of contemporary work by Monet or Sisley; Pissarro's Montfoucault paintings of the mid 1870s often seem quite distant from the 'high' Impressionism of his colleagues. His very conscious rehearsal, at Duret's urging, of kinds of composition which recall Troyon or Millet (figs 49, 55) suggests he was applying his 'modern' touch and colour to stereotypical rural motifs the better to face the market in difficult times. Yet the paintings of threshing machines, which belong to the year in which he returned to more direct images of the Chalon factory at Pontoise, indicate an occasional willingness to accommodate symbols of 'modernization' in his landscape repertoire. Once more we are reminded to consider Pissarro's work as a dialogue between city and country. Above all, Pissarro's Montfoucault images opened up issues about how the peasant and rural life might be represented which would preoccupy him during the next decade.

Representing the Peasant in the 1880s

Pissarro's ambitions to paint large-scale figure pictures, already a feature of his Montfoucault campaigns, came into concentrated focus after 1880. The new challenge involved a shift in working practice – studio work, models, more drawing, fresh media – and an enhanced articulation of Pissarro's ideology. As his anarchist humanitarianism crystallized during the 1880s, figure subjects gave him greater scope than landscapes to construct images of the rural community. His new direction also altered Pissarro's position in the structures and politics of the art world. At the turn of the decade he was close to Degas, working together on *Le Jour et la Nuit*, a project for an album of prints,[104] and Degas's example was an important stimulus. A role as both figure and landscape painter gave him a status within the Impressionist community closer to Berthe Morisot or Renoir than landscape specialists such as Monet and Sisley. In broader terms, the mid 1870s had seen the rapid burgeoning of rural and peasant themes at the Salon, precipitated in part by the death of Millet. The stock of Jules Breton, who like Millet had made his reputation as a 'peasant painter' during the 1850s, was extremely high, and a new generation was emerging, including Léon Lhermitte, whom Degas had wanted to show with the Impressionists in 1879,[105] Jules Bastien-Lepage and Pascal Dagnan-Bouveret, both of whom had abandoned careers as history painters to turn to the newly estimable genre of peasant life. Pissarro's attempts to broaden his range was no doubt also to extend his marketability. His dealer Durand-Ruel, however, tried in 1884 to steer the painter off figure subjects and back to 'attractive landscapes', which he reckoned easier to sell.[106] But in 1886 Monet had to justify the forbidding motifs of his Belle-Isle landscapes to Durand,[107] who liked his artists to paint consistent, tractable subjects. Pissarro found dealers for his figures elsewhere.[108]

In the early and mid 1880s Pissarro's rural figures tended to be read in two ways. 'They are significant because of their truth of movement and also for the moral truth of their observation', pontificated Marcel Fouquier's review of Pissarro's paintings at the 1886 Impressionist exhibition, while the following year Huysmans considered his country people to be represented 'just as they are, precisely and justly'.[109] Alongside this rhetoric of realism was a common tendency to compare Pissarro's figure subjects to Millet's, either branding him as imitator or making positive contrasts.[110] These positions were linked. The argument that Pissarro's images were 'truthful' divorced them, in the eyes of progressive naturalist critics such as Huysmans, from the 'sentimentalism' of Millet and the 'false' peasant subjects of the Salon. 'M. Pissarro', insisted Mirbeau in 1886, 'imitates nothing but nature'.[111]

But the notion that there is such a thing as an immutable 'nature', and that it and its 'natural' inhabitants can be exactly represented, is a fiction created by an urban intelligentsia, a highly simplified contrivance polarizing city and country. The term 'peasant' in late-nineteenth-century France requires a multiplicity of definitions. There were variations not just between regions and the kinds of agriculture in which the rural populations were involved, but between the degree of ownership of and attachment to the land. The term might encompass farmer-proprietors with terrain on various scales, tenant-farmers, smallholders, labourers skilled or otherwise, servants, rural artisans who might own a parcel of land, and so on.[112] But with a record 3.5 million farms in France in the 1880s, with two-thirds of the population living in the commune of their birth,[113] with an agricultural depression, and with many urban dwellers having recent rural roots, it was convenient to construct simple notions of the country. Paintings and books helped do this. For example, Zola's *La Terre*, published in 1887 and based on only a few days' observation of a village community and much library research, proffered stereotype peasants: greedy, disloyal, unprogressive, industrious, bestial, above all tied to the land.

In 1884 Pissarro settled at Eragny, a hamlet some three kilometres north of Gisors. Between the *Vexin normand* to the northwest and the *Vexin français*, stretching thirty-five kilometres southeast to Pontoise, Gisors was an important local market town. As most of the large estates in the region rented out land to tenants in modest plots, much of the regional agriculture was based on smallholdings. About two-thirds of the local farms were run by husband and wife, and only some ten percent of these were over 50 hectares.[114] Cattle were farmed in small numbers, while sheep were rare as American and Australian competition made both mutton and wool uneconomical. The vital cereal crops were also

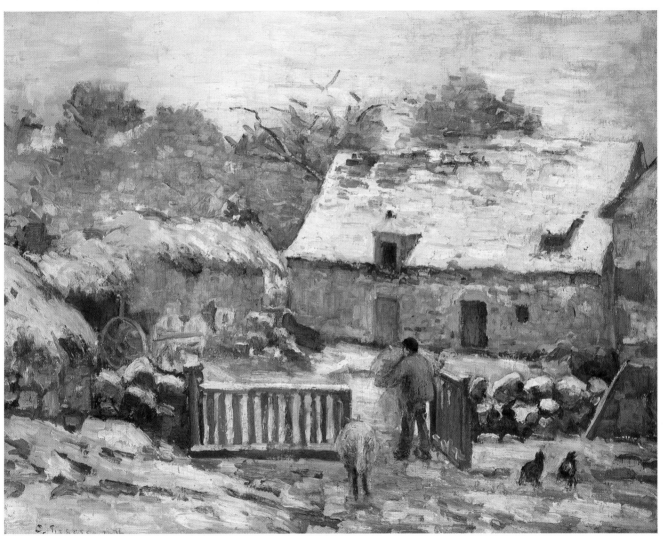

45. C. PISSARRO, *Farm at Montfoucault; snow effect*, 1874. Oil on canvas. 54 × 65 cm. Ashmolean Museum, Oxford.

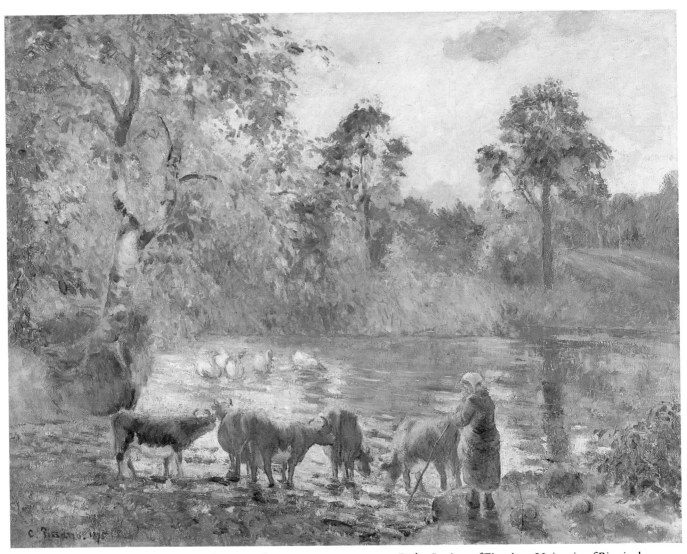

47. C. PISSARRO, *The Pond at Montfoucault*, 1875. Oil on canvas. 73.6 × 92.7 cm. Barber Institute of Fine Arts, University of Birmingham.

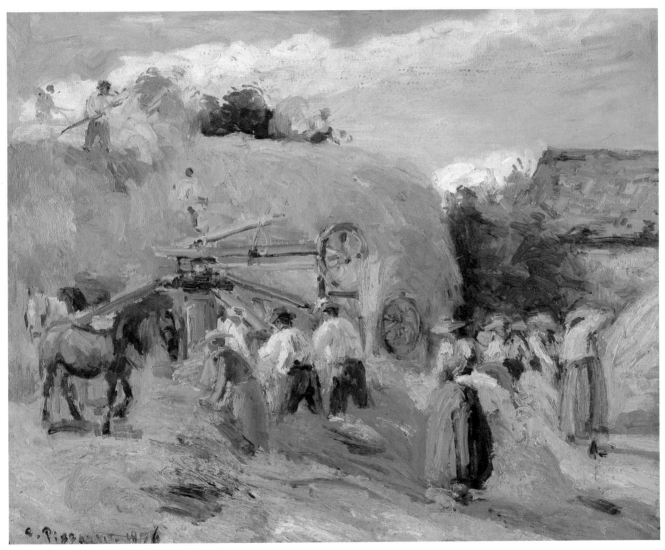

50. C. PISSARRO, *The Threshing Machine*, 1876. Oil on canvas. 54 × 65 cm. Private collection.

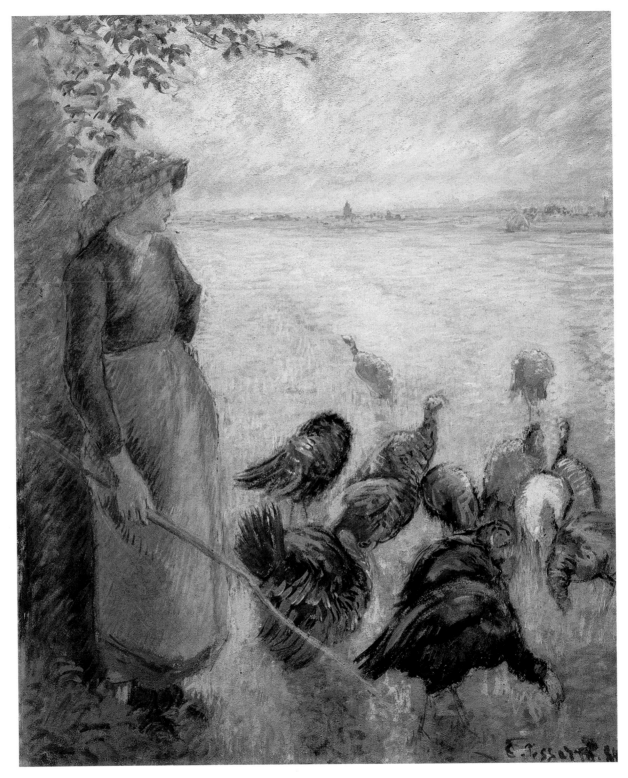

suffering from imports; mechanization only came in the twentieth century, and throughout the 1880s and 1890s the village populations were in gradual decline.[115] Competition from the more industrialized Paris and the north and failure to mechanize had likewise crippled Gisors's hitherto prosperous textile trade, and by 1901 there were only two remaining factories.[116] In broad terms, these were the local patterns to which Pissarro's images were held to be 'true'.

Like other painters of *la vie agreste*, Pissarro himself was not a peasant. Breton was the son of an estate manager, Lhermitte of a village schoolmaster.[117] But if they came from classes above the peasantry in the rural hierarchy, Pissarro, from Jewish bourgeois stock, was a complete outsider. In 1886 one journalist's description of Pissarro dressed him up as a peasant-painter: 'He lives deep in lower Normandy, on a farm which he cultivates himself and which feeds him from the very soil he works. When the harvest has been good and he is free from his labours in the fields, Pissarro takes up his brushes . . . and fixes on canvas the rough existence of the creatures and the country life that he leads himself.'[118] Pissarro was quick to deny this lyrical fiction, writing forcefully to the author that he and his family were 'forced by inexorable necessity to survive not by our "harvests" but by our sales of paintings'.[119] Nevertheless, he was keen to convince himself and others that being an outsider did not disqualify him as a painter of peasant themes. Having read *The Conquest of Bread* in 1892 he was anxious to justify himself *vis-à-vis* Kropotkin's arguments. 'So Kropotkin thinks that one must live as a peasant fully to understand them', he wrote to Mirbeau: 'it seems to me that one must be committed to one's subject to represent it well, but is it necessary to be a peasant? Let's be artists above all, and we'll have the faculty to feel everything, even a landscape without being a peasant.'[120]

Pissarro's attitude to Millet's work was ambivalent. He distanced himself from Millet's reactionary response to the Commune and resented the constant comparisons, complaining in 1882: 'they throw Millet at me, but Millet was biblical! For a Jew that seems to me a bit much!'[121] He visited the Millet retrospective at the Ecole des Beaux-Arts in 1887, and compared Millet to Greuze in the sentimental way his work was read: 'People only see the little side in art; they don't see that certain of Millet's drawings are a hundred times better than his painting, which has really dated'.[122] It seems that for Pissarro Millet's work was too moralistic, but one remains uncertain what he thought was 'dated' about the paintings: their style, their representation of the peasantry, or their moral tone. Despite these reservations, he was delighted to be given three woodcuts by Millet's son-in-law in 1884,[123] and ten years later, finding a painting of a woodcutter made at Piette's farm two decades before, admitted that 'it's a bit Millet, but things have that quality at Montfoucault'.[124]

There are instances in Pissarro's work when Millet's example seems to resonate. The image of a young peasant woman keeping watch over sheep or poultry, leaning on a tree, was stock in Millet's work, and a typical drawing (fig. 56) was illustrated in Sensier's 1881 biography.[125] Pissarro took on this stereotype on a number of occasions, including the *Turkey Girl* of 1884 (fig. 58). His little gouache of harvesters resting (fig. 51), made in 1887, recalls Millet's *Midday Rest*, which Pissarro would probably have known via Lavielle's wood-engraving (fig. 52). And in 1896

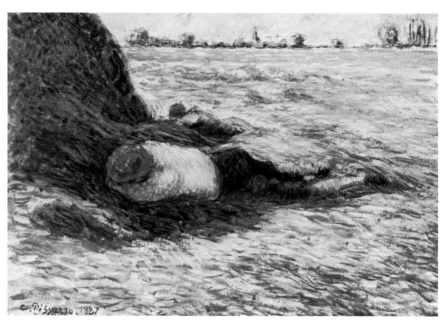

51. C. PISSARRO, *Midday Rest*, 1887. Gouache and watercolour. 16.6 × 23.5 cm. Leeds City Art Gallery.

52. J.-A. LAVIELLE after J.-F. MIL-LET, *Midday Rest*. Wood engraving. Repr. *L'Illustration*, vol. 61, 1873, p. 168.

he revised the *Sower* motif he had explored at Montfoucault in 1875 in a lithograph reminiscent of Millet, not merely in subject, but in the relationship of figure and landscape (figs 53–5).

Pissarro justified such echoes by arguing that his peasants were 'too full of *sensation*' to confuse his images with Millet's.[126] This was a difference not just between ways of seeing but means

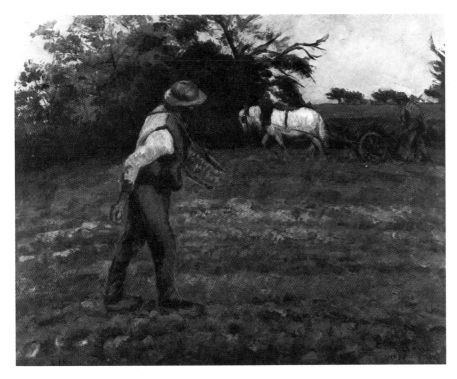

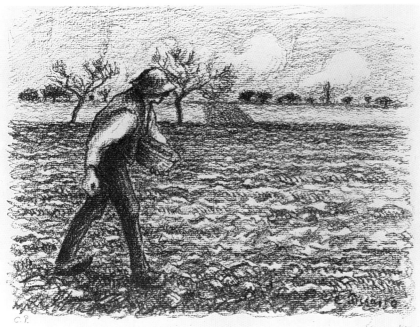

55. J.-F. MILLET, *The Sower*, c.1865. Pastel. 47.1 × 37.5 cm. Sterling and Francine Clark Art Institute, Williams-town, Mass.

53. C. PISSARRO, *The Sower*, 1875. Oil on canvas. 46 × 55 cm. Private collection, Dallas.

of making. If Millet's figure drawing had more volume and dynamism than Pissarro's,[127] it was because he had received a more thorough academic training and had always centred his career on figure painting. In the early 1880s Pissarro was well aware of his 'rough and harsh execution', writing of one figure painting in 1882: 'it's the kind of approach that interests me; it's not what you'd call lively, but what can I do, I'm carried along by my *sensa-tions*'.[129] Pissarro's notion of *synthesis* also played an increasingly important part in his figure compositions. At this date he

54. C. PISSARRO, *The Sower*, 1896. Lithograph. 21.6 × 27 cm. Ashmolean Museum, Oxford.

56. J. F. MILLET, *Shepherdess leaning against a tree*, 1849. Black chalk and stump with traces of white chalk on brown paper. 29.8 × 19.2 cm. Fitzwilliam Museum, Cambridge.

58. C. PISSARRO, *The Turkey Girl*, 1884. Tempera on paper. 81 × 65.5 cm. Museum of Fine Arts, Boston. Reproduced in colour on page 50.

57. C. PISSARRO, *Standing Peasant Girl*, c.1884. Black chalk and watercolour. 50.6 × 39 cm. Whitworth Art Gallery, Manchester.

reminded Lucien to keep referring back to early Renaissance art and the ancient Egyptians, and Lucien had made copies of such reductive yet evocative styles[130] (fig. 60). The progression of one of Pissarro's stock poses – a 'Milletesque' peasant girl leaning against a tree (figs 57–9) – through the 1880s and via various configurations and combinations shows a gradual process of simplification, a cultivation of awkwardness by the very refusal to soften or embellish. The 'synthetic' quality of *The Conversation*, one of the later variants of the pose, has something of the spare, hieratic grandeur Pissarro admired in Egyptian art (figs 59, 60).

Repetition of pose became standard practice for Pissarro during the 1880s. It was an expedient forced upon him in part by absence of models. But such recycling had been habitual with Millet, and was with Lhermitte and of course

60. L. PISSARRO, Copy after Egyptian fresco, c.1880. Pencil and watercolour. 29 × 22.7 cm. Ashmolean Museum, Oxford.

59. C. PISSARRO, *The Conversation*, c.1890–2. Black chalk, sanguine and pencil on grey paper. 60 × 38 cm. Cabinet des Dessins, Musée du Louvre, Paris.

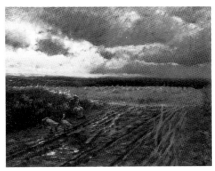

61. G. DE NITTIS, *The Goose Girl*, 1884. Oil on canvas. 65 × 81 cm. Musée du Petit Palais, Paris.

62. C. PISSARRO, *The Cow Girl*, c.1880. Oil on panel. 15 × 24 cm. Private collection.

Degas. Such a synthetic method was far from the immediate observation of Impressionist rhetoric. Pissarro's whole range of making diversified greatly during the 1870s, no doubt encouraged by Degas's example. He continued to make prints, and increasingly used media such as distemper. He experimented with painting on ceramic tiles (figs 76, 123) and made small sculptures of cows which he could use as convenient models for his pictures.[131] None of those activities involved work *en plein air*; they necessitated the studio. His 'truthful' peasant images were very literally fabricated.

Pissarro's images of rural life have been characterized as greatly limited; the peasants resting rather than labouring, the mood vague or pensive, the staffage young women to the exclusion of sturdy men, the failure to define the separate spheres of male and female activity or their overlap.[132] This is a significant misconception, and Pissarro's range can be redefined by giving a cross section of his peasant subjects from the 1880s. There are women doing domestic, interior chores such as mending, sewing and spinning (P&V 1355, 1356, 1360), laundry and washing up (P&V 717, 579). Women also perform functions around the dwelling: fetching water from the well (fig. 65; P&V 1410), picking apples (P&V 545, 695), milk-

63. C. Pissarro, *Shepherd and Flock, Eragny*, 1889. Pastel. 23 × 30 cm. Private collection.

ing cows (fig. 64; P&V 1406), and working in *jardins potagers* (figs 32, 65; P&V 534, 574). And they do farm-work, including harvesting potatoes (P&V 1338, 1405), weeding (fig. 122; P&V 563), and tending poultry, cattle or sheep (figs 58, 62; P&V 1386, 1414). Acknowledging certain divisions of labour, the men are represented further from the village or at traditionally arduous, male tasks, for instance keeping guard over flocks in bad weather or scything corn (fig. 63; P&V 1440, 1443, 1474). Men also work near the house, chopping wood or sorting cabbages (P&V 1336, 617). Finally, men and women work together, not only at the harvest (fig. 116; P&V 713, 771, 1394) but milking, picking apples and shepherding flocks (figs 64, 124; P&V 726, 1628). Such a crude, and far from exhaustive, list suggests that Pissarro explored the variety of Eragny's domestic activity and small-scale agriculture quite thoroughly, although not to a systematic programme.

64. C. Pissarro, *Milking Scene at Eragny*, *c*.1884. Watercolour and black chalk. 15.7 × 19.6 cm. Ashmolean Museum, Oxford.

If women do predominate in the larger, more resolved images this may be for practical reasons, perhaps because the local women were closer to home and easier to observe than the men, and because the market favoured representation of the female peasant. But Pissarro's motifs of country women are far from passive; they involve interaction and narrative, they were constructed to require reading. Developing the 1884 tempera of a *Turkey Girl* from an earlier drawing (figs 57, 58), Pissarro made salient changes. Not only did he make the figure more upright and change her stick so she controls the turkeys, he also opened out the landscape vista. This adolescent girl has a specific responsibility, performed some distance from her village. Pissarro used open space as a pictorial metaphor for isolation, a common device regularly deployed by Millet and other contemporaries, for instance Guiseppe de Nittis in his *Goose Girl* from the Salon of 1884 (fig. 61). Unlike the Italian, Pissarro rejected the hyperbole of stormy weather; his contrivance of mood and meaning are far more subtle. In a later variant he depicted the peasant talking with another young woman (fig. 59). The pair's relationship is exclusive; the spectator has no access to their conversation. Much the same is true of *Young Woman and Child at the Well* of 1882 (fig. 65, p. 63). In village culture the talk exchanged between women at their meeting places, such as the well or wash-house, was wide-ranging and uninhibited.[133] Pissarro's work hints at hierarchical distinctions within the female community. The adolescent in this painting belongs between the world of the girl with whom she chats while resting and the women in the *jardin potager* behind, whose work she already shares. Her task, ferrying two heavy buckets to irrigate the domestic crops, is exacting for her physique, but it is work expected of the female community, whose collective power in the village was sustained not only by their labour but also by their daily exchange of information.

There are omissions in Pissarro's accounts of *la vie agreste*. His peasants occupy a generalized northern French village; there is little attempt to use Eragny for either thoroughgoing sociological survey or exaggerated dramas of rural life. His figures are rarely old and usually young. If this was a response to market demand it necessitated a denial as well as an acceptance for, judging by contemporary Salon catalogues, quaint old folk suited one urban fiction of peasant life (unchanging; repository of traditional values) just as strapping wenches (healthy; unconstrained by bourgeois prudery) did another. One is not inclined to accept Pissarro's youthful population as 'true' at a time when young people were leaving rural communities in increasing numbers.[134] There is no overt social hierarchy in his images, no proprietors or bailiffs, but then Eragny, as a small community, helped him ignore the rural class structure. He notably avoided heroic figures and polarized sexual stereotypes common in contemporary peasant paintings. Both male and female body language is discreet; there are few theatrical gestures, mopping brows, sturdy hands on haunches. Pissarro eschewed certain images regularly found in Breton and Lhermitte: muscular sowers and scythers dominating the landscape with their sweeping strokes, as well as women breastfeeding their babies in the cornfields.[135] These grandiose motifs, rich in associations of male power and female fecundity, formed no part of Pissarro's ideal construction of the peasant as an individual in an harmonious community.

Composing an Anarchist Ideal: *The Gleaners*, 1889

The year 1887 seems to have been a period in which Pissarro began to reassess his position. The previous year had seen what was to be the final Impressionist exhibition, into which Pissarro had introduced Seurat and Signac. He himself had shown paintings which followed their 'Neo-Impressionist' experiments with the division of tone and a pointillist touch (fig. 93). Neither Monet, Renoir nor Sisley had exhibited, and Pissarro's commitment to the new generation finally put paid to the Impressionist alliance of the previous decade. In the wake of the 1887 Millet retrospective and his participation in an Exposition Internationale at the plush Georges Petit Gallery, Pissarro wrote to Lucien that he intended to paint 'figure compositions, done in the studio . . . I must have two major canvases'.[136] He recognized his need for key pictures, to make a contribution on his own terms to painting's construction of rural life and to respond to market pressures for significant work of exhibition status.

The major painting to result from this plan was *The Gleaners* (fig. 70). It was one of Pissarro's most scrupulously prepared pictures; not since the 1882 *Harvest* (P&V 1358; Tokyo, Bridgestone Museum), with which *The Gleaners* makes a distinct contrast, had Pissarro stalked a composition with such care. Eight other works are known which have some bearing on the genesis of *The Gleaners*, and there were almost certainly more. Four are landscape studies. These reveal Pissarro's exploration of the motif, an open field on the broad, flinty downlands to the east of Eragny as they slope towards the valley of the river Epte, with the village out of sight to the left. Taken from slightly different viewpoints, Pissarro's three coloured landscapes represented sequential moments after the harvest and analysed the chromatic balance between the warms of corn and stubble and the cools of distant copses and downs. One watercolour, dated 1888, showed the field cut, the crop piled unbound on the stubble (fig. 66). A pastel had the corn formed up into stooks (fig. 67), while a second watercolour represented the field ploughed up later in the summer (fig. 68). A chalk drawing from a sketchbook is also known (fig. 69), which relates to the left background of the composition more closely than the colour studies.[137] These latter three are undated, and the sequence of these studies is impossible to reconstruct.

Pissarro first made a fan of gleaners which is now lost (P&V 1639). It is very close to the final painting, including a few extra figures, and probably developed its landscape from the chalk drawing and the pastel, which, like the fan, was made on material.[138] A figure drawing for one of the foreground women is dated 1887 (fig. 71), and was probably made in preparation for the fan, along with other untraced figure drawings.[139] The main canvas may have been in hand by 1887, but it seems to have succeeded the fan. It is mentioned in a letter of April 1888: 'I'm working on my picture of *Gleaners*. It's giving me much trouble . . . I lack particulars . . . That's always the great difficulty, I need models, [but] I don't know any more where to find them'.[140] It seems certain that the finely

66. C. PISSARRO, *Harvested Field, Eragny*, 1888. Pencil and watercolour. 23.5 × 29 cm. Private collection.

68. C. PISSARRO, *Ploughed Field, Eragny*, c.1887–8. Pencil and watercolour. 20.9 × 27.6 cm. Ashmolean Museum, Oxford.

67. C. PISSARRO, *Corn-Stooks, Eragny*, c.1887. Pastel on fabric. 23.6 × 29.5 cm. Whitworth Art Gallery, Manchester.

69. C. PISSARRO, *Study of the Downs, Eragny*, c.1887–8. Black chalk. Location and dimensions unknown.

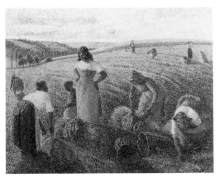

70. C. PISSARRO, *The Gleaners*, 1887–9. Oil on canvas. 65.5 × 81 cm. Kunstmuseum, Basel (Dr H. C. Emile Dreyfus Foundation). Reproduced in colour on page 64.

71. C. PISSARRO, Study for *The Gleaners*, 1887. Black chalk. Location and dimensions unknown.

72. C. PISSARRO, Study for *The Gleaners*: *Baskets*, c.1888–9. Charcoal. 22.6 × 30.5 cm. Philadelphia Museum of Art.

wrought study of baskets, a rare still-life drawing (fig. 72), was made specifically for the painting, as it was necessary to fill the semicircular void at the bottom of the fan. A gouache of gleaners, using the same poses in a more vertical configuration, is also lost (P&V 1444); it may either have served as a study for the painting, or as an independent, even later, variant. Pissarro evidently worked on the canvas over a long period, for it was not until mid August 1889 that he could write with relief to Lucien that *The Gleaners* was almost finished.[141] A fortnight later it was despatched to Boussod et Valadon, Pissarro writing to Theo van Gogh, the gallery's manager: 'I'm sending you by messenger two important canvases, size 25: *The Gleaners* and *Two Peasant Women in a Yard*; these paintings have taken a long time: I think that it wouldn't be too much to ask 800 francs each.'[142] *The Gleaners* found a buyer quickly, but with deductions for commission and framing, Pissarro only made 650 francs.[143]

The final result of Pissarro's lengthy efforts is not a doctrinaire pointillist work, for the surface of *The Gleaners* has a varied texture of dots, dashes and commas. Yet the touch creates a unified effect, enhanced by the glowing evening light which spreads its pink and orange aura over the extensive field, creating long blue-violet shadows. Although the clothes of the foreground women have their local colour, they reflect the chromatics of the landscape. And despite Pissarro's late strengthening of their contours with blue and his use of complementary contrasts to separate figure and ground, nevertheless the figures seem almost integrated with the landscape, existing in harmonious interrelationship with their surroundings. Pissarro appears to be articulating a stock patriarchal fiction: the equation of

woman and nature.[144] This is how it was read by Albert Aurier, reviewing Pissarro's 1890 one-man show at Boussod et Valadon. *The Gleaners* is 'marvellously composed', he wrote; 'the lines of those raised or bent bodies, those folded spines or extended rumps are very cleverly linked and harmonized with the soft, languid sinuosity of the horizon line'.[145]

Other stereotypes and fictions come into play in *The Gleaners*. From one point of view it was an unusual, even outdated, subject to choose. As a practice gleaning — the traditional charity allowed to the rural poor by which they could collect any remaining corn after the harvest was completed — was dying out. The increasing number of smallholders harvested more attentively than the hired hand, leaving less behind; scythes replaced the less efficient sickle; and the very backbreaking effort of gleaning produced ever-declining results.[146] As a subject gleaning had been common, as well as a topic of intense debate, in painting of the 1850s. But perhaps its very currency in earlier peasant painting encouraged Pissarro to recast it in the late 1880s. The gleaner images produced in the 1850s by Millet and Breton stressed the rural class structure. In Millet's *Gleaners* from the Salon of 1857 (fig. 73) the foreground women are the village poor, the harvesters building the stacks behind them the employed labourers paid to bring in the crops of the proprietor of the extensive cornfield, and the rider overseeing the harvest is the landlord or his bailiff.[147] If Millet's painting aroused controversy because of its uncomfortable emphasis on the apparently oppressed rural poor, Breton's *Recall of the Gleaners* (fig. 74) exhibited at the Salon two years later presented a more positive account. The women have managed to gather substan-

65. C. PISSARRO, *Young Woman and Child at the Well*, 1882. Oil on canvas. 81.5 × 66.4 cm. Art Institute of Chicago.

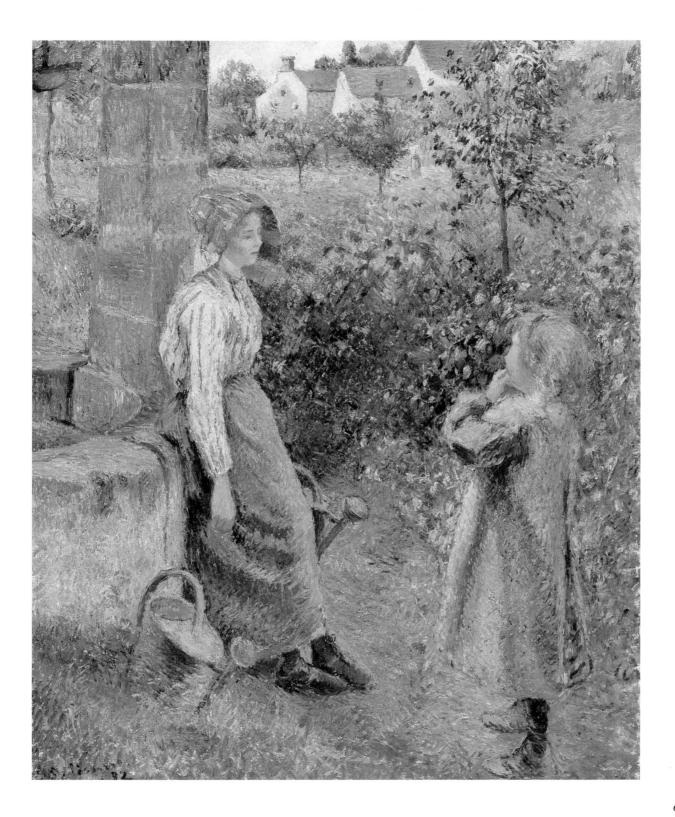

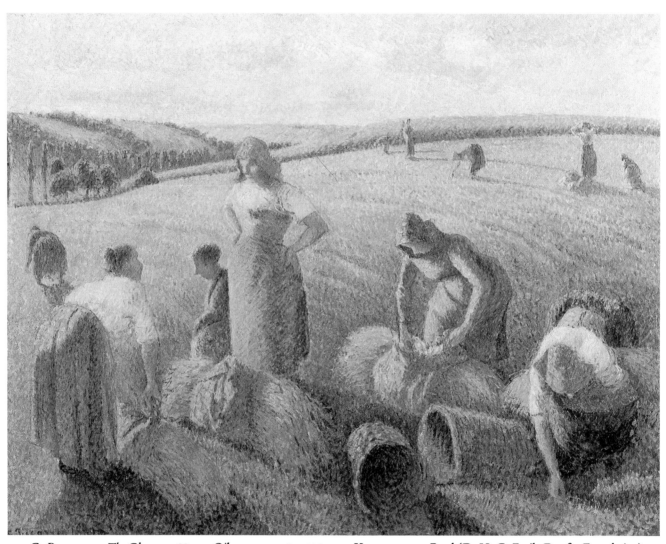

70. C. Pissarro, *The Gleaners*, 1887–9. Oil on canvas. 65.5 × 81 cm. Kunstmuseum, Basel (Dr H. C. Emile Dreyfus Foundation).

tial loads, which they carry nobly towards the spectator. Even so, they obey the *garde champêtre's* call to stop, and a flock of sheep is about to be driven on to the stubble. Here all is well: the land is fertile enough to feed all, and the poorest peasants, only one rung above the beasts, obey authority.

Pissarro appears to have suppressed in *The Gleaners* any residue of the hierarchy or authority which he observed in *The Harvest*. The earlier fan included a man in the background, perhaps an overseer. He was dropped from the painting, and the large property visible from this spot on the Eragny downs – probably the château of Céréfontaine – was masked behind trees. But Pissarro's image promoted other fictions. The bounty of the land – despite the ailing grain economy of the Gisors region – is such that even the gleanings are plentiful, unlike in a near contemporary version of the theme by Lhermitte (fig. 75), which contrasts his gleaners' meagre efforts with the wealth of the stack behind. In both images the women glean but also break off to converse, but it is in Pissarro's that one gets a greater sense of the women working together rather than alongside each other. Pissarro's image is as much a construction of rural life as any other gleaning image. His harmonious, light-filled painting, which seems to celebrate woman's 'natural' place in the landscape, proffers an ideal of a classless community which accorded with his anarchist ideology.

73. LEFT: J.-F. MILLET, *The Gleaners*, 1857. Oil on canvas. 83.5 × 111 cm. Musée d'Orsay, Paris.

75. L. LHERMITTE, *The Gleaners*, c.1890–5. Oil on canvas. 74.9 × 95.9 cm. Philadelphia Museum of Art.

74. J. BRETON, *The Recall of the Gleaners*, 1859. Oil on canvas. 90 × 176 cm. Musée d'Orsay, Paris.

65

The Image of the Market: Exchange between Country and Town

Pissarro's fiction of a classless rural community did not operate in his images of peasants in market towns. For him, the very nature of the subject, the exchange of produce between peasant *producteur* and bourgeoisie, necessitated the interaction of classes. Pissarro had painted a few fairs and fêtes at Pontoise during the 1870s,[148] but his market pictures only began in earnest with the proliferation of figure subjects in the early 1880s. Over the next fifteen years he produced many such scenes, usually in gouache or tempera, for there are only five oil paintings of markets.[149] At Pontoise he had represented the tradi-

tional Foire St Martin, with its horse-fair held in November (fig. 76), but not it seems the smaller Fête de Septembre.[150] At Gisors there were major fairs at Easter, Pentecost and on St Luke's day, but Pissarro preferred the regular weekly markets. He even produced images of Parisian markets. Within this variety lay a consistency, for Pissarro seems deliberately to have conceived the market as the end result of the peasant's labour. Within the broader pattern of his representations of rural life, the market images place the peasant insistently within the structure of the rural economy, providing produce for the town, receiving money

from it. In the market scenes, his peasants are seen to play their role in a class structure and in a capitalist economy.[151]

The market was a topos in paintings of rural life, and as with so many other subjects Pissarro was adapting a stereotype to suit his own ideology and aesthetic. Representations such as Lhermitte's *Apple Market at Landerneau* (Salon of 1878; Philadelphia Museum of Art), Trayer's *Fabric Market* (fig. 77), and even Piette's Pontoise markets shown with the Impressionists in 1877 (fig. 78) favoured horizontal formats, taking in a wide range of information, and a rather theatrical arrangement

76. C. PISSARRO, *Foire de la Saint-Martin, Pontoise: Horse Market*, c.1883. Oil on ceramic tile. 20 × 40.4 cm. Bennington Museum.

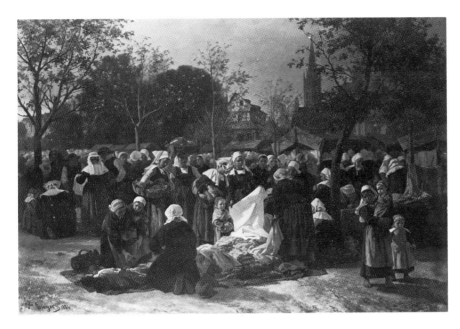

77. J. TRAYER, *The Fabric Market*, 1886. Oil on canvas. 185 × 260 cm. Musée des Beaux-Arts, Quimper.

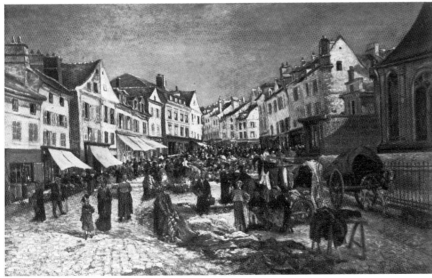

78. L. PIETTE, *Place du Petit Martroy, Pontoise, market day*, 1876. Oil on canvas. 85 × 132 cm. Musée Pissarro, Pontoise.

79. C. Pissarro, *Croquis of Market Scenes*, c.1882–3.
(a) Black chalk. 21.7 × 16.6 cm.
(b) Black chalk. 21.5 × 16 cm.
Ashmolean Museum, Oxford.

(a)

which kept the spectator distanced from the activity. Indeed, Salon paintings such as Lhermitte's and Trayer's are contrived pictures to represent an apparently unified class, and emphasized provincial costume; folk custom all but excludes commerce. Pissarro's attitude was very different. Even in the rapid sketches he made in the early 1880s as he explored the theme he introduced a mixture of classes, viewing the figures from close to (figs 79a, b). Finished works incorporated such initial observations. The *Pork Butcher* and the *Market Stall* (figs 80, 84) deploy compositional devices – cut-off figures, open space, close-up viewpoints – which colleagues such as Degas and Manet had developed in their recent café pictures.[152] By these means Pissarro gives the spectator the

1885/6 C. P. (b)

illusion of physical immersion in the market crowd; each image is a fiction of something glimpsed and essentially transitory, hence the figures whose backs are turned and move away. In a moment, these contrivances make the spectator believe, this chance configuration will have transformed into another. For these paintings are highly contrived. The pose and configuration of the *Pork Butcher* suggest that Pissarro conceived it along the lines of Degas's images of women ironing (fig. 81).[153] X-rays reveal that originally the right-hand figure was painted looking at the wares on display (fig. 82). After an intermediate preparatory drawing (fig. 83) Pissarro reworked the painting, making this figure look away, so dispersing the focus of attention. His niece Nini served as a model

69

for the *Pork Butcher* and the *Market Stall*,
a large tempera.[154] These images, with
an essentially female staffage, include the
basic personnel of the rural town market:
the countrywoman selling local produce,
the maid (an intermediate figure, perhaps
a peasant girl in service in the town), the
bourgeoise provisioning her household.

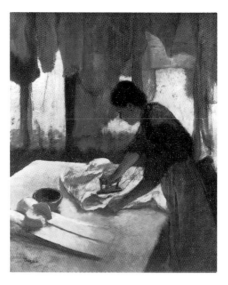

81. E. DEGAS, *Woman Ironing*, c.1876
(later reworked). Oil on canvas.
81.3 × 66 cm. National Gallery of Art,
Washington DC.

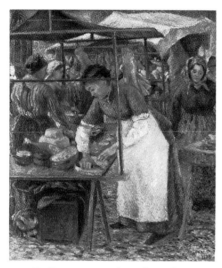

80. C. PISSARRO, *The Pork Butcher*, 1883.
Oil on canvas. 65 × 54.5 cm. Tate Gallery,
London. Reproduced in colour on page 77.

82. C. PISSARRO, X-ray of upper section
of *The Pork Butcher*, no. 80.

Pissarro's use of these types was not
without an element of caricature. In the
Market Stall he offset the strapping stall-
holder with a bourgeoise he called 'very
pale and very sick' and Gauguin 'the
skull-faced old woman'.[155]

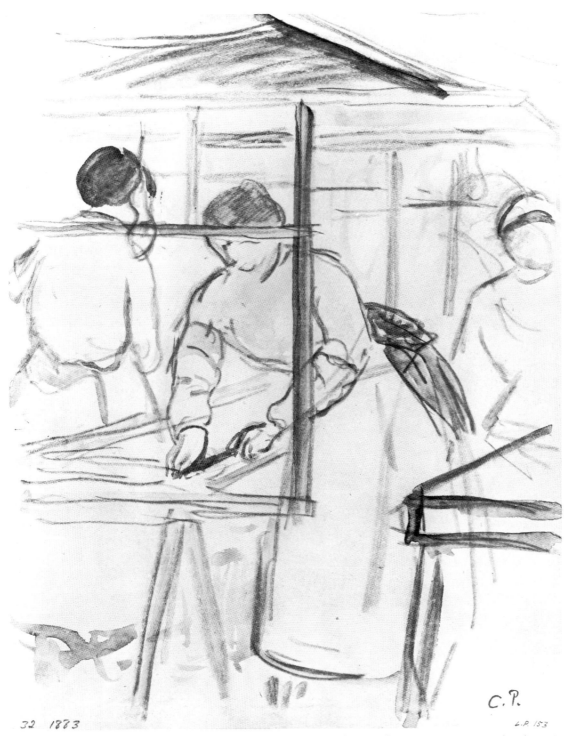

32 1883

C. P.

L.P. 153

83. C. PISSARRO, Study for *The Pork Butcher*, 1883. Black chalk and watercolour. 21.5 × 16.4 cm. Ashmolean Museum, Oxford.

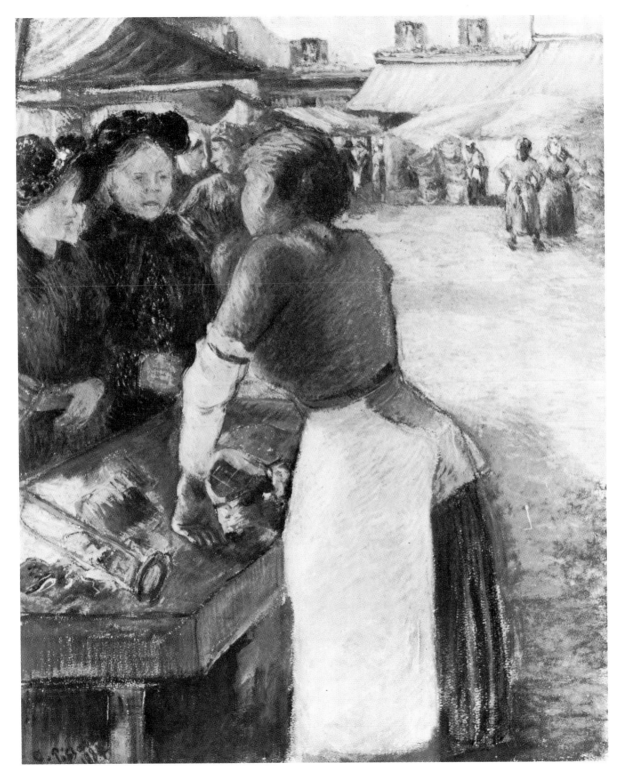

84. OPPOSITE: C. PISSARRO, *The Market Stall*, 1884. Black chalk, tempera and watercolour. 62 × 49 cm. Burrell Collection, Glasgow.

Pissarro's interest in markets took in those of Paris, the ultimate destination for much of the regional produce. Two highly finished watercolours made in 1889, one of a fish market and another a vegetable market (figs 85, 86), are of the same size and suggest that he may have planned or made a series of different metropolitan markets. The *Marché St Honoré* operates in a similar way to the larger paintings. It was developed via preliminary studies, including a careful pen-and-ink drawing on which Pissarro based the right-hand side,[156] to show discreetly polarized classes. For in the *Marché St Honoré*, as in the fish market or the *Market Stall*, we literally side with the stallholders, facing the bonneted bourgeoises across the produce, the means of exchange.

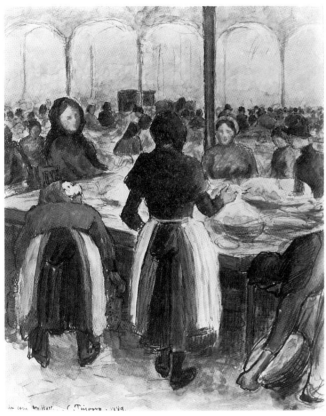

85. C. PISSARRO, *A Corner of Les Halles*, 1889. Black chalk, watercolour, pen and ink. 29.5 × 22.8 cm. Fogg Art Museum, Cambridge, Mass.

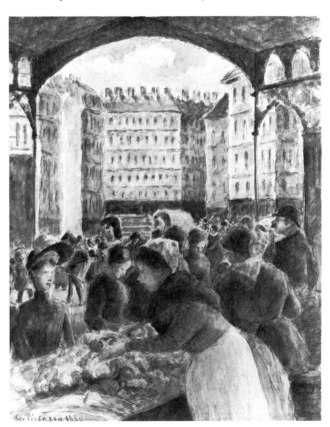

86. C. PISSARRO, *The Marché St Honoré*, 1889. Black chalk and watercolour, with pen and ink. 29.3 × 22.7 cm. Private collection.

One of Pissarro's last, and most involved, market compositions was *Market at Gisors, rue Cappeville*; its very complicated evolution resulted in a coloured etching, pulled in seven states, and an uncut woodblock (figs 90, 92).[157] Although the general motif seems to date back to a painting of 1885 (P&V 690), the project proper apparently began in 1893 with a horizontal drawing of a market scene in mixed media (fig. 87). This deep-toned image, heightened by brighter accents, gives a synoptic account of the market crowd, framed by

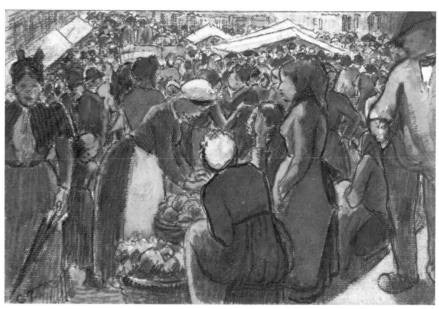

87. C. PISSARRO, *Market at Gisors, rue Cappeville*, c.1893. Black chalk, watercolour and gouache on pale brown paper. 17.3 × 25.3 cm. Private collection.

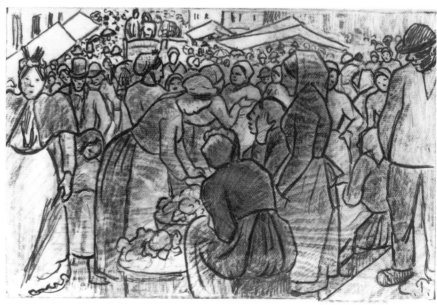

88. C. PISSARRO, *Market at Gisors, rue Cappeville*, c.1893. Pen and indian ink over charcoal and pencil on tracing paper. 20.6 × 25.5 cm. (paper); 17.3 × 25.5 cm. (sight). Ashmolean Museum, Oxford.

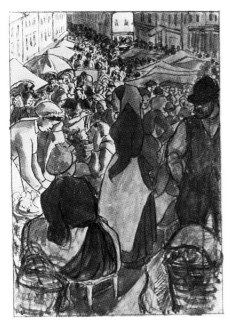

89. C. PISSARRO, *Market at Gisors, rue
Cappeville*, 1893. Black chalk, pen and ink,
grey and brown washes, heightened with chi-
nese white, on tracing paper. 27.5 × 20.9 cm.
(paper); 25 × 17.4 cm. (image). Ash-
molean Museum, Oxford.

90. C. and L. PISSARRO, *Market at
Gisors, rue Cappeville*, 1893. Pen and indian
ink, heightened with chinese white, on
uncut woodblock; extensive annotations in
margins. 31.5 × 23.2 cm. Whitworth Art
Gallery, Manchester.

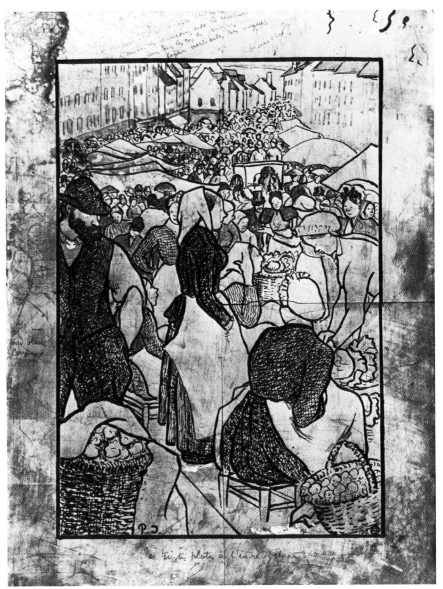

a bourgeoise on the left and a peasant
on the right who appears to look across
at her. Pissarro made a tracing based on
this gouache (fig. 88), but then
relinquished the horizontal, perhaps
because of the rather overt polarity it
implied. A third drawing now played
its part. Traced and heighted in wash
(fig. 89) this study effected a narrative
compromise between horizontal and
vertical. For example, the loss of the
bourgeoise to the left margin was com-
pensated by the inclusion of another
middle-class woman under a parasol,
behind the stooping maid in the mid-
dleground. Apparently the composition
was then taken in two directions. First
Pissarro transferred it to a woodblock
(fig. 90). This took place in 1893,
according to a letter to Georges that

75

October: 'I'm working on the *Market* for the block that Lucien's going to engrave. I'm very uncertain whether it should be done vertically or horizontally.'[158] Although Pissarro annotated the block extensively to help Lucien make a wood-engraving from it, in the event the block was never cut. Over a year passed, until in mid December 1894 Pissarro wrote to Lucien that he would shortly be send-ing him an impression of a colour etch-ing of a market subject, 'for which you have the woodblock'.[159] A month later he sent Lucien a black-and-white impression worked with coloured crayon (fig. 91).[160] The final colour etching, one of five Pissarro made in this experimental medium, must have fol-lowed soon after (fig. 92).

The complicated evolution of the *Market at Gisors, rue Cappeville* project is of importance because it shows how dur-ing the second half of his career Pissarro no longer acknowledged the traditional hierarchy in which painting held sway. This sequence of studies was intended to result in prints, and simultaneously involved both intricate technical con-siderations and decisions about how the class structure of the Gisors marketplace should be represented. Close analysis of the sequence reveals that his construction of the market did not simply depend upon the polarization of class types. Pis-sarro also juggled with narrative. What had been in the initial gouache a leer across the picture area from peasant to bourgeoise became a more reciprocated glance between the seated country-woman and the now bearded peasant.

Interrelationships between figures deep in the crowd were adjusted, with some being dropped, others enhanced or intro-duced, so the interaction is multiple: peasants converse, a maid tests a veg-etable, townspeople look on or trade with the peasants. Thus a small image, scrupulously reworked, came to define Pissarro's final construction of the rural market: a place where the labour of the land meets the money of the town, where there is neither quite uncommunicative polarization of classes nor equal exchange, into which the spectator is implicitly introduced but the peasant remains dominant.

91. C. PISSARRO, *Market at Gisors, rue Cappeville*, 1894. Etching in black ink, heightened in coloured crayons; annotated in margins. 19.6 × 13.7 cm. (plate); 19.6 × 13.7 cm. (composition). Ashmolean Museum, Oxford.

92. LEFT: C. PISSARRO, *Market at Gisors, rue Cappeville*, 1894. Etching in colour. 20.2 × 14.2 cm. Ashmolean Museum, Oxford.

80. OPPOSITE: C. PISSARRO, *The Pork Butcher*, 1883. Oil on canvas. 65 × 54.5 cm. Tate Gallery, London.

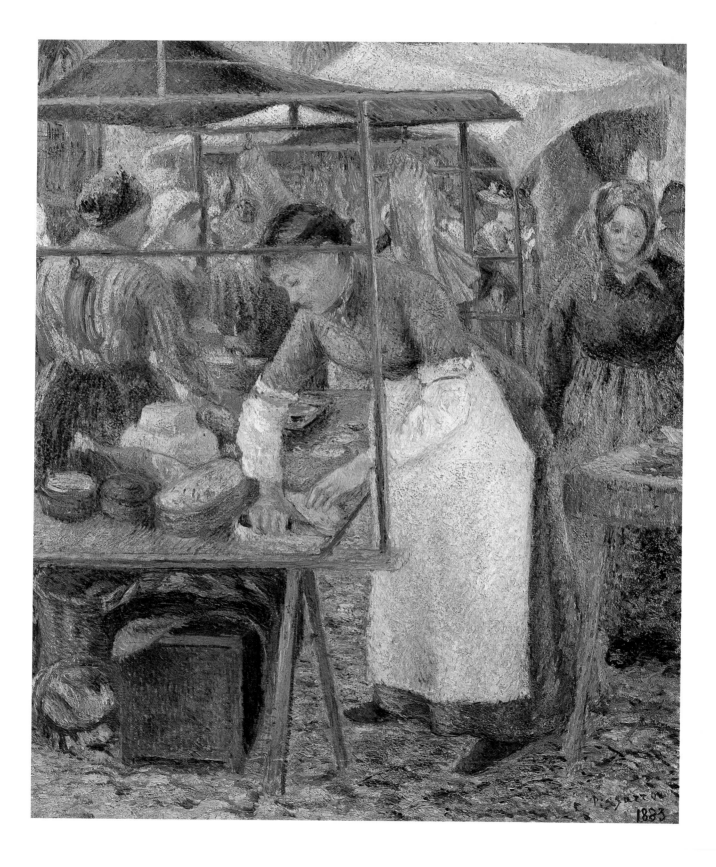

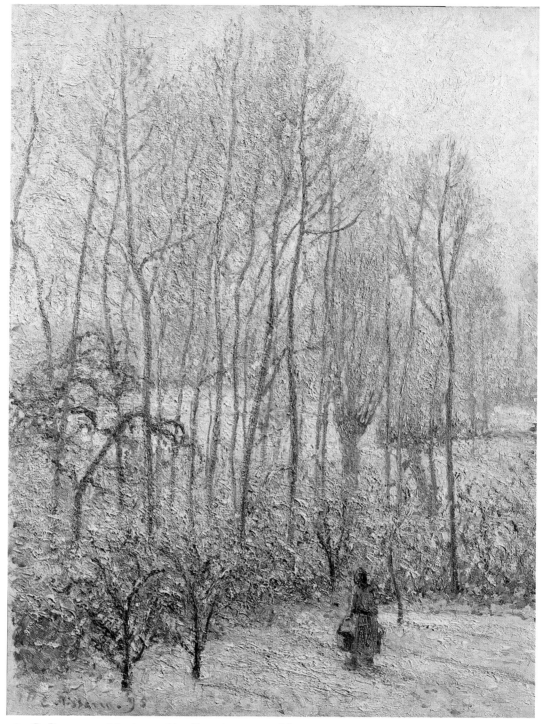

98. C. PISSARRO, *Morning, sunshine effect, winter*, 1895. Oil on canvas. 82.3 × 61.5 cm.
Museum of Fine Arts, Boston.

97. OPPOSITE: C. PISSARRO, *St Charles, Eragny, sunset*, 1891. Oil on canvas. 80.8 × 64.9 cm.
Sterling and Francine Clark Art Institute, Williamstown, Mass.

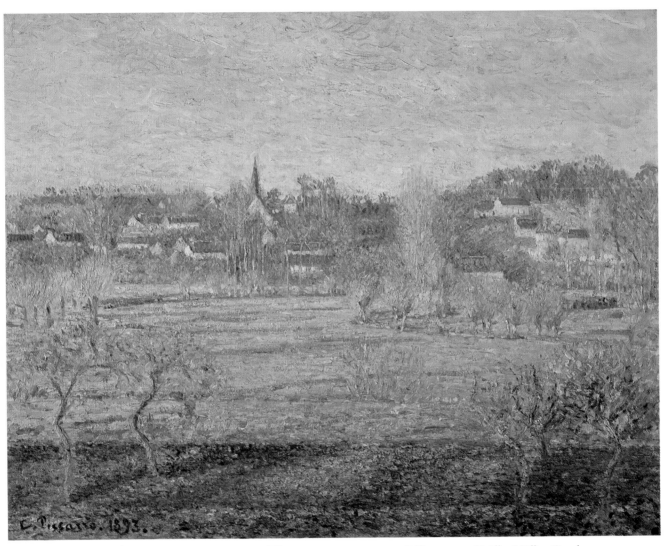

96. C. PISSARRO, *February, sunrise, Bazincourt*, 1893. Oil on canvas. 65 × 81.5 cm. Rijksmuseum Kröller-Müller, Otterlo.

The Late Rural Idylls: Constructing 'the True Poem of the Countryside'

In 1890 *The Gleaners* (fig. 70) was shown in the first of what became a series of one-man shows. The following decade, which saw Pissarro's growing success with collectors and consequent financial stability, also witnessed new patterns emerging in French culture and society. Growing radicalism within the proletariat, the rise of a Left-wing press, contact with the progressive ideas of other writers and artists, anarchist activity and terrorist acts, all contributed to the definition of Pissarro's ideological position at this period. Intellectuals were increasingly attracted to anarchism's contempt for the oppressiveness of the dominant bourgeoisie and celebration of the individual's creative individuality. The ideal of an harmonious future society, founded on rural communities, appealed to the anarchist intellectual Mirbeau, who saw it prefigured in Pissarro's paintings, in which 'man is always in perspective in a vast telluric harmony'.[161]

But such terminology was not confined to the politically radical. The later 1880s had seen the rise of Symbolism, both in literature and the visual arts. Symbolism repudiated the descriptive — the detailing of facts, however gross or unpalatable, that was the method of novelists such as Zola — and retreated into the evocative, favouring the suggestion of mood and emotion rather than the statement of the modern and tangible. For a Symbolist critic like Albert Aurier, whose political views were far from progressive, Pissarro painted 'that majestic tranquillity, that solemn melancholy which envelops the forms and the creatures of the fields'.[162] While Pissarro

nursed a deep scepticism about Symbolism, not least because he felt it evaded pressing social concerns,[163] his work was nevertheless created within the Symbolist climate to which younger artist-colleagues, such as Seurat, Signac and his eldest son Lucien, held some allegiance. Pissarro was content with critical accounts of his work by Mirbeau, Geffroy and Lecomte which were couched in such lyrical terms, and even used them himself, for in an 1892 interview he talked of how in his studio paintings 'impressions ... are coordinated and enhance each other's value to create the true poem of the countryside'.[164]

If Pissarro seems to have admitted that his art was an idyllic fiction, the use of rural imagery to construct an ideal was hardly exclusive to Symbolists or the Left. Paul Déroulède, for instance, founder of the militarist Ligue des Patriotes, adapted *la vie agreste* to his ideology of Catholicism and *Revanche* against Prussia. In his *Chants du Paysan* of 1894 the poems dwell on the sacred soil of France which should be defended at all costs, the mother earth, God's gift of fruitfulness, and even the benefits of agricultural machinery.[166] In his autobiography published in 1890 Jules Breton, by then a pillar of the French art establishment and a man of staunchly conservative views, employed an idealist vocabulary not far removed from Pissarro's, when he wrote: 'looking at a twilight scene, it matters little that my eye should receive an impression of the view if my spirit does not at the same time receive a feeling of repose, tranquillity and peace'.[165] Breton's paintings of the

1880s and 1890s took on a visionary quality, for as the agriculture of his native Artois disappeared beneath coal mines and slagheaps his work dwelt nostalgically on changeless images of the country.[167] During the eighties Lhermitte produced a series of monumental canvases which reinforced Catholic ideals of family and toil, and he too rejected images of rural modernization.[168] Pissarro's means (scrupulous preparation, balanced composition), subjects (peasant conversation, tending animals, the harvest), and omissions (machinery, the bourgeoisie) find close parallels in those of Breton and Lhermitte. However opposed their ideologies, however different the look of their paintings, all three manipulated rural imagery to construct a fictional ideal.[169]

The Meadows

In 1884 Pissarro gave Lucien his reasons for settling in Eragny; 'the house is superb and cheaper: 1,000 francs, with garden and meadows. It's two hours from Paris; I've found the countryside more beautiful than Compiègne. Spring's beginning, the pastures are green, the distant silhouettes fine.'[170] Country and city interlocked: what to paint and where to sell. Pissarro immediately began to paint the view westwards from his house, across the watermeadows of the Epte valley to the hamlet of Bazincourt on rising ground a kilometre away.[171] Working in an even more confined orbit than at Louveciennes or L'Hermitage, for almost two decades Pissarro chose the nearby meadows, and especially the

93. C. PISSARRO, *View from my window, overcast weather*, 1886 (reworked 1888). Oil on canvas. 65 × 81 cm. Ashmolean Museum, Oxford.

Bazincourt motif, as the regular site for his contemplation of nature. His letters of the 1890s are packed with references to the motif: 'The weather's been very good recently . . . dry cold, hoar frost and radiant sunshine, so I've begun a series of studies from my window' (December 1891); 'at the moment the countryside's covered in snow, all three of us are busy at the windows on the unique and beautiful motif of Bazincourt' (December 1892); 'it's magical at the moment' (October 1893).[172] This is the language of the Impressionist: direct observation of nature, serial work to record changes of light and climatic conditions.

Pissarro's first major canvas of the Bazincourt motif, for all its specific title, *View from my window, overcast weather* (fig. 93), was in fact a transitional painting. Painted in the spring of 1886 it was one of his first Neo-Impressionist experiments, evoking the cloud-filtered light with a dotted touch and an increased attention to the chromatic vibration between complementaries. Shown at the 1886 Impressionist exhibition in a room with Seurat's *La Grande-Jatte* (1884–6; Chicago, Art Institute) and pointillist canvases by Signac and Lucien, *View from my window* conveyed Pissarro's commitment to the new style. But this innovation displeased Durand-Ruel. He told Pissarro the picture would not sell because of the red roof and the poultry-yard; this was somewhat disingenuous of the dealer, who happily handled Millet's farmyard subjects.[173] Although Pissarro later reworked and re-signed the painting, Durand's anxiety about the roof can still be understood. Its 'synthetic' simplicity has a jarring quality, and Pissarro's later views of the motif tended to avoid forms that shoved into the picture space.

Pissarro explored the view beyond his property, looking over the uncluttered meadows to Bazincourt in the distant trees, in an important series of water-colours made in 1890, many drawn on

sheets of the same size, dated, often exactly, and sometimes annotated with the weather *effet*.[174] Thus one is a study of winter frost, another of summer sunset (figs 94, 95). Although on occasion these watercolours served as a preliminary study for an oil, they seem primarily intended as private observation; as Pissarro wrote to Lucien the following year, 'Remember that watercolour is a good means to help one's memory, above all with transitory effects'.[175] Similar groups or

94. C. Pissarro, *Hoar Frost*, 1890. Pencil and watercolour. 20.8 × 26.2 cm. Ashmolean Museum, Oxford.

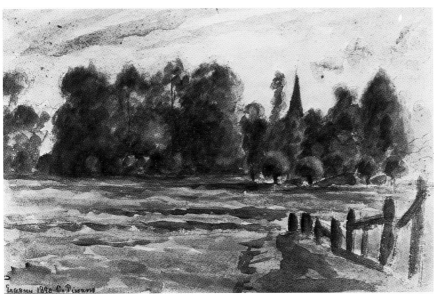

95. C. Pissarro, *Landscape, Eragny*, 1890. Black chalk and watercolour. 16 × 23.8 cm. Whitworth Art Gallery, Manchester.

sequences of informal studies analysing changes of light and weather on essentially the same motif were not uncommon in the Impressionist circle. The printmaker Félix Bracquemond, for example, had made at least two watercolours in March 1873 of trees in daylight and at dusk, while Caillebotte had executed a series of oil sketches of a view at different times of day.[176] Such an exercise was necessary for Pissarro in 1890. He found the Neo-Impressionist technique made his paintings slow to execute and somewhat stiff. Watercolour was a means to revive acuity of *sensation* and fluency of touch, and also enhanced his awareness of the value of producing series of related images, a practice that went back many years to the pairs and groups made at Louveciennes and Pontoise. And they encouraged less comprehensiveness, more equilibrium. *View from my Window* is an inclusive panorama; it is a restless stocktaking of barn, poultry-yard, *jardin potager*, orchard and cattle, viewed from a proprietorial viewpoint. The later *February, sunrise, Bazincourt* (fig. 96, p. 80), by contrast, is unified by the enveloping *effet*; as the sun comes up behind us, the warm light of this cold morning sorts the landscape into receding planes, so it is held in a gently disciplined structure not far removed from the neo-classical regulations in which Pissarro had been trained. It was the watercolours which had helped recapture this balance of structure and confidence in Impressionist *sensation*.

Pissarro's motifs in the meadows around Eragny also included vertical compositions. One of the finest of these is a *St Charles, sunset* (fig. 97, p. 78), which demonstrates some of the benefits Pissarro had drawn from his Neo-Impressionist experience. Depicting a site between Eragny and Gisors, it is evenly worked in dry steady touches, a

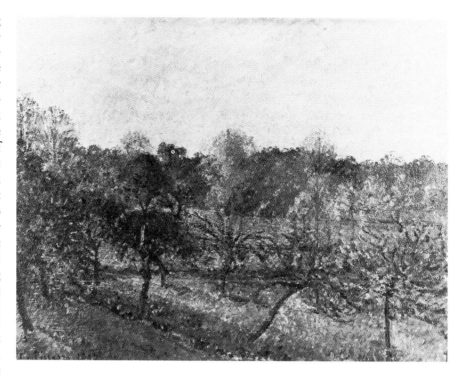

99. C. PISSARRO, *Sunset, Eragny, autumn*, 1902. Oil on canvas. 73 × 92 cm. Ashmolean Museum, Oxford.

medley of flecks and points, and extraordinarily varied in its colour combinations, with the trees alone varying from deepest blue to bright yellow. Shepherd, flock and shack provide activity and scale, but the human element is dominated by the natural. The declining sun spills warm, subsuming light over the landscape; intensity of observation becomes visionary lyricism. Although Durand-Ruel refused to buy the painting, it was much admired by Monet, whose interest may have been heightened by the fact that he was just starting his series of Poplars.[177] By mid decade Pissarro's handling had broadened and flattened and his colour was more generally observed. While *Morning, sunshine effect, winter* of 1895 (fig. 98, p. 79) may lack the transcendental luminosity of the

earlier *St Charles, sunset*, its harmonious grey-pink tonality absorbs the peasant woman into the enveloping winter *effet*, creating the consonance between human and nature of which Mirbeau had written in 1892.

The view towards Bazincourt fascinated Pissarro up to the end of his life, and the orchard behind his house furnished the motif for his powerful *Sunset, Eragny, autumn*, made in 1902 (fig. 99). The heavy paint surface and close values recall his paintings of the 1860s, although the textures are more varied and the colour range is more resonant. The apparent surrender to the rhythms and roughness of nature reminds us how considered and constructed are the images of the meadows at Eragny. For all their attention to the specific *effet*, these paintings place before us various fictions: of man subsumed by nature, of man composing nature, of man owning nature.

The Bathers

The nude had been a topic of intense debate in French art since the 1850s and 1860s, when the paintings of Courbet and Manet challenged academic conventions by refusing to traffic in idealized bodies in timeless settings. In naturalist criticism a campaign developed for a plausible alternative, for the artist to represent the nude (all but assumed to be female) with frank treatment of flesh and in everyday environments. Huysmans put these arguments in his 1879 Salon review. He rejected paintings purporting to represent the nude *en plein air* but actually showing delicate pink bodies painted in a draught-proof studio, demanding 'farm girls baked and tanned by constant sun and rain'.[178]

Although the work of two of his main protégés, Cézanne and Gauguin, had shown an engagement with such critical demands, Pissarro entered late into this debate, for it was not until the mid 1890s that he began to treat the nude in finished work with any consistency. Yet the nude had always had a presence in his work, however casual and sporadic, and had served different purposes. The occasional nudes he drew in the 1870s and 1880s as studies for his images of agricultural labour, some perhaps from the model but mainly from memory (fig. 100), can be seen as the residue of his student practice of life drawing.[179] Other drawings of the female nude seem to have served a more private purpose. These include early sheets such as one of the young Julie sewing as well as the more erotically charged drawings that began to proliferate in Pissarro's sketchbooks during the 1880s. A small canvas of a bather in a wooded stream, painted on the back of an 1876 L'Hermitage landscape, and some

100. C. PISSARRO, *Study of Two Female Nudes*, c.1875–80. Black and brown chalk on buff paper. 17.5 × 21.4 cm. Yale University Art Gallery, New Haven.

101. C. PISSARRO, *Study of a nude woman bending*, c.1894. Charcoal. 28.8 × 22.3 cm. Ashmolean Museum, Oxford.

Lucien posed and even, to his great amusement, himself[183] – and the stooping figure in *Two Bathers* was based on a life drawing which would seem to have been posed by Julie (figs 101, 102). Pissarro was pleased with the results. 'Stunning', he wrote to Lucien: 'perhaps it's too natural; they're fleshy peasant women ... firm! I'm afraid that'll offend delicate sensibilities, but I think it's the best I've done.'[184] He seems to have perceived of such images as part of the naturalist/idealist debate, siding with the Huysmans line.

The pace quickened with bad weather in spring 1894. 'I've done a whole series of romantic printed drawings, which seem amusing enough, a quantity of *Bathers* in all kinds of poses set in

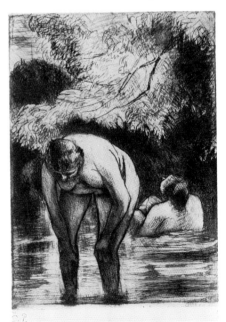

102. C. PISSARRO, *Two Bathers*, 1894. Etching. 18 × 12.7 cm. Ashmolean Museum, Oxford.

marginal jottings of reclining nudes in an 1884 letter indicate that Pissarro did occasionally think of painting the nude.[180]

A letter to Lucien of July 1893 is the earliest indication of a substantial project. 'I've also prepared some little arrangements of peasant women bathing in a clear stream, in the shade of some willows. This tropical heat invites one to do shady riverside motifs, [and] it seems to me that I'm better able to appreciate their poetic side.' But the absence of a model meant his little figures were only 'skittles'.[181] Although we do not know in what medium these images were made, Pissarro's imagination was not fettered by lack of models.[182] In January the next year he was at work on bather images in earnest, pulling two etchings. Pissarro was often forced to use members of his family as models –

paradisical landscapes, [and] interiors also, *Peasant Women at their toilette*, etc. They are motifs which I can paint when I can't go out. It's very interesting because the values – the blacks and whites – give the tone for the paintings. I've done them heightened with col-

our.'[185] What did Pissarro mean by 'romantic'? Perhaps, simply, that these were imaginary images, or it may be that he was thinking of lithographs of bather subjects from the Romantic period, which he would surely have known (fig. 103). For all their rapidly worked

informality, his monotypes (or *dessins imprimés* as he called them) belong in this tradition of prints catering for male fantasies, although the colouration of a monumental seated nude (fig. 104) gives her the 'baked' quality Huysmans demanded.

103. C. BARGUE, *The Water's Edge*, 1850. Tint lithograph. 31.6 × 23.9 cm. Bibliothèque Nationale, Paris.

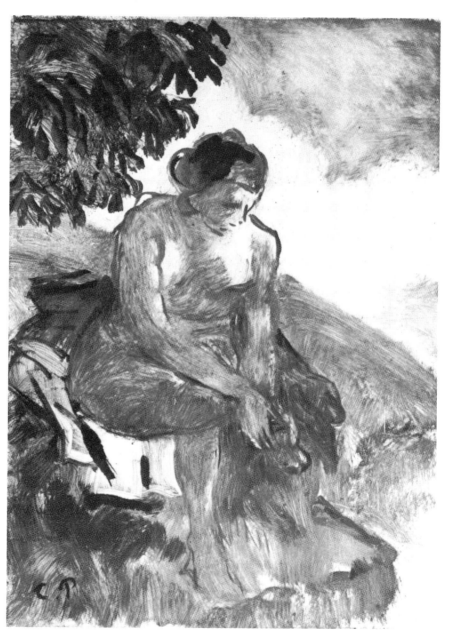

104. C. PISSARRO, *Nude seated on a bank*, *c*.1894. Coloured monotype. 17.5 × 12.6 cm. Museum of Fine Arts, Boston.

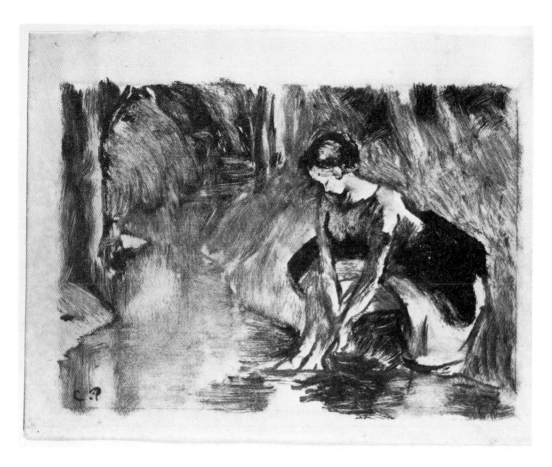

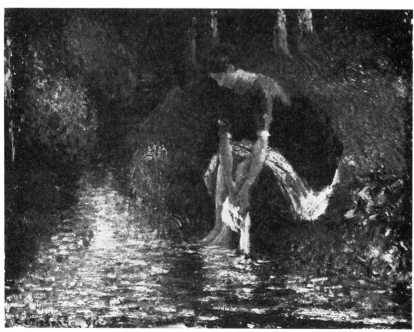

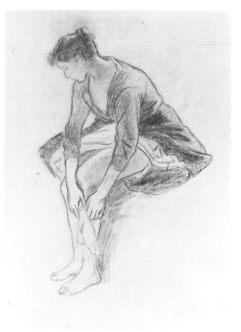

105. OPPOSITE ABOVE: C. PISSARRO, *Peasant Girl washing her feet,* c.1894. Monotype. 12.5 × 17.5 cm. Metropolitan Museum of Art, New York.

106. OPPOSITE BELOW LEFT: C. PIS-SARRO, *Young Woman bathing her feet,* 1894. Oil on canvas. 33 × 41 cm. Indianapolis Museum of Art.

107. OPPOSITE BELOW RIGHT: C. PISSARRO, Study for *Young Woman bathing her feet,* c.1895. Black chalk and pastel on pale grey paper. 53.1 × 39.1 cm. Ashmolean Museum, Oxford.

From such monotypes Pissarro went on to paintings.[186] A tiny print of a peasant girl bathing her feet in a stream (fig. 105) was developed into a small painting in 1894 (fig. 106). Both seem to have done without a model. However, a larger canvas of this subject made the following year was worked up from a preparatory drawing for which Pissarro got a young woman to pose (figs 107, 108). In 1895 Pissarro also painted the same motif with a woman sitting naked on the bank, drying her leg after bathing (fig. 109). The fictive quality of these paintings is thus apparent from their making; observation followed fantasy. In the large, luminous canvas of the peasant clothed (fig. 108), the tranquillity of the scene is emphasized by the stillness of the water and the raking light, applied

108. BELOW: C. PISSARRO, *Young Woman bathing her feet,* 1895. Oil on canvas. 73 × 92 cm. Sara Lee Corporation, Chicago.

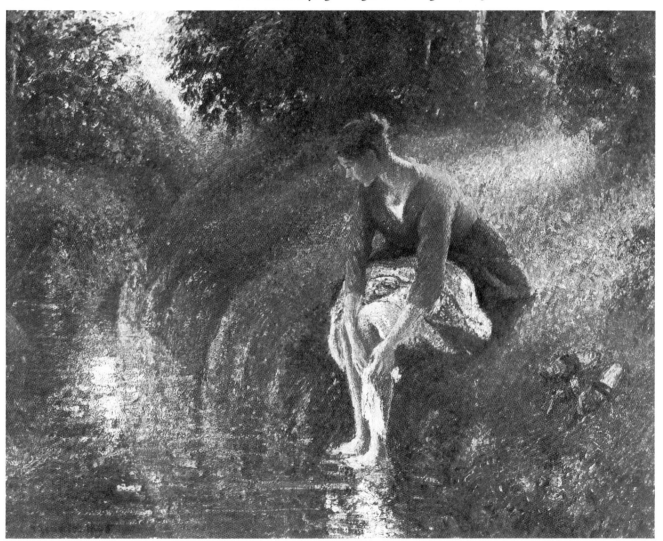

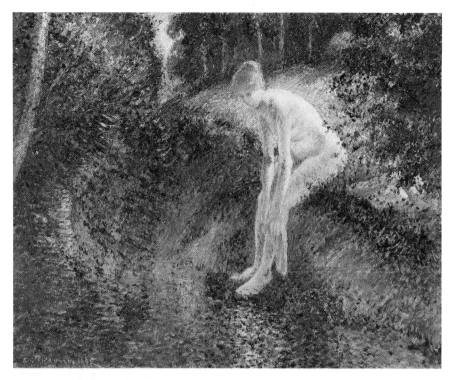

109. C. PISSARRO, *Bather in the Woods*, 1895. Oil on canvas. 60.3 × 73 cm. Metropolitan Museum of Art, New York. Reproduced in colour on page 105.

with an even touch; it is a scene the spectator seems to chance upon. For the equally calm *Bather in the Woods* (fig. 109) Pissarro imaginatively 'undressed' the model, discreetly exposing the unidealized body. But here the spectator is made to glimpse the naked bather from behind a screen of trees, to pry secretly on her privacy. Neither washing of the person nor the clothes were apparently common among contemporary French peasants.[187] Pissarro, in determinedly taking up the bathing theme, was less representing observed daily life than following a stereotype for nineteenth-century landscape painters such as Millet (fig. 110), Daubigny, Corot and Diaz,[188] adopting an existing iconography for such subjects. His 1895 etching of a bathing peasant woman confronted by a gaggle of geese (figs 111, 112) has precedents in Millet's *Goose Girl*, shown at his 1887 retrospective, and in a print by Bracquemond, Pissarro's collaborator on the ill-fated *Le Jour et la Nuit*[189] (fig. 113). The geese seem to serve as substitutes for the spectator/voyeur; they are as 'natural' in such a scene as the peasant's nakedness. The chic coiffure of Bracquemond's model betrays the essentially urban quality of his image, whereas Pissarro's extreme synthesis of contour stresses a body untrained by the corset.

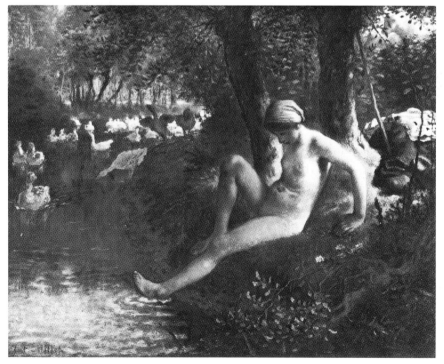

110. J.-F. MILLET, *The Goose Girl*, 1863. Oil on canvas. 38 × 46.5 cm. Walters Art Gallery, Baltimore.

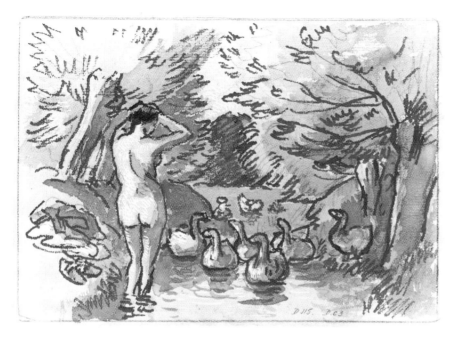

111. C. PISSARRO, Study for *Bather with Geese*, 1895. Pen, brown ink and grey wash, heightened with chinese white, on beige paper; framed in pencil. 13.7 × 18.7 cm. Ashmolean Museum, Oxford.

113. F. BRACQUEMOND, *Canards surpris*, 1882. Etching and drypoint. 37.6 × 26.8 cm. Art Gallery of Ontario, Toronto.

112. C. PISSARRO, *Bather with Geese*, 1895. Etching. 12.7 × 17.3 cm. Ashmolean Museum, Oxford.

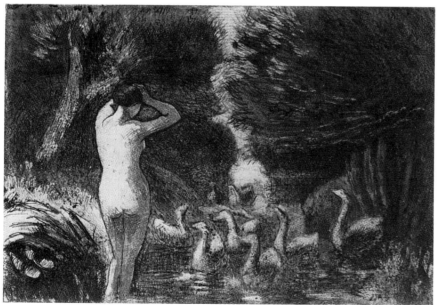

'You must do the nude like you do the chickens, ducks or geese', Pissarro urged his son Georges in 1894.[190] He was encouraging instinctive, individual synthesis, and warning against academic formulae. In a letter to Lucien written the same day Pissarro criticized Charles Shannon's nudes for their pre-ordained sophistication while justifying Puvis de Chavannes's figures for having 'a certain ignorance or awkwardness'.[191] This was the anarchist's argument, placing the individual over the establishment, and a desire to produce a personal interpretation of the bather conventions was perhaps one of Pissarro's motives for taking up the nude. Another seems to have been self-indulgence. He often referred to making bather images as 'amusant',[192] and they seem to have satisfied his fantasies. Bathers were also marketable. In 1895 Pissarro sold thirteen canvases to Durand-Ruel for only 10,000 francs, a 'disastrous' sum.[193] But six months earlier the *Bather in the Woods* (fig. 109) alone had sold to the Japanese collector Tamadasa Hayashi for 1,800 francs.[194] Bather subjects were convenient for Pissarro: they occupied his imagination, could be made in the studio, and moved on the market. But they involved compromises. For all his commitment to the 'naturalist' nude, Pissarro's bathers could not escape from the subject's conventional vocabulary. The fiction of the female peasant naked by the stream played with conventional myths about the 'natural' behaviour (and hence morality) of the countrywoman. Thus his bathers are far from 'true' images of Eragny life. The banks of the Epte merely gave Pissarro an expedient imaginative spur to construct his own images of a pastoral idyll.

Work in the Fields

The third group of idealized images to be conjured from the Eragny locality consists of scenes of rural labour. Pissarro produced fewer complex figure compositions in the 1890s than he had in the previous decade, but these have a resonant harmoniousness and resolution. They are all studio pictures, built up carefully from drawings, their unity often enhanced because they are reprises of existing designs, so the motif is increasingly synthetic and idealized.

In mid December 1890 Pissarro informed Lucien that a fan he had made for him was finished;[195] this was the superb *Peasant Women planting pea-sticks* (fig. 114). Notionally set on the downs above Eragny, it is a generalized idyll, its fiction compounded by the fact that this gouache of a spring task, performed under the blossoming apple-trees, was made during the winter. The women's faces are all but anonymous, but this is not oppressive. The shared rhythm of their arms and bodies gives a powerful sense of community to this repetitive task, and the effect has often been compared to dance.[196] Pissarro took up the motif in a painting, which he completed in 1891 and showed at his one-man exhibition at Durand-Ruel's the following year (fig. 115). More sharply coloured than the almost fresco-like gouache, the painting reduced the number of figures and pulled the composition into an emphatically vertical format. The insistent frontality of the central woman, flanked by two companions, gives the image an almost ritualistic quality, Pissarro here celebrating the metaphorical collusion of woman and nature. A variant of this figure recurs at the left of *Hay Harvest*

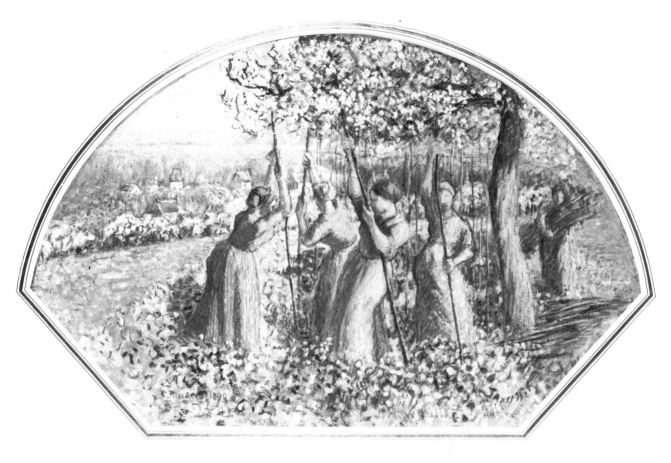

114. ABOVE: C. PISSARRO, *Peasant Women planting pea-sticks*, 1890. Gouache and black chalk on grey-brown paper. 40.7 × 64.1 cm. (paper); 39 × 60.2 cm. (fan). Ashmolean Museum, Oxford.

115. LEFT: C. PISSARRO, *Peasant Women planting pea-sticks*, 1891. Oil on canvas. 55 × 46 cm. Private collection, on loan to Sheffield City Art Galleries. Reproduced in colour on page 108.

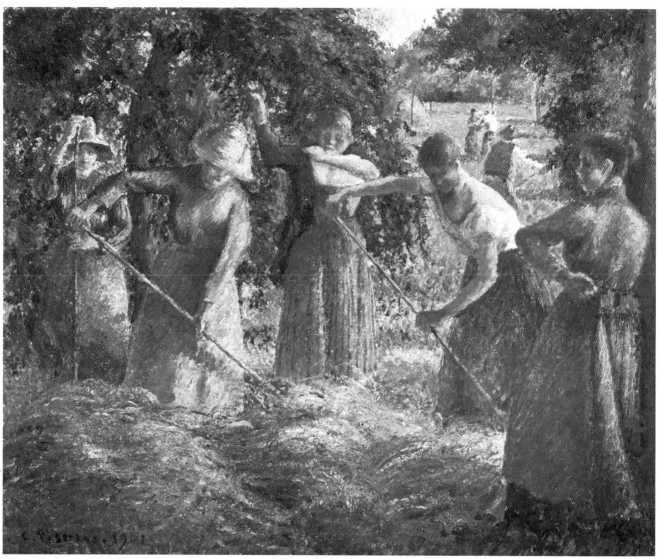

116. C. PISSARRO, *Hay Harvest at Eragny*,
1901. Oil on canvas. 54 × 65 cm. National
Gallery of Canada, Ottawa.

at Eragny (fig. 116), with another frontal
figure used in the centre, pulling on her
jacket. One of Pissarro's last statements
on this theme, the *Hay Harvest* was care-
fully prepared via a preliminary gouache
and several drawings.[197] There are ten
figures, seven women and three men, but
the attention is centred on the haymaking
of the foreground women, raking to the
same rhythm. Their movement is held
by the three standing figures, and the
balance of poses and actions is unified

by a warm, musty coloration and a dis-
creetly rough, 'rural' texture. These
images are pastorals, then; they construct
an ideal of a changeless golden age of
rural community. Pissarro was not alone
in holding this ideal dear. As well as
Lhermitte and the elderly Breton,
younger painters such as the Belgian
Henry Van de Velde – who wrote prais-
ing Pissarro's peasant compositions[198] –
and Henri Martin played upon this fic-
tion. Martin's large murals, for example,

painted for the Capitole at Toulouse in 1903 (fig. 118), share Pissarro's fascination with repetition as a metaphor for community in a bountiful landscape.

Pissarro's creation of an harmonious rural world was not restricted to his paintings. As usual, poses and motifs were in regular passage between different media. A stooping figure from the *The Gleaners* was recycled in *Spring* (fig. 119), and Pissarro also drew a version of *Hay Harvest at Eragny* (fig. 117). Both of these were to have been incorporated in *Les Travaux des Champs*, a cycle of prints on which Pissarro and Lucien collaborated off and on from 1886 to 1903.[199] Pissarro

117. LEFT: C. PISSARRO, *Hay Harvest at Eragny*, c.1901. Pen and indian ink with chinese white over pencil on tracing paper laid down on card. 14.1 × 14.9 cm. Ashmolean Museum, Oxford.

118. H. MARTIN, *Summer: Men scything*, 1903. Oil on canvas. Capitole, Toulouse.

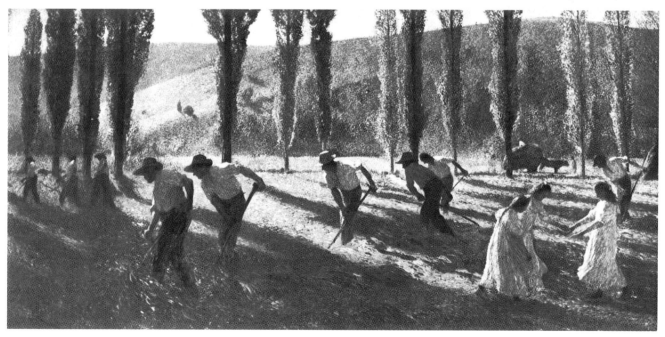

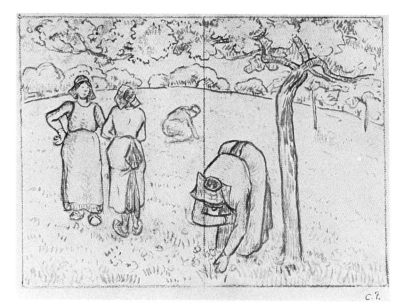

119. C. PISSARRO, Study for *Spring*, c.1894–5. Red-brown and indian ink over charcoal on blue paper; framed in black chalk. 23.6 × 29.9 cm. Ashmolean Museum, Oxford.

drew the images, which Lucien transferred to woodblocks for printing. As a project it was consistent with their anarchist ideology: two individuals combining their craftsmanly skills. However, outside pressures – the need to paint saleable pictures, Lucien settling in England – only permitted sporadic work on *Les Travaux des Champs*. At least one print was ready by 1888, when Theo van Gogh took some impressions for the fairly low price of 5 francs each, although the first album was not completed until 1893 and the second never finished.[200] This time-lag accounts for the published album's uneven stylistic character. The earlier images, made in the later 1880s, are drawn in a loose, broken manner and printed in black-and-white,[201] whereas the two major colour woodblocks (figs 121, 122), the product of a spate of collaboration in autumn 1893, have heavier, more 'synthetic' contours which Pissarro compared to stained glass.[202] The intensity of the work and the closeness of the collaboration is evident from a preparatory sheet for *Femmes faisant l'herbe* (fig. 120).

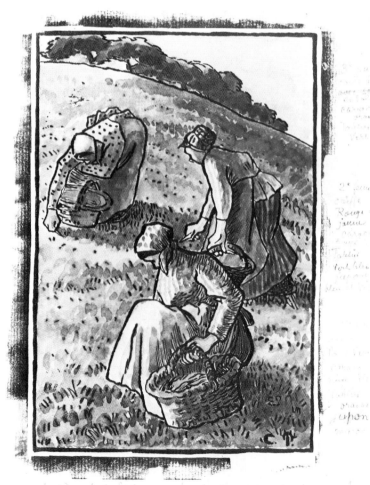

120. LEFT: C. PISSARRO, Study for *Femmes faisant l'herbe*, c.1893. Woodcut in black ink, coloured with watercolour; annotated in margins. 21.2 × 17.8 cm. (paper); 17.5 × 11.8 cm. (block). Ashmolean Museum, Oxford.

121. OPPOSITE: C. PISSARRO, *Femmes faisant l'herbe*, 1893. Wood engraving in colour. 17.5 × 11.8 cm. Ashmolean Museum, Oxford.

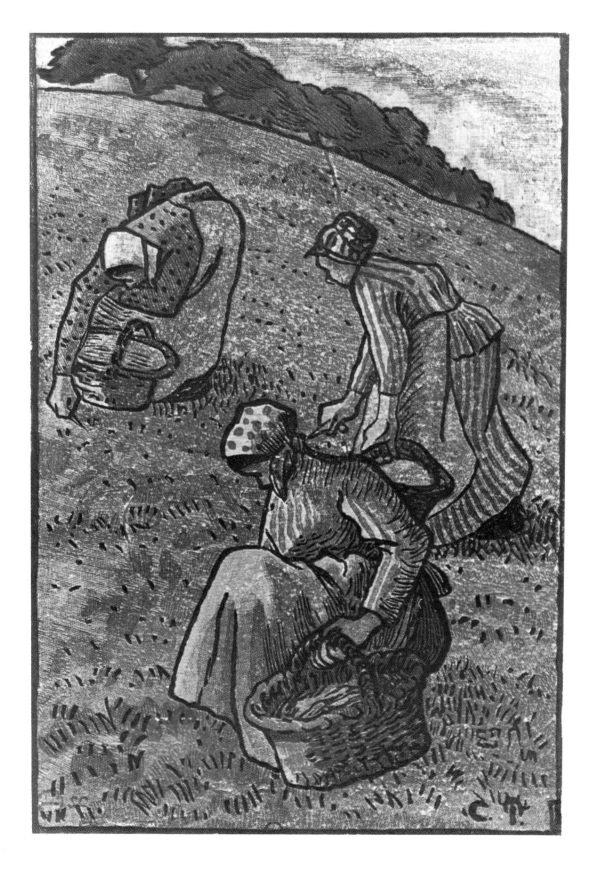

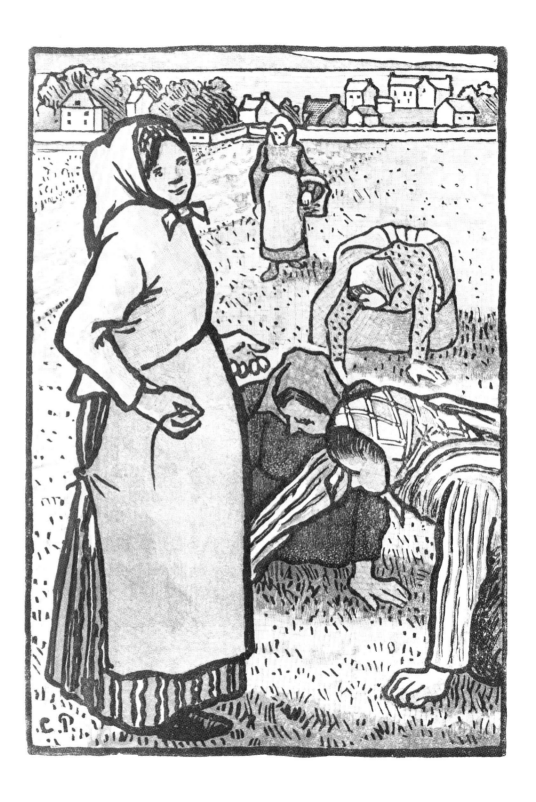

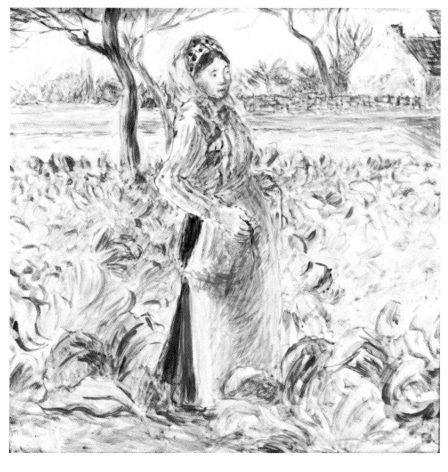

A black-and-white impression was taken from a woodblock on a sheet of paper the other side of which Lucien had used for a study of a dead cat for his series of illustrations *Il était une bergère* in 1886.[203] Pissarro then carefully coloured this impression with watercolour, using the margin to test his hues and write instructions for the printing in colour. Past images were raided for poses and compositions to be used in *Les Travaux des Champs*. The *Sower* from Montfoucault (fig. 53) was printed but not included in the first album; the *Threshing Machine* was drawn for the second, but no block made; and the standing figure in *Women weeding* was lifted from a ceramic tile made in the early 1880s (fig. 123). The two multicoloured prints from the album glow with a subtly coloured warmth, and their flat printed surface gives them a steady, unified quality unlike, say, the ceramic tile from which Pissarro had taken the figure. The tile has a busy graphic surface, full of *sensation*, typical of the early 1880s; the woodcut of *Women weeding*, with its 'synthetic' contours, has a greater monumentality. The two coloured prints thus work to produce the same effect as Pissarro's paintings of the period, images of harmonious communal labour.

125. C. PISSARRO, *The Young Beggar Girls*, 1890. Black chalk, watercolour and gouache. 29 × 21 cm. Private collection, Toronto.

Pissarro's tiles, which seem to have been made between 1876, with Piette's encouragement, and the early 1880s, were not his only ventures into the realm of the decorative arts.[205] As well as fan-shaped gouaches (fig. 114), he also painted designs on wood. A small panel with a motif of apple-pickers (fig. 124) is a rare example of this. The frieze-like motif is surrounded by a red frame, flecked with pale blue and yellow, and the fact that the panel is curved suggests that Pissarro intended it as the lid of a box; indeed in 1886 he asked Lucien to buy him twelve panels for a box.[206] A tracing of the design in reverse is close in size and handling to another drawing of grape-picking, from which a second decorative panel may well have been made.[207] *Apple-picking*, which reads from left to right, is a synoptic image of the communal activity of the harvest; it carries over to a functional domestic object Pissarro's pastoral ideal.

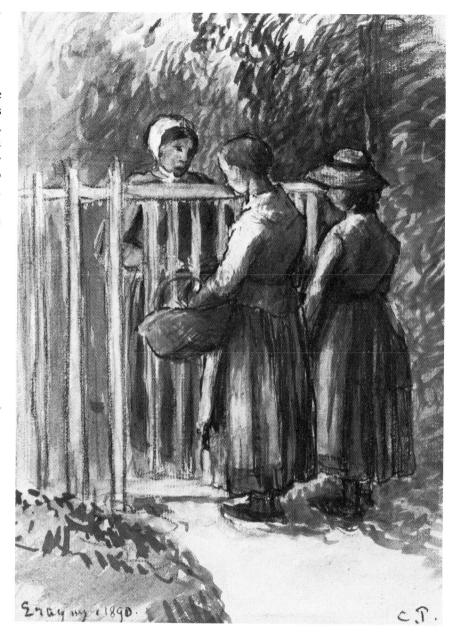

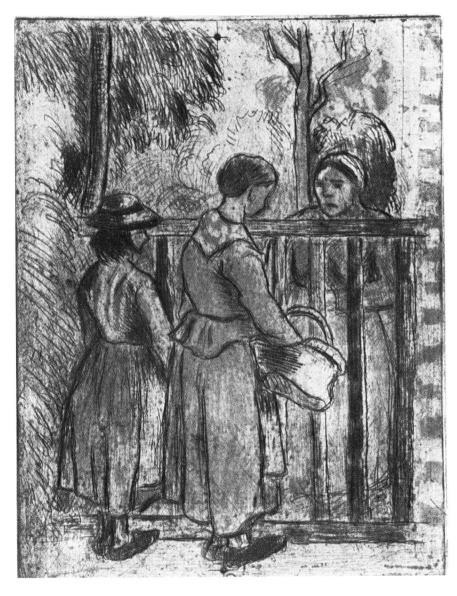

126. C. PISSARRO, *The Young Beggar Girls*, *c*.1894–5. Etching in colour. 20 × 15 cm. Ashmolean Museum, Oxford.

Pissarro's fiction of a rural idyll was maintained throughout the 1890s, against the odds. First anarchist actions and their suppression and then the Dreyfus Affair preoccupied him; his ideological position engaged him in a struggle against what he saw as oppression and injustice. In his art it seems that his answer was to proffer an almost visionary ideal of *la vie agreste*, ignoring the modernization of rural France and celebrating Kropotkin's utopian concept of rural life. But Pissarro's vision of the country was not entirely ideal. There are images of the poor. In 1890 he made *The Young Beggar Girls*, a gouache which served four years later as the study for a coloured etching (figs 125, 126). Whereas in paintings when Pissarro had used the image of the gate it had been open, welcoming, in *The Young Beggar Girls* and another print of the 1890s it is closed, the householder literally fencing off poverty from her existence.[208] Occasionally in prints Pissarro revealed flaws in his pastoral ideal, the dominant fiction of his late Eragny paintings, be they landscapes, bathers or scenes of labour in the fields. There is dissonance even in 'the true poem of the countryside'.

Representing the City: the Rouen campaigns

Paradoxically, Pissarro's responses to the city became more concentrated as his images of rural life became more idyllic. His first intense urban campaign was at Rouen in 1883. He visited the city again for two lengthy periods in 1896, then once more in 1898. During visits to Lucien he painted London sites and in the later nineties and early 1900s worked in Dieppe, Le Havre and extensively on motifs of the Parisian boulevards and parks. This apparent paradox was at its most acute in 1889, when Pissarro both completed *The Gleaners* (fig. 70), one of his most harmonious 'poems of the countryside', and the *Turpitudes Sociales*, his bitterly caricatural attack on the Parisian bourgeoisie and its oppression of the lower classes.

Turpitudes Sociales was an album of twenty-eight pen-and-ink drawings made for Pissarro's British niece Esther Isaacson, with whom he had been corresponding for some time about anarchism. The album was finally bound and sent off at the very end of the year, but despite its being dated 1890, it is very much a product of 1889. That year had begun with the failure of a *coup* by General Boulanger and a stockmarket crash, but the success of the Universal Exhibition, staged to celebrate the centenary of the French Revolution and

127. C. PISSARRO, *Turpitudes Sociales: frontispiece*, 1889. Pencil, pen and ink. 31.5 × 24.5 cm. Mr Daniel Skira, Geneva.

centred on the new Eiffel Tower, stabilized the position of the Republican regime. Although Pissarro seems initially to have admired some of the sights and spectacles of the Universal Exhibition, the *Turpitudes* album uses the Eiffel Tower as a symbol of bourgeois Paris; on the frontispiece the dawning sun of anarchy rises behind it with apocalyptic force as Father Time looks on sagely (fig. 127).[209] Two images apparently intended for the album but finally replaced by slightly varied drawings give something of the album's range. *The Stockbrokers* (fig. 128) shows the steps of the Paris Bourse but, although finished, was discarded for a variant which brought the businessmen closer. This made Pissarro's caricatural treatment of their features more overt, sharpening his attack on capitalists, whom he open-handedly treated as 'Jewish' stereotypes.[210] He also discarded a finished drawing of the *Golden Calf*, another caricature of capitalism, preferring a more 'naturalistic' treatment to an adaptation of Biblical narrative. This negotiation of different possibilities reminds us that Pissarro was not at home in the genre of caricature, and he needed to find a graphic style and apposite imagery from stock conventions. *Asphyxiation* (fig. 129) remains uncompleted; it was replaced by a drawing which illuminates the bodies more and stresses the anguish of their faces. The motif, which appears to show three young women workers in their garret driven to suicide by poverty, was a topos in mid-century painting. For instance, Octave Tassaert's well-known *Unfortunate Family* (fig. 130), a suicide scene

128. C. PISSARRO, Study for *Turpitudes Sociales: The Stockbrokers*, 1889. Pencil, pen and ink. 22.5 × 18 cm. Ashmolean Museum, Oxford.

shown at the Salon of 1850, was in the Musée de Luxembourg, the national collection of modern art, throughout Pissarro's career.[211] *Turpitudes Sociales* was never published, despite its graphic character, for Pissarro prudently preferred to demonstrate his anarchist allegiance by utopian paintings rather than confrontational caricature. The importance of the album here is that it uses the city as crucible for Pissarro's strictures against capitalism and the bourgeoisie. Caricature itself is a fundamentally urban medium; it was in Rouen in 1883 that Pissarro bought Champfleury's *Histoire de la Caricature*, sharpening his fascination with graphic satire.[212] And Pissarro's drawings in the *Turpitudes*, if not based on stock caricatural motifs, derived from his own observations in the city; one of the pages of the album, the funeral cortège of a cardinal, was taken from a watercolour made in 1883 in Rouen.[213]

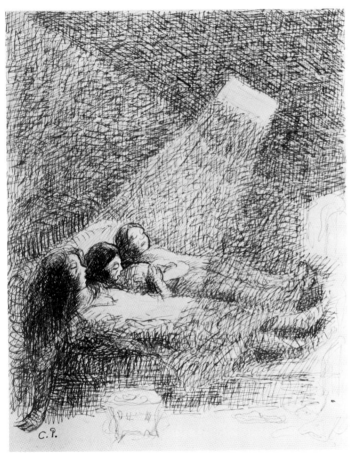

129. C. PISSARRO, Study for *Turpitudes Sociales: Asphyxiation*, 1889. Pencil, pen and ink. 23.1 × 17.7 cm. Ashmolean Museum, Oxford.

130. O. TASSAERT, *Unfortunate Family*, 1849. Oil on canvas. 115 × 76 cm. Musée d'Orsay, Paris.

109. OPPOSITE ABOVE: C. PISSARRO, *Bather in the Woods*, 1895. Oil on canvas. 60.3 × 73 cm. Metropolitan Museum of Art, New York.

124. OPPOSITE BELOW: C. PISSARRO, *Apple Picking*, *c.*1890–5? Oil on panel. 10 × 26.5 cm. Private collection.

136. C. PISSARRO, *Boieldieu Bridge, Rouen, damp weather*, 1896. Oil on canvas. 73.7 × 91.4 cm. Art Gallery of Ontario, Toronto.

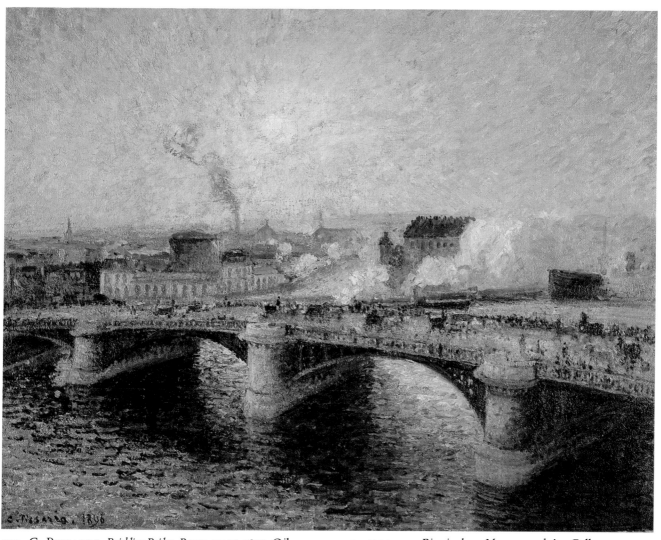

137. C. PISSARRO, *Boieldieu Bridge, Rouen, sunset*, 1896. Oil on canvas. 72.4 × 91.4 cm. Birmingham Museum and Art Gallery.

115. OPPOSITE: C. PISSARRO, *Peasant Women planting pea-sticks*, 1891. Oil on canvas. 55 × 46 cm. Private collection, on loan to Sheffield City Art Galleries.

131. T. ANCILOTTI, *The Port of Rouen*, 1878. Oil on panel. 36 × 62.5 cm. Musée des Beaux-Arts, Rouen.

Rouen preoccupied Pissarro over a period of fifteen years. It is not certain what first drew him there in autumn 1883. He greatly admired the medieval buildings and their sculptural decorations, writing enthusiastically about them to Dr de Bellio; indeed, when the municipal authorities planned to knock down an old house in 1900, Pissarro sent in a letter of protest.[214] However, his images of such subjects are chiefly confined to prints, appropriate media for the topographical tradition.[215] Whereas a contemporary such as Torello Ancilotti achieved a balance between the medieval grandeur of the city and the modern commerce of the quay (fig. 131), Pissarro's thirteen canvases of the 1883 campaign include the cathedral only three times, and then as a distant motif with the modern elements played down. He favoured the river traffic and the bustle of the wharves, and as such the Rouen paintings are at once a geographical and iconographical continuation of his earlier motifs of barges on the Seine and

Oise (figs 4, 21, 26). In his first letter from Rouen Pissarro described a quayside subject (fig. 133): 'I've begun a motif along the bank going towards the church of St Paul; looking towards Rouen, on the right all the quayside houses are lit by the morning sun, in the distance there's the stone bridge, to the left the island with its houses, factories, boats, lighters, to the right a lot of large barges in all colours' (*see* map; fig. 132). He also mentioned two paintings of the same motif, one a sunlit *effet*, the other overcast.[216] Other letters complain of the difficulties of *plein-air* work, but it seems that Pissarro needed a change of scene to continue this kind of painting, for at home he was increasingly making figure subjects in the studio. Three other paintings were made from the Quai de Paris to the east of the city centre, looking downstream or over to the factory chimneys of the Ile Lacroix,[217] Pissarro confronting industrial sites more directly

132. OPPOSITE: Map of Rouen. From K. Baedeker, *Paris and Environs*, London, 1900, between pp. 390–1.

133. C. PISSARRO, *Quai de Paris, Rouen*, 1883. Oil on canvas. 54 × 66 cm. Philadelphia Museum of Art.

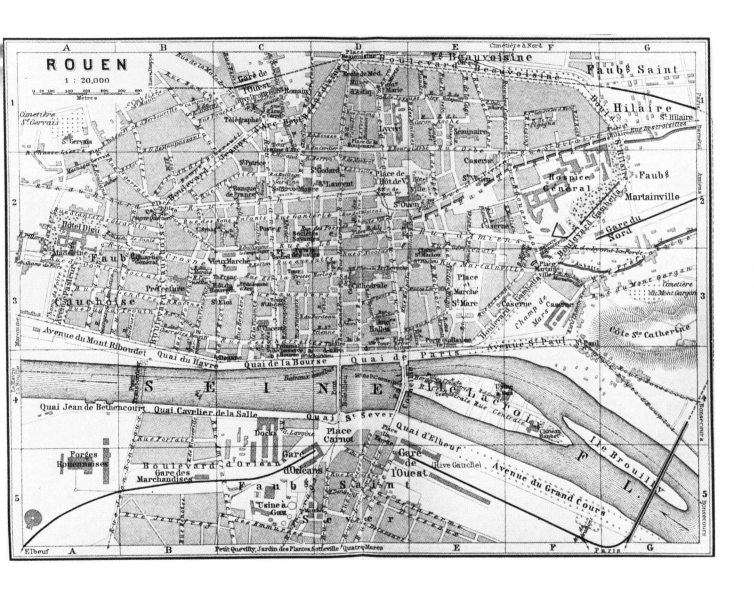

ROUEN

1 : 20,000

than he had for a decade. The 1883 Rouen campaign served both to develop Pissarro's serial *plein-air* practice and to readdress expressly modern subjects.

That fusion of modernity of technique and motif also applies to the haunting *Ile Lacroix, Rouen, mist* (fig. 134). The composition was first conceived in a drawing and etchings of 1883,[218] but only painted five years later, despite Pissarro not having visited Rouen in the meantime. The subtle simplicity of this Neo-Impressionist canvas recalls Whistler's work (fig. 135), alongside which Pissarro had shown in 1886 at the Georges Petit Gallery. Like Charles Angrand's *The Seine at Dawn* (1889; Geneva, Petit Palais), Pissarro's *Ile Lacroix*, made from memory, seems to have been a conscious attempt to marry Whistler's extreme reductiveness to the new divisionism in order to create a mood. It was in this Symbolist vein that the painting was received, Gustave Geffroy admiring 'the first forms of a town eerily looming, a pallid atmosphere vaguely coloured or discernable, far off'.[219]

Pissarro's determination to tackle the industrial city in the 1890s sets him apart

134. C. PISSARRO, *L'Ile Lacroix, Rouen, mist*, 1888. Oil on canvas. 44 × 55 cm. Philadelphia Museum of Art.

from former Impressionist colleagues such as Monet and Renoir, whose work had long ceased to confront the modern. It aligns him more closely with the Neo-Impressionist and anarchist Maximilien Luce's construction, in his contemporaneous paintings of the mines and steelworks of Charleroi, of industry as awesome and sublime, a power that should not be allowed to enslave workers but be harnessed for their benefit. For Pissarro's later Rouen paintings negotiate a balance between Impressionist observation and anarchist humanitarianism.

'I know that Old Man Pissarro's busy on Rouenneries', reported Angrand to Signac in November 1896.[220] In fact Pissarro's autumn visit was his second of the year; he had already spent the early months in Rouen. Writing to Lucien, who was honeymooning there, Pissarro had praised 'beautiful Rouen, so old and artistic. But how hideous the new quarter is, what a slap on the bourgeois' cheek . . . But so what, they've no conscience and don't care about it.'[221] If in 1883 Pissarro had concentrated on the north bank of the river, the two campaigns of 1896 and his final visit in 1898 switched focus to the southern St Sever bank, a heavily industrialized sector. Rouen was flourishing at this period; its docks handled some 5,000 ships per year, with 1.5 million tons of cargo. To facilitate traffic a new iron bridge, the Pont Boieldieu, had been erected in 1887.[222] Of the twenty-eight Rouen paintings of 1896, eleven focus on St Sever and eight on the Pont Boieldieu which led there, while only two show

the 'old and artistic' rooves and spires.[223] 'I've got effects of fog and mist, rain, sunset, overcast sky, motifs of the bridges cropped in different ways, quays with ships; but what particularly interests me is a motif of the iron bridge in wet weather [fig. 136, p. 106], with very busy traffic, vehicles, pedestrians, workers on the docks, boats, steam, mist in the distance, very vivid and active. I'm waiting for a nice little shower to put it in order.'[224] Pissarro was using the 'natural' vocabulary of *plein air* and *sensation* to describe the *Boieldieu Bridge, damp weather*, but what the motif represents is emphatically man-made; factories, gasworks, bridge, boats, crane, carts, even the smoke that puffs from so many outlets. Viewed from his hotel window, the steep perspective makes the bridge and river cross at sharp diagonals, enhancing the spectator's sense of the city's momentum; making and meaning work in harmony. If 'natural' tones of green and brown provide the canvas's coherence, it is commercial elements – yellow crates, viridian barrels, scarlet hulls – that provide the colour accents. But in a canvas of identical size Pissarro

treated the same motif in an entirely different manner. The *Boieldieu Bridge, sunset* (fig. 137, p. 107) dissolves the motif in a haze of subtle complementaries: liverish red and blanched green, grey-violet and buttery yellow. Buildings, vessels and traffic are softened by the radiance of the sunset, and the city takes on an almost visionary quality reminiscent of Turner, whose work Pissarro much admired at this time.[225] The difference between these two paintings is far more than mere *effet*. One represents the city as a bustling commercial centre, the other fuses man's active environment with the splendour of nature. Neither seems to convey antagonism to the city; rather, in their different ways, they are celebrations. Together these two imposing paintings construct contrasting accounts of Rouen. For the modern city, just as much as the country, could be worked into different fictions.

Two other paintings, one painted in 1896 and the other two years later, set up the same kind of polarity. *Misty Morning* (fig. 138) embraces the riverscape in a warm terracotta envelope; it has a more prosaic geniality than the

135. J. WHISTLER, *Nocturne: Blue and Silver – Battersea Reach*, c.1870–5. Oil on canvas. 49.9 × 76.5 cm. Freer Gallery of Art, Washington DC.

138. C. PISSARRO, *Rouen, Misty Morning*, 1896. Oil on canvas. 57.1 × 73.5 cm. Hunterian Art Gallery, University of Glasgow.

later *Sunset, Port of Rouen (smoke)* (fig. 139), in which the sinking sun throws light towards the spectator, drenching the canvas with light. The antagonism Pissarro had voiced about industrial Rouen seems to have evaporated, for in October 1896 he described such pictures looking straight across the river enthusiastically. 'I've got a motif which will make poor Mourey despair: imagine, from my window, the new quarter of Saint-Sever, straight across, with the frightful Gare d'Orléans all new and shiny, and a lot of striking chimneys, big and small. On the first plane, boats and water, left of the station the working-class quarter which runs along the quay to the iron bridge, the Pont Boieldieu; it's morning, with sun and mist. That imbecile Mourey is a brute to think that it's banal and down-to-earth. It's as beautiful as Venice.'[226] Gabriel Mourey was a Symbolist critic, and Pissarro apparently conceived these paintings as a deliberate counter to Symbolists and 'neo-catholics' who promoted more literary and fantastic subjects. For Pissarro beauty could be found in the everyday world, however banal or unpromising the motif, especially if the human elements were mollified or uplifted by the natural effects. By a careful combination of site and weather, touch and colour, Pissarro conjured out of Rouen a poem of the city.

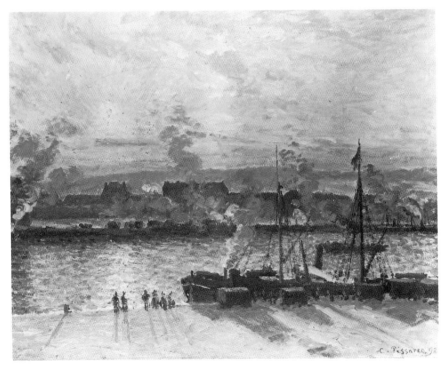

139. C. PISSARRO, *Sunset, Port of Rouen, (smoke)*, 1898. Oil on canvas. 65 × 81 cm. National Museum of Wales, Cardiff.

Afterword

Pissarro's career does not fall into easily resolved patterns. He questioned his own view of the world and his means of representing it. Writers have seen Pissarro's career in terms of stylistic shifts, oscillating from neoclassical and Barbizon conventions via *plein-air* Impressionism and then Neo-Impressionism towards the enveloping luminosity of his late work. What might be considered feeble eclecticism[228] was in fact cogent and self-critical. Pissarro adapted his handling of paint, his articulation of shape, his rendering of colour, in relation to the demands of subject and ideology, of *sensation*, and of the market. The paintings of Montfoucault have rough surfaces because, Pissarro would have us believe, that is how *sensation* led him. But he was surely also aware, in the wake of Millet's career, that the art market had certain expectations of paintings of *la vie agreste*: harsh handling suited harsh subjects. Again, if the consistent surface and unifying aura of a canvas such as *The Gleaners* was to represent late afternoon light on the Eragny downlands, they equally acted as a metaphor for the ideal of rural community so central to Pissarro's anarchist beliefs. Making and meaning acted in close conjunction with Pissarro, but they were part of a pattern of pressures – ideological, commercial, personal – which formed and re-formed the character of his work.

Equivocation was intrinsic to such a negotiation of different possibilities and pressures. Pissarro in the mid 1870s was unsure how to represent modern or industrial elements in his Pontoise landscapes and uncertain in his treatment of the figure in rural images. Twenty years on, the Rouen paintings represent the industrial city with confidence and the late peasant images construct the country populations in stylistic and moral harmony. A combination of technical experience and ideological assurance, both hard won after years of self-assessment, provided the elderly Pissarro's work with a stability not to be found in his immensely varied 'Impressionist' work of the 1870s. What underlies Pissarro's whole career, for all its equivocations and paradoxes, is his insistent recourse to nature, via the artifice of landscape painting, to construct an ideal world. That ideal shifted, of course; it might be a balance of modern and traditional, a myth of classless ruralism, a vision of the heroic city. It also required editing. Pissarro's fictional country is unthreatened by agricultural crisis or the 'modernization' of rural France; immediate concordances between his images and patterns of social change are elusive. His representations of the city are only troubled in private drawings. Response to individual *sensation*, commitment to the avant-garde, belief in an anarchist utopia, composition of the observed landscape into the painted *paysage*: these characteristics were reconciled in the work of Pissarro the idealist.

Notes

The following abbreviations have been used:

P&V: L.-R. PISSARRO/L. VENTURI, *Camille Pissarro. Son art – son oeuvre*, 2 vols, Paris, 1939.
B/L: R. BRETTELL/C. LLOYD, *Catalogue of Drawings by Camille Pissarro in the Ashmolean Museum*, Oxford, 1980.
D: L. DELTEIL, *Le Peintre-Graveur illustré. XVII. Pissarro, Sisley, Renoir*, Paris, 1923.
P: J. LEYMARIE/M. MELOT, *The Graphic Works of the Impressionists*, London, 1972.
Corres. I: *Correspondence de Camille Pissarro. I, 1865–1885*, ed. J. BAILLY-HERZBERG, Paris, 1980.
Corres. II: Ibid, II, 1886–1890, Paris, 1986.
Corres. III: Ibid, III, 1891–1894, Paris, 1988.
Lettres: *Camille Pissarro. Lettres à son fils Lucien*, ed. J. REWALD, Paris, 1950.
Courtauld neg. refers to a photographic archive of Pissarro works, mainly untraced drawings, held in the Witt Library, Courtauld Institute, London University.

1. *A Day in the Country*, 1984–5; Clark, 1985; *The New Painting*, 1986; Herbert, 1988.
2. *Pissarro*, 1980–1; Adler, 1979; Shikes/Harper, 1980; B/L; *Corres. I, II, III*.
3. House, in Lloyd (ed.), 1986, p. 32.
4. Williams, 1973.
5. For Pissarro's early years see Shikes/Harper, 1980, pp. 17–62.
6. For drawings of historical landscapes see *Dante and Virgil entering Hell* (Sotheby's, 29 June 1977, no. 315) and a sheet attributed to Pissarro, Yale University Art Gallery, 1973. 132.

7. Ackerman, 1977, p. 129.
8. Zeldin, 1973, p. 553.
9. Weber, 1977.
10. Herbert, 1970, pp. 44–5; Magraw, 1983, p. 321.
11. Magraw, 1983, p. 324.
12. J. Horne, 'The Peasant in 19th. Century France' in *The Peasant in French 19th. Century Art*, 1980, p. 23.
13. Magraw, 1983, p. 325.
14. Ackerman, 1977.
15. Philipponeau, 1956, p. 69.
16. *Lighting up the Landscape*, 1986, p. 78.
17. *Corres. III*, Letter 667, to Lucien, 10 June 1891, p. 94.
18. Maillet (pref.) letter of 7 July 1898, n.p; *Corres. III*, Letter 775, to Lucien, 25 April 1892, p. 219.
19. House, in Lloyd (ed.), 1986, pp. 20–5.
20. *Corres. III*, Letter 936, to Lucien, 28 September 1893, p. 374.
21. *Corres. III*, Letter 930, to Lucien, 15 September 1983, p. 368.
22. *Lettres*, 1950, 4 December 1895, p. 391.
23. *Corres. I*, Letter 202, to Lucien, 25 December 1883, p. 264; *Corres. II*, Letter 306, to Lucien, January 1886, p. 15. For 'sensation' and 'synthèse' see Shiff, 1984; Shiff, *Art Bulletin*, 1984; House, in Lloyd (ed.), 1986.
24. Shikes/Harper, 1980, p. 64.
25. Bailly-Herzberg (ed.), 1985, pp. 13–14; for the suppression of the Commune see Piette's letter to Pissarro, 30 January 1872, p. 72.
26. For example *Corres. I*, Letter 166, to Lucien, 5 July 1883, p. 227.
27. For Pissarro and politics see *inter alia* Nicolson, 1946; Fermigier, 1972; Lloyd, 1975; Shikes/Harper, 1980, chap. 18; Thorold, 1980; Thomson, *Arts Magazine*, 1982; Hutton, 1987.
28. *Corres. III*, Letter 774, to Mirbeau, 21 April 1892, p. 217.
29. Mirbeau, 1891, p. 83.

30. Duhem, 1903, p. 190.
31. Herbert, 1970; *Théodore Rousseau*, 1982.
32. Lecomte, 1892, p. 79.
33. Gsell, 1892; quoted in House, *Monet*, 1986, p. 156.
34. *Lighting up the Landscape*, 1986, no. 9.
35. Although known as *Barges on the Marne* and dated *c*.1864, the painting represents the same cliffs alongside the river as *Donkey Ride at La Roche-Guyon* (P&V 45; England, private collection). Pissarro worked at La Roche-Guyon in autumn 1865.
36. See also *Banks of the Marne at Chennevières*, Salon, 1865 (P&V 46; Edinburgh, National Gallery of Scotland); *A Square at La Roche-Guyon*, *c*.1865 (P&V 49; Berlin, Neue Nationalgalerie); *Still-Life* 1867 (P&V 50; Toledo Museum of Art).
37. Hellebranth, 1976, nos 222 (1859), 223, 228, (1864), 229 (1868), 232 (1870), 236 (1874), 238 (1876), 239 (1877), 240 (1878).
38. Herbert, in Merriman (ed.), 1982, p. 147.
39. Brettell, 1977, pp. 131–3.
40. *Corres. I*, pp. 29–32; *A Day in the Country*, 1984–5, p. 80.
41. P&V 17, 24.
42. *De Renoir à Vuillard*, 1984; *A Day in the Country*, 1984–5, pp. 79–107; Clark, 1985, pp. 147–204; Herbert, 1988, pp. 195–264.
43. Herbert, 1988, p. 196.
44. Goncourt, 1956, I, p. 205.
45. *Retrospective Camille Pissarro*, 1984, p. 15.
46. Gould, 1966.
47. *Corres. I*, letter of 6 November 1870, p. 17; Shikes/Harper, 1980, pp. 87–9.
48. See Félicie Estruc's letter, 10 March 1871 (*Corres. I*, pp. 69–70, n. 7) and Pissarro's correspondence with the landlord M. Retrou, Letter 12, late March 1871, pp. 68–70 and p. 68, n. 1.
49. Howard, 1961, p. 329; Dayot, p. 72.

50. See for example interpretations of Monet in Tucker, 1982, pp. 57–62; Tucker, 1984.
51. For the uncertainty of Pissarro's dating at this period see Brettell in *Camille Pissarro*, 1980–1, p. 19. Pissarro painted two similar views, one apparently calm and verdant (P&V 90), the other seemingly devastated (not in P&V; with Kornfeld und Klipstein, Bern, November 1972).
52. Apart from the four paintings discussed, other riverside paintings are P&V 65, 124 (perhaps a pair) and P&V 95 (Tokyo, Bridgestone Museum of Art).
53. 'Villemer', 1867, pp. 149–50; Herbert, 1988, pp. 210–19.
54. Barron, 1886, pp. 480–1; Herbert, 1988, p. 202.
55. Brettell, 1977, p. 205.
56. Pissarro painted this motif twice again: P&V 64 (1868); P&V 152 (1872), of which he made an etching, D.8.
57. The other was P&V 58 (New York, Guggenheim Museum).
58. *Camille Pissarro*, 1980–1, no. 9.
59. Zola, 'Mon Salon', *L'Evénement illustré*, 19 May 1868 (from Zola, 1974, p. 109).
60. Brettell, 1977, pp. 55–6.
61. Brettell, 1977, pp. 39–40.
62. Brettell, 1977, p. 41.
63. Philipponeau, 1956, pp. 66–7.
64. Brettell, 1977, pp. 52–9.
65. Brettell, 1977, pp. 49–51.
66. For Daubigny see Herbert, in Merriman (ed.), 1986, p. 147, and for Monet Tucker, 1982, p. 11.
67. P&V 163, 184–5 (1872); P&V 220, 223–5, 233, 235 (1873); P&V 415 (1877).
68. Brettell, 1977, pp. 60–1.
69. Brettell, 1977, pp. 62, 172–3.
70. Brettell, 1977, pp. 173–4.
71. *Corres. I*, Letter 108, to Monet, 18 September 1882, p. 165.
72. For the renovation of old properties see Brettell, 1977, p. 84.
73. P&V 214, 215, 217. Brettell, 1977, pp. 137–56.
74. P&V 353–4, 355–6. Brettell, 1977, pp. 157–64.

75. *The New Painting*, 1986, p. 160.

76. *The New Painting*, 1986, p. 206. P&V 151, 183–6 (1872) are the other Pontoise panoramas.

77. *Corres. I*, Letter 183, to Lucien, 22 October 1883, p. 243; *Lettres*, 1950, 17 June 1899, p. 469. As a student Pissarro would have studied the perspective necessary to produce panoramas, and panoramic perspective grids appear in his later sketchbooks: see Courtauld neg. no. 52/59/28.

78. His important tempera *The Harvest* (P&V 1358) shows such a large property dominating the landscape: see *Impressionist Drawings*, 1986, p. 47.

79. Tucker, 1982, pp. 181, 183–5.

80. *Corres. III*. Letter 666, to Lucien, 21 May 1891, p. 9; ibid, Letter 768, to Durand-Ruel, 21 March 1892, p. 210.

81. Sickert, 'French Pictures and Knoedler's Gallery', *Burlington Magazine*, July 1923 (from Sickert, 1947, p. 157).

82. Ephrussi, 1880, p. 487.

83. *Corres. I*, Letter 37, to Duret, 20 October 1874, p. 95.

84. *Corres. I*, p. 74, n.b. Pissarro inscribed on the verso of P&V 39 that it had been made at Montfoucault in 1864.

85. I am most grateful to M. Pierre du Pontavice, Mayor of Melleray, for showing me the local archives and the Montfoucault property in August 1988.

86. For Piette see Bailly-Herzberg (ed.), 1985, pp. 9–14.

87. Bailly-Herzberg (ed.), 1985, pp. 121–2 (letter of late 1875).

88. Bailly-Herzberg (ed.), 1985, p. 101 (letter of January 1874).

89. *Corres. I*, Letter 38, to Duret, 11 December 1874, p. 96.

90. *Corres. I*, letter from Duret, 14 December 1874, p. 96, n. 3.

91. P&V 269, 285, 287 show the house; P&V 278, 280–1, 283, 294 the farmyard; P&V 268, 275, 1525, 1527, 1530 the pond; P&V 274, 284, 286 the outskirts of the farm; P&V 279, 282 the more distant fields.

92. P&V 276, 277. P&V 271 and 288 are compositions with major figures, both named peasant women.

93. Shiff, *Art Bulletin*, 1984, p. 688, has suggested Pissarro was concerned with 'coloured greys' in *Piette's House at Montfoucault* (fig. 44).

94. *Corres. I*, Letter 21, to Duret, 2 May 1873, p. 80.

95. Segalen, 1983, esp. chap. 3.

96. P&V 1529.

97. P&V 330–1.

98. P&V 317, 318, 329.

99. E.g. P&V 320, 323–4, 329.

100. P&V 363–4; 367–8.

101. Delteil, 1921, no. 94; *Lhermitte*, 1974, p. 19; Hamerton, 1892, p.47.

102. Brettell, 1977, p. 102.

103. P&V 367–8, 413, 680; P&V 1528–9; B/L 80, 243A/B, 245, 342, 376–8.

104. For Pissarro and *Le Jour et la Nuit* see *Camille Pissarro*, 1980–1, p. 192, and nos 156–61.

105. *The New Painting*, 1986, p. 248.

106. *Corres. I*, letter from Durand-Ruel, 23 October 1884, p. 316, n. 1.

107. House, *Monet*, 1986, p. 25.

108. See *inter alia* Jampoller, 1986; *Impressionist Drawings*, 1986, pp. 39, 42.

109. Fouquier, 1886; Huysmans, 1887, p. 353.

110. E.g. Bigot, 1882, p. 282, condemned him as derivative, while 'Labruyère', 1886, defended him against the charge. Huysmans changed his position from 1881 to 1882; see Huysmans (ed. Juin), 1975, pp. 237, 265. The debate continued in the 1890s; see Geffroy, 1890 and H. Van de Velde, 'Du Paysan en Peinture', *L'Art Moderne*, 22 February 1891 (*Henry Van de Velde*, 1987–8, pp. 236–8).

111. Mirbeau, 1886; also 'Labruyère', 1886.

112. For this complexity see *inter alia* R./C. Brettell, 1983; Pollock, 1984; Burns, 1984, pp. 11–13.

113. Burns, 1984, p. 12.

114. Price, 1987, p. 101; Menard, 1987, pp. 5, 7.

115. Menard, 1987, pp. 6, 2.

116. Menard, 1987, p. 19.

117. Breton, 1982–3, p. 7; *Lhermitte*, 1974, p. 25.

118. Anon. [H. Leroux], 1886.

119. *Corres. II*, Letter 342, to Leroux, late July 1886, p. 57.

120. *Corres. III*, Letter 774, to Mirbeau, 21 April 1892, p. 217.

121. *Corres. II*, Letter 419, to Lucien, 2 May 1887, p. 157; *Corres. I*, Letter 100, to Duret, 12 March 1882, p. 158.

122. *Corres. II*, Letter 424, to Lucien, 16 May 1887, p. 169.

123. *Corres. I*, Letter 224, to Lucien, early March 1884, p. 293. The woodcuts were Delteil, 1906, nos 32–4; see B/L, p. 18, n. 20.

124. *Corres. III*, Letter 1066, to Lucien, 5 November 1894, p. 503.

125. *Sensier*, 1881, p. 297, repr.

126. *Corres. II*, Letter 558, to Georges, 17 December 1889, p. 313.

127. *Camille Pissarro*, 1980–1, pp. 27–8.

128. *Corres. I*, Letter 144, to Lucien, 4 May 1883, p. 202.

129. P&V 541; *Corres. I*, Letter 100, to Duret, 12 March 1882, p. 157.

130. *Corres. I*, Letter 164, to Lucien, 25 June 1883, p. 224; ibid., Letter 167, 8? July 1883, p. 229. Lucien's copies after Egyptian frescoes, Holbein, and Clouet are in the Ashmolean Museum.

131. Shikes/Harper, 1980, p. 138, p. 339, n. 138; *Camille Pissarro*, 1980–1, no. 214; Thomson, 1983.

132. Herbert, 1970, p. 52; R./C. Brettell, 1983, p. 49; *The New Painting*, 1986, p. 386; House, in Wilmerding (ed.), 1986, p. 158.

133. Segalen, 1983, pp. 138–9.

134. E.g. at Bennecourt: Ackerman, 1977, p. 128.

135. There are only two images from this period of women feeding babies (P&V 1366, 1616); one an interior, the other out-of-doors; neither breast-feeds. (The Pissarros had lost a baby in 1870 from an infection transmitted by a wet nurse.)

136. *Corres. II*, Letter 423, to Lucien, 15 May 1887, p. 167.

137. Courtauld neg. no. 52/43/32a–33.

138. Thomson, 1980, p. 260.

139. Courtauld neg. no. 52/26/27a.

140. *Corres. II*, Letter 480, to Lucien, 28 April 1888, p. 227.

141. *Corres. II*, Letter 536, to Lucien, 12 August 1889, p. 288.

142. *Corres. II*, Letter 538, to Theo van Gogh, 2 September 1889, p. 289.

143. *Corres. II*, Letter 544, to Julie, 28 September 1889, pp. 297–8.

144. For a different reading see Nochlin, in Lloyd (ed.), 1986, p. 9.

145. Aurier, 1890, p. 512.

146. Weber, 1977, p. 129n.

147. *Millet*, 1975–6, no. 65; Chamboredon, 1977, pp. 15–16.

148. P&V 178, 188, 449.

149. Lloyd, 1985, pp. 23–4.

150. P&V 1372; Brettell, 1977, p. 219.

151. *Camille Pissarro*, 1980–1, p. 29; R./C. Brettell, 1983, pp. 132–3; Lloyd, 1985; Nochlin, in Lloyd (ed.), 1986, p. 6.

152. *Camille Pissarro*, 1980–1, p. 29.

153. Thomson, *Burlington Magazine*, 1982, p. 163.

154. *Camille Pissarro*, 1980–1, no. 60.

155. *Corres. I*, Letter 276, to Durand-Ruel, early June 1885, p. 335; undated letter from Gauguin to Pissarro, *Archives*, 1975, no. 53.

156. The study is in the Fogg Art Museum: *Camille Pissarro*, 1980–1, no. 137. Another related drawing is Courtauld neg. no. 52/21/44a–45.

157. For existing accounts see B/L pp. 51–2; *Camille Pissarro*, 1980–1, nos 186–9; Lloyd, *Print Quarterly*, 1985.

158. *Corres. II*, Letter 591, to Georges, 22 October 1893, p. 389.

159. *Corres. III*, Letter 1080, to Lucien, 14 December 1894, p. 521.

160. *Lettres*, 1950, 18 January 1895, p. 363.

161. Mirbeau, 'Camille Pissarro', *Le Figaro*, 1 February 1892 (quoted from Mirbeau, 1922, p. 152).

162. Aurier, 1890, p. 506.

163. B. Thomson, 1982.

164. Gsell, 1892. Quoted from House, *Monet*, 1986, p. 156.

165. Déroulède, 1894: 'Préface', p. i; 'Moissons', p. 11; 'Machine à battre', pp. 15–16.

166. Breton, 1982–3, p. 22 (quoted from J. Breton, *La Vie d'un Artiste: Art et Nature*, Paris, 1890, p. 280).

167. Breton, 1982–3, p. 20.

168. Lhermitte, 1974, pp. 17–19.

169. See the discussion by House, in Wilmerding (ed.), 1986, pp. 166–7.

170. *Corres. I*, Letter 222, to Lucien, 1 March 1884, p. 291.

171. P&V 631, 632 (snow), 633, 634 (fog).

172. *Corres. III*, Letter 737, to Lucien, 28 December 1891; Letter 847, to Esther Isaacson, 9 December 1892, pp. 284–5; Letter 950, to Lucien, 17 October 1893, p. 388.

173. *Corres. II*, Letter 348, to Lucien, 30 July 1886, p. 64. For Durand-Ruel and Millet's farmyards see Murphy, 1984, nos 101, 138.

174. For examples of this group see Thomson, 1980, p. 261 and p. 263, nn. 33–5.

175. *Corres. III*, Letter 661, to Lucien, 13 May 1891, p. 81.

176. Fig. 54 served as a study for P&V 753. *From Delacroix to Cézanne*, 1977, no. 24; *Caillebotte*, 1989, nos 7–13.

177. *Corres. III*, Letter 651, to Lucien, 8 April 1891, p. 57.

178. Huysmans, 'Le Salon de 1879' (in Huysmans, *L'Art Moderne*, ed. Juin, 1975, pp. 35–6).

179. For life drawings see B/L 36 recto/verso, 37, 38 recto. For the memory studies see Lloyd, Princeton, 1982, p. 6; p. 13, n. 13.

180. For the private drawings see Courtauld neg. no. 52/25/18–19 (Julie); B/L 175C recto/verso, 175E, 210D; Courtauld neg. no. 53/32/2a–3. The painting is P&V 376; for the drawings in the letter (*Corres. I*, Letter 225, to Lucien, 9 March 1884, p. 225) see House, *Monet*, 1986, p. 39.

181. *Corres. III*, Letter 905, to Lucien, 3 July 1893, p. 341.

182. House, in Wilmerding (ed.), 1986, p. 25.

183. B/L 258 (Lucien); for Pissarro himself see *Pissarro and Pontoise*, 1981, no. 36 repr.

184. *Corres. III*, Letter 979, to Lucien, 21 January 1894, p. 420.

185. *Corres. III*, Letter 1001, to Lucien, 19 April 1894, p. 445.

186. Shapiro/Melot, 1975.

187. Weber, 1977, pp. 147–8.

188. Van Liere, 1980.

189. Thomson, *Burlington Magazine*, 1982, p. 164.

190. *Corres. III*, Letter 1086, to Georges, 27 December 1894, p. 527.

191. *Corres. III*, Letter 1087, to Lucien, 27 December 1894, p. 528.

192. E.g *Corres. III*, Letter 1078, to Lucien, 6 December 1894, p. 519; n. 185 above.

193. *Lettres*, 1950, 11 April 1895, pp. 376–7.

194. *Lettres*, 1950, 20 October 1895, p. 385.

195. *Corres. II*, Letter 609, to Lucien, 19 December 1890, p. 376.

196. *Camille Pissarro*, 1980–1, p. 36, no. 212; Thomson, 1981, p. 190; *Impressionist Drawings*, 1986, p. 35.

197. P&V 1954; B/L 276; drawings sold Sotheby's, 29 June 1977, no. 216 and Sotheby Parke Bernet, 12 May 1977, no. 217.

198. H. Van de Velde, 'Du Paysan en Peinture', *L'Art Moderne*, 22 February 1891 (quoted in *Van de Velde*, 1987–8, pp. 236–8).

199. For *Travaux des Champs* see B/L, pp. 66–85; *Camille Pissarro*, 1980–1, nos 203–8.

200. *Corres. III*, Letter 504, to Lucien, 4 September 1888, p. 249; B/L 70.

201. P.199, 200, 204.

202. *Corres. III*, Letter 934, to Lucien, 23 September 1893, pp. 372–3.

203. For *Il était une bergère* see *Impressionist Drawings*, 1986, p. 46, nos 61a–d.

204. P.205; B/L 376–8.

205. Bailly-Herzberg (ed.), 1985, p. 133; Shikes/Harper, 1980, p. 138, p. 339, n. 138; *Camille Pissarro*, 1980–1, no. 214.

206. *Corres. II*, Letter 314, to Lucien, c.16 February 1886, p. 26.

207. B/L 308–9.

208. P&V 691–2, 931; D.183.

209. Fermigier, 1972; Thomson, *Arts Magazine*, 1982; Hutton, 1987.

210. Nochlin, 1987–8, p. 98.

211. See also Breton's *La Faim* (1850: destroyed), repr. Breton, 1982–3, fig. 10.

212. *Corres. I*, Letter 219, to Lucien, 17 February 1884, p. 287.

213. Thomson, *Arts Magazine*, 1982, pp. 85–6.

214. *Corres. III*, Letter 1091, to de Bellio, 8 November 1883, p. 535; letter from Angrand to Signac, April 1900, in Lespinasse (ed.), 1988, p. 121.

215. Lloyd, 1986, p. 76.

216. P&V 602–3; *Corres. I*, Letter 180, to Lucien, 11 October 1883, p. 238.

217. P&V 604, 605, 607.

218. B/L 287; P.131; D.69.

219. Geffroy, 1890.

220. Lespinasse (ed.), 1988, p. 75 (letter of November 1896).

221. *Corres. II*, Letter 811, to Lucien, 19 August 1892, p. 253.

222. Lloyd, 1986, p. 86.

223. P&V 954–5, 957–60, 965, 967–70 (St Sever); P&V 948–53, 956, 964 (Pont Boieldieu); P&V 947, 973 (old city).

224. *Lettres*, 1950, 26 February 1896, p. 400.

225. For Pissarro's admiration for Turner see, for example, *Corres. III*, Letter 1017, 23 June 1894, p. 463.

226. *Lettres*, 1950, 2 October 1986, p. 419.

227. *Lettres*, 1950, 11 November 1896, p. 426.

228. Lanes, 1965.

Bibliography

E. ACKERMAN, 'Alternative to Rural Exodus: The Development of the Commune of Bonnières-sur-Seine in the Nineteenth Century', *French Historical Studies*, vol. X, no. 1, Spring 1977, pp. 126–48.

K. ADLER, *Camille Pissarro: a biography*, London, 1978.

ANON. [H. LEROUX] 'L'Exposition des Impressionnistes', *La République Française*, 17 May 1886.

Archives de Camille Pissarro, Paris, Hôtel Drouot, 21 November 1975.

M.-M. AUBRUN, *Jules Bastien-Lepage, 1848–1884. Catalogue raisonné de l'oeuvre*, Paris, 1985.

A. AURIER, 'Camille Pissarro', *Revue Indépendante*, sér. 3, no. 14, March 1890, pp. 503–15.

J. BAILLY-HERZBERG, 'Camille Pissarro et Rouen', *L'Oeil*, no. 312, July–August 1981, pp. 54–9.

J. BAILLY-HERZBERG (ed.), *Mon cher Pissarro: Lettres de Ludovic Piette à Camille Pissarro*, Paris, 1985.

L. BARRON, *Les Environs de Paris*, Paris, 1886.

C. BIGOT, 'Beaux-Arts. Les Petits Salons . . . L'Exposition des Artistes Indépendants', *La Revue Politique et Littéraire*, 3 sér., no. 9, March 1882, pp. 281–2.

Jules Breton and the French Rural Tradition, Omaha, Nebraska, Joslyn Art Museum, November 1982–January 1983.

R. BRETTELL, 'Pissarro and Pontoise: the Painter in a Landscape', unpublished Ph.D. thesis, Yale University, 1977.

R. and C. BRETTELL, *Painters and Peasants in the Nineteenth Century*, Geneva, 1983.

M. BURNS, *Rural Society and French Politics. Boulangism and the Dreyfus Affair, 1886–1900*, Princeton, 1984.

Gustave Caillebotte, 1848–1894. Dessins, Etudes, Peintures, Paris, Brame et Lorenceau, February–March 1989.

A. CALLEN, *Techniques of the Impressionists*, London, 1982.

J.-C. CHAMBOREDON, 'Peinture des rapports sociaux et invention de l'éternel paysan: les deux manières de Jean-François Millet', *Actes de la Recherche en Sciences Sociales*, 17/18, November 1977, pp. 6–28.

T. J. CLARK, 'The Productions of the Press', *Times Literary Supplement*, 11 April 1975, p. 401.

T. J. CLARK, *The Painting of Modern Life. Paris in the Art of Manet and his Followers*, London, 1985.

A Day in the Country. Impressionism and the French Landscape, Los Angeles / Chicago / Paris, 1984–5.

A. DAYOT, *L'Invasion: Le Siège, 1870: La Commune, 1871*, Paris, n.d.

From Delacroix to Cézanne. French Watercolour Landscapes of the Nineteenth Century, University of Maryland Art Gallery, October–November 1977.

L. DELTEIL, *Le Peintre-Graveur Illustré. I. J.-F. Millet . . .*, Paris, 1906.

L. DELTEIL, *Le Peintre-Graveur Illustré. Daubigny*, Paris, 1921.

P. DEROULEDE, *Chants du Paysan*, Paris, 1894.

H. DUHEM, 'Camille Pissarro; souvenirs', in *Impressions d'art contemporain*, Paris, 1913, pp. 187–94.

C. EPHRUSSI, 'Exposition des Artistes Indépendants', *Gazette des Beaux-Arts*, pér.2, XXI, pp. 485–8.

F. FAGUS, 'Gazette d'Art. Exposition Pissarro'. *Revue blanche*, XXIV, January–April 1901, pp. 222–3.

A. FERMIGIER, 'Pissarro et l'Anarchie', in *Turpitudes Sociales*, Geneva, 1972.

M. FLEMING, *The Anarchist Way to Socialism. Elisée Reclus and Nineteenth Century European Anarchism*, Totowa/London, 1979.

M. FOUQUIER, 'Les Impressionnistes', *Le XIXe Siècle*, 16 May 1886.

G. GEFFROY, 'Camille Pissarro', *La Justice*, 15 February 1890.

E. & J. DE GONCOURT, *Journal. Mèmoires de la Vie Littéraire*, 22 vols, ed. R. Ricatte, Monaco, 1956.

C. GOULD, 'An Early Buyer of French Impressionists in England', *Burlington Magazine*, CVIII, no. 765, March 1966, pp. 141–2.

P. GSELL, 'La Tradition artistique française; I. L'Impressionnisme', *La Revue Politique et Littéraire*, XLIX, 26 March 1892, p. 404.

P. G. HAMERTON, *The Present State of the Fine Arts in France*, London, 1892.

R. HELLEBRANTH, *Charles-François Daubigny, 1817–1878*, Morges, 1976.

R. L. HERBERT, 'City vs. Country: the Rural Image in French Painting from Millet to Gauguin', *Art Forum*, vol. VIII, February 1970, pp. 44–55.

R. L. HERBERT, 'Industry in the Changing Landscape from Daubigny to Monet', in J. Merriman (ed.), *French Cities in the 19th. Century*, London, 1982, pp. 139–64.

R. L. HERBERT, *Impressionism. Art, Leisure and Parisian Society*, London/New Haven, 1988.

Homage to Camille Pissarro: The Last Years, 1890–1903, Memphis, Dixon Gallery and Gardens, May–June 1980.

J. HOUSE, *Monet: Nature into Art*, London, 1986.

J. HOUSE, 'Camille Pissarro's idea of unity', in C. Lloyd (ed.), *Studies on Camille Pissarro*, London, 1986, pp. 15–34.

J. HOUSE, 'Camille Pissarro's *Seated Peasant Woman*: the Rhetoric of Inexpressiveness', in *Essays in Honour of Paul Mellon*, ed. J. Wilmerding, Washington, 1986, pp. 154–71.

M. HOWARD, *The Franco-Prussian War*, London, 1961.

J. HUTTON, 'Camille Pissarro's *Turpitudes Sociales* and Late Nineteenth Century French Anarchist Anti-Feminism', *History Workshop*, no. 24, Autumn 1987, pp. 32–61.

J.-K. HUYSMANS, 'Chronique d'Art. L'Exposition Internationale de la Rue de Sèze', *Revue Indépendante*, n.s., III, no. 8, June 1887, pp. 345–55.

J.-K. HUYSMANS, *L'Art Moderne. Certains*, (ed. H. Juin), Paris, 1975.

Impressionist Drawings from British Public and Private Collections, Oxford/Manchester/Glasgow, 1986.

L. JAMPOLLER, 'Theo van Gogh and Camille Pissarro; correspondence and an exhibition', *Simiolus*, vol. 16, no. 1, 1986, pp. 50–61.

'LABRUYERE', 'Les Impressionnistes, II', *Le Cri du Peuple*, 26 May 1886.

J. LANES, 'Loan Exhibition at Wildenstein', *Burlington Magazine*, CVII, no. 746, May 1965, pp. 275–6.

A. LANT, 'Purpose and Practice in French Avant-Garde Print-making of the 1880s', *Oxford Art Journal*, vol. 6, no. 1, 1983, pp. 18–29.

G. LECOMTE, *L'Art Impressionniste d'après la collection privée de M. Durand-Ruel*, Paris, 1892.

F. LESPINASSE (ed.), *Charles Angrand. Correspondances, 1883–1926*, Rouen, 1988.

Léon Lhermitte (1844–1925), Oshkosh, Wisconsin, Paine Art Center and Arboretum, September–November 1974.

Lighting up the Landscape. French Impressionism and its Origins, Edinburgh, National Gallery of Scotland, August–October 1986.

C. LLOYD, 'Camille Pissarro and Hans Holbein the Younger', *Burlington Magazine*, CXVII, November 1975, pp. 722–6.

C. LLOYD, 'Camille Pissarro and Japonisme', in *Japonisme in Art. An International Symposium*,

ed. Y. Chisaburo, Tokyo, 1980, pp. 173–88.

C. LLOYD, *Camille Pissarro*, Geneva, 1981.

C. LLOYD, 'Camille Pissarro: towards a reassessment', *Art International*, XXV, 1–2, January 1982, pp. 59–66.

C. LLOYD, 'Camille Pissarro at Princeton', *Record of the Art Museum, Princeton University*, vol. 41, no. 1, pp. 16–32.

C. LLOYD, 'The Market Scenes of Camille Pissarro', *Art Bulletin of Victoria*, no. 25, 1985, pp. 16–32.

C. LLOYD, 'An Uncut Woodcut by Lucien Pissarro', *Print Quarterly*, vol. 2, no. 4, 1985, pp. 309–14.

C. LLOYD (ed.), *Studies on Camille Pissarro*, London, 1986. Ibid., 'Camille Pissarro and Rouen', pp. 75–93.

R. MAGRAW, *France, 1815–1914. The Bourgeois Century*, London, 1983 (third ed., 1988).

E. MAILLET (pref.), *Quatorze Lettres de Julie Pissarro*, Pontoise/La Ferté-Milon, 1984.

M. MELOT, 'La Pratique d'un artiste: Pissarro graveur en 1880', *Histoire et Critique des Arts*, no. 2, 1977, pp. 14–38.

C. MENARD, 'Cinq Villages en Vexin Français, 1876–1976', *Société Historique et Géographique du Bassin de l'Epte: Dossiers*, no. 2, Gisors, 1987, pp. 3–19.

Jean-François Millet, (1814–1875), Paris, Grand Palais, October 1975–January 1976.

Millet's 'Gleaners', Minneapolis Institute of Arts, April–June 1978.

O. MIRBEAU, 'Exposition de Peinture. 1, rue Lafitte', *La France*, 21 May 1886.

O. MIRBEAU, 'Camille Pissarro', *L'Art dans les Deux Mondes*, no. 8, 10 January 1891, pp. 83–4.

O. MIRBEAU, *Des Artistes*, I, Paris, 1922.

Modern British Woodcuts and Wood-Engravings in the Collection of the Whitworth Art Gallery, Manchester, 1962.

A. MURPHY, *Jean-François Millet*, Boston, Museum of Fine Arts, 1984.

The New Painting: Impressionism, 1874–1886, Washington/San Francisco, 1986.

B. NICOLSON, 'The Anarchism of Camille Pissarro', *The Arts*, no. 2, 1946, pp. 43–51.

L. NOCHLIN, 'Camille Pissarro: the unassuming eye', in C. Lloyd (ed.), *Studies on Camille Pissarro*, London, 1986, pp. 1–14.

L. NOCHLIN, 'Degas and the Dreyfus Affair: a Portrait of the Artist as an Anti-Semite', in *The Dreyfus Affair: Art, Truth and Justice*, New York, Jewish Museum, September 1987–January 1988, pp. 96–116.

The Painterly Print. Monotypes from the Seventeenth to the Twentieth Century, New York/Boston, 1980–1.

The Peasant in French 19th. Century Art, Dublin, Douglas Hyde Art Gallery, October–November 1980.

M. PHILIPPONEAU, *La Vie Rurale de la Banlieue Parisienne*, Paris, 1956.

R. PICKVANCE, 'La Grenouillère', in J. Rewald/F. Weitzenhoffer (eds), *Aspects of Monet*, New York, 1984, pp. 36–51.

Pissarro in England, London, Marlborough Gallery, June–July 1968.

Camille Pissarro, 1830–1903, London/Paris/Boston, 1980–1.

Pissarro & Pontoise, Pontoise, Musée Pissarro, November 1980–January 1981.

Retrospective Camille Pissarro, Tokyo/Fukuoka/Kyoto, 1984.

G. POLLOCK, 'Revising or reviving Realism?', *Art History*, vol. 7, no. 3, September 1984, pp. 359–68.

Pontoise du XVIIe siècle à la fin du XIXe, Pontoise, Musée de Pontoise, May–September 1988.

Post-Impressionism. Cross-Currents in European Painting, London, Royal Academy, November 1979–March 1980.

R. PRICE, *A Social History of Nineteenth Century France*, London, 1987.

B. RECCILONGO, *Camille Pissarro. Grafica Anarchica*, Rome, 1981.

De Renoir à Vuillard. Marly-le-Roi, Louveciennes, leurs environs, Musée Promenade de Marly-le-Roi-Louveciennes, March–June 1984.

J. ROSENSAFT, 'Le Néo-Impressionnisme de Camille Pissarro', *L'Oeil*, no. 223, February 1974, pp. 52–7, 75.

Théodore Rousseau, 1812–1867, Norwich/London, 1982.

M. SEGALEN, *Love and Power in the Peasant Family. Rural France in the Nineteenth Century*, Oxford, 1983.

A. SENSIER, *La Vie et l'Oeuvre de Jean-François Millet*, Paris, 1881.

B. SHAPIRO, *Camille Pissarro. The Impressionist Printmaker*, Boston, Museum of Fine Arts, 1973.

B. SHAPIRO/M. MELOT, 'Les Monotypes de Camille Pissarro', *Nouvelles de l'Estampe*, XIX, January-February 1975, pp. 16–23.

R. SHIFF, *Cézanne and the End of Impressionism*, Chicago, 1984.

R. SHIFF, 'Review Article' (of recent Pissarro publications), *Art Bulletin*, LXVI, no. 4, December 1984, pp. 681–90.

R. SHIKES/P. HARPER, *Camille Pissarro. His Life and Work*, London, 1980.

W. SICKERT, *A Free House! . . . The Writings of Walter Richard Sickert*, ed. O. Sitwell, London, 1947.

B. THOMSON, 'Camille Pissarro and Symbolism; some thoughts prompted by the recent discovery of an annotated article', *Burlington Magazine*, CXXIV, no. 946, January 1982, pp. 14–21, 23.

R. THOMSON, 'Drawings by Camille Pissarro in Manchester Public Collections', *Master Drawings*, XVIII, no. 3, Autumn 1980, pp. 257–63.

R. THOMSON, 'Camille Pissarro and the Figure', *The Connoisseur*, vol. 207, no. 833, July 1981, pp. 187–90.

R. THOMSON, Review of Brettell/Lloyd, *Drawings by Camille Pissarro in the Ashmolean Museum* (1980), *Burlington Magazine*, CXXIV, no. 948, March 1982, pp. 163–4.

R. THOMSON, 'Camille Pissarro, *Turpitudes Sociales*, and the Universal Exhibition of 1889', *Arts Magazine*, vol. 56, no. 8, April 1982, pp. 82–8.

R. THOMSON, 'The Sculpture of Camille Pissarro', *Source*, II, no. 4, Summer 1983, pp. 25–8.

A. THOROLD, *Artists, Writers, Politics: Camille Pissarro and his Friends*, Oxford, Ashmolean Museum, 1980.

P. TUCKER, *Monet at Argenteuil*, New Haven/London, 1982.

P. TUCKER, 'The First Impressionist Exhibition and Monet's *Impression, Sunrise*; a Tale of Timing, Commerce and Patriotism', *Art History*, vol. 7, no. 4, December 1984, pp. 465–76.

Henry Van de Velde (1863–1957). Schilderen en tekeningen, Antwerp/Otterlo, 1987–8.

E. VAN LIERE, 'Solutions and Dissolutions: the Bather in Nineteenth Century French Painting', *Arts Magazine*, vol. 54, no. 9, May 1980, pp. 104–14.

'MARQUIS DE VILLEMER' [pseud. C. YRIATE], *Les Femmes qui s'en vont*, Paris, 1867.

R. WILLIAMS, *The Country and the City*, London, 1973.

E. WEBER, *Peasants into Frenchmen. The Modernisation of Rural France, 1870–1914*, London, 1977.

G. WEISBERG, 'Jules Breton, Jules Bastien-Lepage, and Camille Pissarro in the Context of Nineteenth Century Peasant Painting and the Salon', *Arts Magazine*, vol. 56, no. 6, February 1982, pp. 115–19.

T. ZELDIN, *France, 1848–1945. I. Ambition, Love, Politics*, Oxford, 1973.

E. ZOLA, *Le Bon Combat. De Courbet aux Impressionnistes*, (ed. J.-P. Bouillon), Paris, 1974.

Chronology

1830 Born 10 July in Charlotte-Amalie, St Thomas, Danish Virgin Islands.

Son of businessman Frédéric Pissarro (1802–65), who had emigrated from Bordeaux in 1824, and Rachel Pomié-Manzana (c.1795–1889); both practising Jews. Camille had three brothers and two step-sisters from his mother's previous marriage.

1842–7 Attends boarding school at Passy, in Parisian suburbs.

1847–52 Works in family business on St Thomas.

1852–4 Works in Venezuela with Fritz Melbye, a Danish painter.

1855 Settles in France, with relations at Passy, and definitively abandons business career.

Universal Exhibition in Paris, the first staged under the Second Empire (1852–70).

The rebuilding of Paris, under Baron Haussmann, Napoleon III's Prefect of the Seine, is under way. The capital is provided with extensive new streets, sewers, parks and public buildings at the cost of severe dislocation of the population, especially the working classes, forced out of their traditional *quartiers* to the industrial suburbs. Despite the disruption, the population of Paris almost doubles under the Second Empire, from 1 million in 1850 to 1.8 million in 1870.

1856 Probably attends academic studios of François Picot and Henri Lehmann at this time. In circle of Danish artists.

1857–8 Receiving monthly allowance from family.

Works at Montmorency and La Roche-Guyon.

1859 Exhibits at the Salon: *Landscape at Montmorency*. Life drawing at Académie Suisse.

Meets Monet.

1860 Meets Chintreuil.

Probably begins relationship with Julie Vellay, his mother's maid.

1861 FEBRUARY–MARCH: shares studio with Piette.

16 APRIL: registered as copyist at the Louvre.

Meets Guillaumin and Cézanne.

1863 23 FEBRUARY: birth of son Lucien (d.1944).

MAY: three works at the Salon des Refusés: *Landscape; Etude; Village*.

Meets Zola through Cézanne.

Joins *Société des Aquafortistes*; makes first prints.

Works at La Varenne-Saint-Maur on the Marne near Chennevières.

1864 Exhibits at the Salon: *Banks of the Marne* (fig. 1); *Route de Cachalas, at La Roche-Guyon*.

Works at La Varenne-Saint-Maur, and visits Piette at Montfoucault.

1865 Exhibits at the Salon: *Chennevières, on the Banks of the Marne* (P&V 46; Edinburgh, National Gallery of Scotland); *The Riverbank*.

18 MAY: birth of daughter Jeanne-Rachel (d.1874).

Despite allowance, forced to work as lawyer's messenger.

1866 Settles at Pontoise at beginning of year, but maintains contact with Paris.

Exhibits at Salon: *Banks of the Marne in Winter* (P&V 47: Chicago, Art Institute).

Meets Manet. Regular attendance at Zola's *Thursdays* and at Café Guerbois, Paris, with Monet, Bazille, Renoir, Sisley, Guillemet, etc.

1867 Refused at Salon and Universal Exhibition.

1868 Exhibits at Salon: *The Côte de Jallais* (fig. 24); *The Hermitage* (?P&V 58: New York, Guggenheim Museum).

Difficult financial situation; paints blinds with Guillaumin.

1869 By May (or earlier) at Louveciennes. Exhibits at Salon: *The Hermitage*.

1870 Exhibits at Salon: *Autumn; Landscape*.

JULY: outbreak of Franco-Prussian War, with rapid French military collapse.

SEPTEMBER: Third Republic proclaimed. Prussian forces lay siege to Paris.

Pissarro and family flee to Montfoucault.

21 OCTOBER: birth of daughter Adèle-Emma, who dies on 5 November.

DECEMBER: family arrive in London. Meets the dealer Durand-Ruel, also in exile.

1871 Paris, besieged and bombarded over the harsh winter, sues for peace at end of January. The conservative and strongly provincial National Assembly, elected in February, agrees punitive terms of Treaty of Frankfurt, signed in May. These terms and the character of the Assembly, based in Versailles, are motives behind the establishment of the Paris Commune in March, which is suppressed by Versaillais forces in the 'Bloody Week' of late May. Till 1879 French politics dominated by conservatives.

MARCH: Pissarro exhibits at Durand-Ruel's London gallery.

MAY: shows at First Annual International Exhibition at South Kensington, but refused at Royal Academy. Visits National Gallery.

14 JUNE: marries Julie in Croydon.

22 NOVEMBER: birth of son Georges (d.1961) at Louveciennes.

1872 JANUARY–JULY: Louveciennes.

AUGUST: returns to Pontoise.

Exhibits at Durand-Ruel's gallery in London, probably including *Rue de Voisins* (fig. 11), and sells via small dealers Martin and Tanguy in Paris.

1873 Working with Cézanne, Guillaumin, Béliard in environs of Pontoise.

Returns to etching, encouraged by Dr Gachet.

Selling to small group of collectors including Duret, Degas, Albert and Henri Hecht, the baritone Faure.

With Monet, plans an independent exhibition group, based on artisans' co-operatives.

1874 APRIL–MAY: first 'Impressionist' exhibition; 5 works in catalogue.

Exhibits at Durand-Ruel's gallery in London.

24 JULY: birth of son Félix (d.1897).

AUGUST: at Montfoucault.

OCTOBER: returns to Montfoucault.

1875 FEBRUARY: returns to Pontoise.

Exhibits at Durand-Ruel's gallery in London.

1876 FEBRUARY–MARCH: Piette visits Pissarro in Pontoise.

APRIL–MAY: second Impressionist exhibition; 12 works in catalogue.

Work being bought by Dr de Bellio, Caillebotte, Personnaz, Chocquet, Murer.

Autumn: at Montfoucault. Begins making ceramic tiles.

1877 APRIL: third Impressionist exhibition; 22 works in catalogue, including *Côte des Boeufs, L'Hermitage* (fig. 39) and *View of Saint-Ouen-l'Aumone* (fig. 37).

28 MAY: sale at Hotel Drouot; Pissarro's work sells poorly.

1878 15 APRIL: death of Piette.

JULY: meets Diego Martelli.

Experiments with painting on cement, and makes first fan (P&V 1609).

21 NOVEMBER: birth of son Ludovic-Rodo (d.1952).

1879 Collapse of right wing with Republican majority in the Senate and election of Grévy as President.

APRIL–MAY: fourth Impressionist exhibition; 38 works in catalogue, including *Wash-house at Bougival* (fig. 19), among them 12 fans and 4 pastels.

SUMMER: Gauguin works with Pissarro at Pontoise.

Produces prints intended for Degas's ill-fated album *Le Jour et la Nuit*.

1880 Amnesty of former Communards.

APRIL: fifth Impressionist exhibition; 10 paintings and a fan, plus 5 frames of prints including different states of the same image.

23 DECEMBER: eye trouble first mentioned in a letter.

1881 FEBRUARY: Durand-Ruel resumes buying from Impressionist circle, supported by Union Générale bank.

APRIL: sixth Impressionist exhibition; 28 works in catalogue, among them 15 gouaches and 2 pastels.

SUMMER: Cézanne and Gauguin work at Pontoise.

27 AUGUST: birth of daughter Jeanne (d.1948).

1882 JANUARY: crash of Union Générale; Durand-Ruel financially embarrassed.

MARCH: seventh Impressionist exhibition; 36 works in catalogue, among them 10 gouaches and a tempera (P&V 1358).

AUGUST: visit to Burgundy.

Making sculpture to aid work in studio.

DECEMBER: moves to village of Osny outside Pontoise.

1883 APRIL–JULY: exhibits 11 works at Durand-Ruel's Impressionist exhibition in London.

MAY: one-man show at Galerie Durand-Ruel; 70 works.

JUNE–JULY: Gauguin at Osny. Plan to make Impressionist tapestries comes to nothing.

OCTOBER (EARLY)–28 NOVEMBER: visit to Rouen. Gauguin visits.

1884 Legalization of Trades Unions indicative of gradual rise of organized Left. Disillusioned with the failure of moderate Republican administrations to effect social reforms, Pissarro is reading Leftist papers such as *Le Prolétaire*.

4 APRIL: settles at Eragny-sur-Epte, near Gisors, his home until his death.

Forced to sell work at very low prices. Increasing production of gouaches and other works on paper; quicker to make and easier to sell than oils.

8 AUGUST: birth of son Paul-Emile (d.1972).

1885 Reading anarchist paper *Le Révolté*.

AUTUMN: at Guillaumin's studio meets Signac; later meets Seurat. Also meets young Leftist writers such as Robert Caze and Jean Ajalbert.

1886 Increasing financial difficulties; producing works on paper for small-scale dealers. Begins to work in pointillist manner derived from Seurat, reworking some old canvases.

SPRING: Durand-Ruel has some success in the United States with Impressionist paintings.

MAY–JUNE: eighth Impressionist exhibition. Pissarro shows in a room with Lucien, Seurat and Signac. 20 works in catalogue, including *View from my window* (fig. 93), among them 4 gouaches, 5 etchings and, framed together, 6 pastel studies of peasant women.

Meets Octave Mirbeau and Félix Fénéon.

1887 Finds work in new manner difficult to place; forced to sell a Degas pastel and Barye bronze from his collection.

FEBRUARY: exhibits with Les XX in Brussels.

Meets Maximilien Luce, Emile Verhaeren.

Millet exhibition at the Ecole des Beaux-Arts, Paris.

AUTUMN: begins contact with Theo van Gogh at Galerie Boussod et Valadon.

1888 JANUARY: exhibits etchings at offices of *La Revue Indépendante*.

JULY: Luce and Léo Gausson visit Eragny.

SEPTEMBER: eye problems (infection of tear duct) now serious, and recurs periodically throughout life.

1889 JANUARY–FEBRUARY: exhibits with Peintres-graveurs at Galerie Durand-Ruel.

JANUARY–APRIL: popular support for General Boulanger almost culminates in an autocratic *coup*.

FEBRUARY: exhibits with Les XX in Brussels.

MAY: on death of mother inherits nothing.

MAY–NOVEMBER: Universal Exhibition. Pissarro visits; two of his paintings are on show.

DECEMBER: completes *Turpitudes Sociales* album.

1890 The 1890s saw an increasing polarization in French politics. In November 1890 Cardinal Lavigerie launched the Roman Catholic *Ralliement* (Rallying) which, together with militarist agitation for *Revanche* (Revenge) against Germany, saw the revival of the Right. On the far Left the anarchist terror campaign of 'propaganda by deed' was launched against the establishment.

FEBRUARY–MARCH: one-man show at Boussod et Valadon; catalogue introduction by Gustave Geffroy. 25 works shown, including *The Gleaners* (fig. 70).

MARCH: Administration des Beaux-Arts buys two etchings for the national collections.

MAY–JUNE: visit to London with Luce.

Increasingly abandons Neo-Impressionist manner.

1891 FEBRUARY: exhibits at Lex XX in Brussels.

APRIL: shares exhibition at Durand-Ruel with Mary Cassatt.

JULY: eye operation.

DECEMBER: stays with Mirbeau at Les Damps; reading Kropotkin.

1892 FEBRUARY: Major one-man show at Galerie Durand-Ruel; catalogue introduction by Georges Lecomte. 75 works, of which Durand buys 10.

SPRING: anarchist bombings in Paris.

MAY–AUGUST: visit to London with Luce.

SUMMER: buys house previously rented at Eragny; money lent by Monet.

SEPTEMBER: stays with Mirbeau at Les Damps.

NOVEMBER: Third Republic compromised by corruption of Panama Scandal.

1893 JANUARY: paints in Paris (Gare St Lazare *quartier*).

MARCH: one-man show at Galerie Durand-Ruel; 41 works.

1 MAY: special number of *La Plume* on anarchism; Pissarro contributes a drawing.

APRIL–JULY: eye inflammation resulting in operation.

SUMMER: barn at Eragny converted into studio.

First portfolio of *Travaux des Champs* apparently ready for publication.

5 DECEMBER: Durand-Ruel buys paintings valued at 23,600 francs.

9 DECEMBER: Vaillant bombs the Chamber of Deputies.

1894 FEBRUARY–MARCH: exhibits with La Libre Esthétique, Brussels.

FEBRUARY–APRIL: anarchist bombings in Paris following the execution of Vaillant.

MARCH: one-man show at Galerie Durand-Ruel; 98 works.

24 JUNE: assassination of President Carnot, followed by repressive legislation and arrests of suspected anarchists.

25 JUNE: visits Belgium with wife and Félix. Meets Henry Van de Velde and anarchist geographer Elisée Reclus.

AUGUST: 'Trial of the Thirty', including anarchist friends Jean Grave and Fénéon.

LATE SEPTEMBER: returns to Eragny.

DECEMBER: Captain Dreyfus sentenced for espionage.

1895 JANUARY: Théo van Rysselberghe visits Eragny.

FEBRUARY–APRIL: exhibits with La Libre Esthétique, Brussels.

MAY: promises collaboration on Grave's anarchist paper *Les Temps Nouveaux*.

1896 20 JANUARY–29 MARCH: visit to Rouen (Hotel de Paris, Quai de Paris).

APRIL–MAY: one-man show at Galerie Durand-Ruel; catalogue introduction by Arsène Alexandre. 35 works; able to repay loan to Monet.

8 SEPTEMBER–12 NOVEMBER: visit to Rouen (Hotel d'Angleterre, Cours Boieldieu).

Growing public opinion about Dreyfus's innocence.

1897 JANUARY–FEBRUARY: paints in Paris (boulevards).

MAY–JULY: visit to London during illness of Lucien.

1898 13 JANUARY: congratulates Zola on open letter 'J'accuse', exposing injustice of Dreyfus's condemnation.

6 JANUARY–28 APRIL: paints in Paris (avenue de l'Opéra).

JUNE: one-man show at Galerie Durand-Ruel; 28 works.

JUNE–JULY: visit to Burgundy and Lyons.

22 JULY–17 OCTOBER: visit to Rouen (Hotel d'Angleterre, Cours Boieldieu).

OCTOBER: visits Amsterdam for Rembrandt exhibition.

Les Temps Nouveaux publish lithograph *The Plough* (D.194) as frontispiece for text by Kropotkin.

1899 Paints in Paris (Tuileries Gardens).

MARCH–APRIL: one-man show at Galerie Bernheim; 23 works.

19 SEPTEMBER: Dreyfus accepts a pardon.

SEPTEMBER–OCTOBER: visits Varengeville-sur-mer on Channel coast.

NOVEMBER: visits Moret-sur-Loing, near Fontainebleau.

1900 Paints in Paris (Tuileries Gardens).

APRIL–NOVEMBER: Universal Exhibition. Impressionists given a room, with 8 works by Pissarro.

JULY–SEPTEMBER: visits Dieppe and Berneval.

1901 JANUARY: one-man show at Galerie Durand-Ruel; 42 works.

APRIL–MAY: visits Moret-sur-Loing.

JULY–SEPTEMBER: visits Dieppe.

NOVEMBER: paints in Paris (Louvre, Pont Neuf).

1902 Paints in Paris (Louvre, Pont Neuf).

MAY–JUNE: visits Moret-sur-Loing.

JULY–SEPTEMBER: visits Dieppe.

1903 MARCH–MAY: paints in Paris (Louvre, Pont Neuf).

JULY–SEPTEMBER: visits Le Havre.

13 NOVEMBER: dies in Paris.

Catalogue

Works are listed in chronological order. Measurements are given in centimetres, height before width. Works on paper are on white paper unless otherwise stated. Abbreviated references are given to the catalogues listed above the Notes.

1. *The Small Factory*, c.1862–5.
Oil on canvas. 26.5 × 40.2cm.
P&V 66.
Musée d'Art Moderne,
Strasbourg. Fig.6.

2. *Banks of the Marne*, 1864.
Oil on canvas. 81.9 × 107.9cm.
Not in P&V.
Glasgow Art Gallery and
Museum. Fig.1.

3. *Barges at La Roche-Guyon*,
c.1865.
Oil on canvas. 46 × 72cm.
Not in P&V.
Musée Pissarro, Pontoise. Fig.4.

4. *The House of Père Gallien,
Pontoise*, 1866.
Oil on canvas. 40 × 55cm.
P&V 48. Ipswich Museums
and Galleries. Fig.23.

5. *View from Louveciennes*. c.1869.
Oil on canvas. 52.5 × 82cm.
P&V 85.
The Trustees of the National
Gallery, London. Fig.8.

6. *La Grenouillère at Bougival*,
c.1869.
Oil on canvas. 35 × 46cm.
P&V 174.
Collection of the Earl of Jersey.
Fig.18.

7. *Louveciennes*, 1870.
Oil on canvas. 45.8 × 55.7cm.
P&V 97.
Southampton City Art
Gallery. Fig.14.

8. *Rue de Voisins, Louveciennes*,
1871.
Oil on canvas. 46 × 55.5cm.
Not in P&V.
Manchester City Art Galleries.
Fig.11.

9. *The Seine at Marly*, 1871.
Oil on canvas. 44 × 60cm.
P&V 122.
Private collection, Switzerland.
Fig.20.

10. *Wash-House at Bougival*, 1872.
Oil on canvas. 46.5 × 56cm.
P&V 175.
Musée d'Orsay, Paris.
Fig.19.

11. *The Seine at Port-Marly*, 1872.
Oil on canvas. 46 × 55.8cm.
P&V 187.
Staatsgalerie, Stuttgart. Fig.21.

12. *Landscape near Pontoise*, 1872.
Oil on canvas. 46 × 55cm.
P&V 163.
Visitors of the Ashmolean
Museum, Oxford. Fig.29.

13. *Misty Morning at Creil*, 1873.
Oil on canvas. 38 × 56.5cm.
Not in P&V.
Private collection, Switzerland.
Fig.31.

14. *Kitchen Gardens at L'Hermitage*,
1874.
Oil on canvas. 54 × 65.1cm.
P&V 267.
National Gallery of Scotland,
Edinburgh. Fig.32.

15. *The Fireplace*. Study for *The
Kitchen at Piette's House,
Montfoucault*, 1874.
Pastel and black chalk.
50 × 32.3cm.
JPL Fine Arts, London.
Fig.42.

16. *Piette's House at Montfoucault,
snow*, 1874.
Oil on canvas. 45.9 × 67.6cm.
P&V 287.
Sterling and Francine Clark
Art Institute, Williamstown,
Mass. Fig.44.

17. *Farm at Montfoucault; snow effect*,
1874.
Oil on canvas. 54 × 65cm.
P&V 283.
Visitors of the Ashmolean
Museum, Oxford. Fig.45.

18. *Female Peasant carrying a Load of
Hay, Montfoucault*, c.1874–5.
Black chalk. 23.9 × 30.5cm.
B/L 80.
Visitors of the Ashmolean
Museum, Oxford. Fig.46.

19. *The Pond at Montfoucault*, 1875.
Oil on canvas. 73.6 × 92.7cm.
P&V 320.
The Barber Institute of Fine
Arts, University of
Birmingham [Birmingham
only]. Fig.47.

20. *The Threshing Machine*, 1876.
Oil on canvas. 54 × 65cm.
P&V 367.
Privately owned. Fig.50.

21. *The Oise at Pontoise, grey weather*,
1876.
Oil on canvas. 53.5 × 64cm.
P&V 353.
Boymans-van Beuningen
Museum, Rotterdam. Fig.34.

22. *Quay at Pontoise, after rain*, 1876.
Oil on canvas. 46 × 55cm.
P&V 355.
Private collection, on loan to
Whitworth Art Gallery,
University of Manchester.
Fig.35.

23. *View of Saint-Ouen-l'Aumone*,
1876.
Oil on canvas. 58.5 × 80.5cm.
P&V 344.
Yale University Art Gallery,
New Haven, Gift of Helen G.
Altschul, widow of Frank
Altschul, BA 1908. Fig.37.

24. *The Côte des Boeufs,
L'Hermitage*, 1877.
Oil on canvas. 115 × 87.5cm.
P&V 380.
The Trustees of the National
Gallery, London. Fig.39.

25. *Village near Pontoise*, 1878.
Oil on canvas. 55 × 65.5cm.
P&V 447.
Öffentliche Kunstsammlung,
Kunstmuseum, Basel. Fig.33.

26. *Sous-bois landscape at
L'Hermitage*, 1879.
Softground etching, aquatint,
and drypoint. 21.8 × 26.8cm.
D. 16.
Visitors of the Ashmolean
Museum, Oxford. Fig.40.

27. *Horizontal Landscape*, 1879.
Etching and aquatint.
11.7 × 39.5cm.
D. 17.
Visitors of the Ashmolean
Museum, Oxford. Fig.41.

28. *Young Woman and Child at the
Well*, 1882.
Oil on canvas. 81.5 × 66.4cm.
P&V 574.
The Art Institute of Chicago,
Potter Palmer Collection.
Fig.65.

29. *Croquis of Market Scenes*,
c.1882–3.
(a) Black chalk.
21.7 × 16.6cm.
B/L 168F.
(b) Black chalk. 21.5 × 16cm.
B/L 168H.
Visitors of the Ashmolean
Museum, Oxford. Fig.79.

30. *Foire de la Saint-Martin,
Pointoise: Horse Market*, c.1883.
Oil on ceramic tile.
20 × 40.4cm.
P&V 1668.
Bennington Museum,
Vermont. Fig.76.

31. *Quai de Paris, Rouen*, 1883.
Oil on canvas. 54 × 66cm.
P&V 606.
Philadelphia Museum of Art,
Bequest of Charlotte Dorrance
Wright. Fig.133.

32. *The Pork Butcher*, 1883.
Oil on canvas. 65 × 54.5cm.
P&V 615.
The Trustees of the Tate
Gallery, London. Fig.80.

33. Study for *The Pork Butcher*,
1883.
Black chalk and watercolour.
21.5 × 16.4cm.
B/L 168E.
Visitors of the Ashmolean
Museum, Oxford. Fig.83.

34. *Peasant Woman in a Cabbage
Field*, c.1883–5.
Oil on ceramic tile. 20 × 20cm.
P&V 1667.
Bennington Museum,
Vermont. Fig.123.

35. *The Market Stall*, 1884.
Black chalk, tempera and
watercolour. 62 × 49cm.
P&V 1389.
The Burrell Collection,
Glasgow Museums and Art
Galleries. Fig.84.

36. *Milking Scene at Eragny*, c.1884.
Black chalk and watercolour.

15.7 × 19.6cm.
B/L 166.
Visitors of the Ashmolean Museum, Oxford. Fig.64.

37. *Standing Peasant Girl*, c.1884.
Black chalk and watercolour.
50.6 × 39cm.
Whitworth Art Gallery, Manchester. Fig.57.

38. *The Turkey Girl*, 1884.
Tempera on paper.
81 × 65.5cm.
P&V 1414.
Museum of Fine Arts, Boston, Juliana Cheney Edwards Collection. Fig.58.

39. *View from my window, overcast weather*, 1886 (reworked 1888).
Oil on canvas. 65 × 81cm.
P&V 721.
Visitors of the Ashmolean Museum, Oxford. Fig.93.

40. *Midday Rest*, 1887.
Gouache and watercolour.
16.6 × 23.5cm.
P&V 1415.
Leeds City Art Galleries. Fig.51.

41. *Corn-Stooks, Eragny*, c.1887.
Pastel on fabric. 23.6 × 29.5cm.
P&V 1605.
Whitworth Art Gallery, Manchester. Fig.67.

42. *Ploughed Field, Eragny*, c.1887-8.
Pencil and watercolour.
20.9 × 47.6cm.
B/L 191.
Visitors of the Ashmolean Museum, Oxford. Fig.68.

43. *Harvested Field, Eragny*, 1888.
Pencil and watercolour.
23.5 × 29cm.
Private collection. Fig.66.

44. Study for *The Gleaners: Baskets*, c.1888-9.
Charcoal. 22.6 × 30.5cm.
Philadelphia Museum of Art, Henry P. McIlhenny Collection in memory of Frances P. McIlhenny. Fig.72.

45. *The Gleaners*, 1887-9.
Oil on canvas. 65.5 × 81cm.
P&V 730.
Kunstmuseum, Basel (Dr H. C. Emile Dreyfus Foundation). Fig.70.

46. *L'Ile Lacroix, Rouen, mist*, 1888.
Oil on canvas. 44 × 55cm.
P&V 719.
Philadelphia Museum of Art, John G. Johnson Collection. Fig.134.

47. Study for *Turpitudes Sociales: The Stockbrokers*, 1889.
Pencil, pen and ink.
22.5 × 18cm.
B/L 210A.
Visitors of the Ashmolean Museum, Oxford. Fig.128.

48. Study for *Turpitudes Sociales: Asphyxiation*, 1889.
Pencil, pen and ink.
23.1 × 17.7cm.
B/L 210B.
Visitors of the Ashmolean Museum, Oxford. Fig.129.

49. *The Marché St Honoré*, 1889.
Black chalk and watercolour, with pen and ink.
29.3 × 22.7cm.
Private collection. Fig.86.

50. *Shepherd and Flock, Eragny*, 1889.
Pastel. 23 × 30cm.
P&V 1578.
Private collection. Fig.63.

51. *Hoar frost*, 1890.
Pencil and watercolour.
20.8 × 26.2cm.
B/L 234.
Visitors of the Ashmolean Museum, Oxford. Fig.94.

52. *Landscape, Eragny*, 1890.
Black chalk and watercolour.
16 × 23.8cm.
Whitworth Art Gallery, University of Manchester. Fig.95.

53. *Peasant Women planting pea-sticks*, 1890.
Gouache and black chalk on grey-brown paper.
40.7 × 64.1cm. (paper);
39 × 60.2cm. (fan).
P&V 1652.
Visitors of the Ashmolean Museum, Oxford. Fig.114.

54. *The Young Beggar Girls*, 1890.
Black chalk, watercolour and gouache. 29 × 21cm.
P&V 1445.
Yaneff Gallery, Toronto,
Ontario. Fig.125.

55. *The Conversation*, c.1890-2.
Black chalk, sanguine and pencil on grey paper.
60 × 38cm.
Département des Arts Graphiques, Musée du Louvre, Paris [Glasgow only]. Fig.59.

56. *Apple Picking*, c.1890-5?
Oil on panel. 10 × 26.5cm.
Not in P&V.
Private collection. Fig.124.

57. *Peasant Women planting pea-sticks*, 1891.
Oil on canvas. 55 × 46cm.
P&V 772.
Private collection, on loan to Sheffield City Art Galleries. Fig.115.

58. *St Charles, Eragny, sunset*, 1891.
Oil on canvas. 80.8 × 64.9cm.
P&V 769.
Sterling and Francine Clark Art Institute, Williamstown, Mass. Fig.97.

59. *February, sunrise, Bazincourt*, 1893.
Oil on canvas. 65 × 81.5cm.
P&V 833.
Kröller-Müller Museum, Otterlo, The Netherlands. Fig.96.

60. Study for *Femmes faisant l'herbe*, c.1893.
Woodcut in black ink, coloured with watercolour; annotated in margins.
21.2 × 17.8cm. (paper);
17.5 × 11.8cm. (block).
B/L 328.
Visitors of the Ashmolean Museum, Oxford. Fig.120.

61. *Femmes faisant l'herbe*, 1893.
Wood engraving in colour.
17.5 × 11.8cm.
P. 202.
Visitors of the Ashmolean Museum, Oxford. Fig.121.

62. *Women weeding*, c.1893.
Wood engraving in colour.
18 × 12cm.
P. 203.
Visitors of the Ashmolean Museum, Oxford. Fig.122.

63. *Market at Gisors, rue Cappeville*, c.1893.

Black chalk, watercolour and gouache on pale brown paper.
17.3 × 25.3cm.
Not in P&V.
Private collection. Fig.87.

64. *Market at Gisors, rue Cappeville*, c.1893.
Pen and indian ink over charcoal and pencil on tracing paper. 20.6 × 25.5cm. (paper);
17.3 × 25.5cm. (sight).
B/L 295.
Visitors of the Ashmolean Museum, Oxford. Fig.88.

65. *Market at Gisors, rue Cappeville*, 1893.
Black chalk, pen and ink, grey and brown washes, heightened with chinese white, on tracing paper. 27.5 × 20.9cm. (paper);
25 × 17.4cm. (image).
Visitors of the Ashmolean Museum, Oxford. Fig.89.

66. C. and L. Pissarro, *Market at Gisors, rue Cappeville*, 1893.
Pen and indian ink, heightened with chinese white, on uncut woodblock; extensive annotations in margins.
31.5 × 23.2cm.
Whitworth Art Gallery, University of Manchester. Fig.90.

67. *Market at Gisors, rue Cappeville*, 1894.
Etching in black ink, heightened in coloured crayons; annotated in margins.
19.6 × 13.7cm. (plate);
19.6 × 13.7cm. (composition).
B/L 299.
Visitors of the Ashmolean Museum, Oxford. Fig.91.

68. *Market at Gisors, rue Cappeville*, 1894.
Etching in colour.
20.2 × 14.2cm.
D. 112.
Visitors of the Ashmolean Museum, Oxford. Fig.92.

69. *Study of a nude woman bending*, c.1894.
Charcoal. 28.8 × 22.3cm.
B/L 257.
Visitors of the Ashmolean Museum, Oxford. Fig.101.

70. *Two Bathers*, 1894.
Etching. 18 × 12.7cm.
D. 116.
Visitors of the Ashmolean
Museum, Oxford. Fig.102.

71. *Nude seated on bank*, c.1894.
Coloured monotype.
17.5 × 12.6cm. Museum of
Fine Arts, Boston, Gift of Mr
and Mrs Benjamin A.
Trustman. Fig.104.

72. *Peasant Girl washing her feet*,
c.1894.
Monotype. 12.5 × 17.5cm.
Metropolitan Museum of Art,
New York, Harris Brisbane
Dick Fund, 1947. Fig.105.

73. Study for *Spring*, c.1894–5.
Red-brown and indian ink over
charcoal on blue paper; framed
in black chalk. 23.6 × 29.9cm.
B/L 332. Visitors of the
Ashmolean Museum, Oxford.
Fig.119.

74. *The Young Beggar Girls*,
c.1894–5.
Etching in colour. 20 × 15cm.
D. 110.
Visitors of the Ashmolean
Museum, Oxford. Fig.126.

75. Study for *Bather with Geese*,
1895.
Pen, brown ink and grey wash,
heightened with chinese white,
on beige paper; framed in
pencil. 13.7 × 18.7cm.
B/L 301.
Visitors of the Ashmolean
Museum, Oxford. Fig.111.

76. *Bather with Geese*, 1895.
Etching. 12.7 × 17.3cm.
D. 115.
Visitors of the Ashmolean
Museum, Oxford. Fig.112.

77. *Morning, sunshine effect, winter*,
1895.
Oil on canvas. 82.3 × 61.5cm.
P&V 911.

Museum of Fine Arts, Boston,
John Pickering Lyman
Collection. Fig.98.

78. *The Sower*, 1896.
Lithograph. 21.6 × 27cm.
D. 155.
Visitors of the Ashmolean
Museum, Oxford. Fig.54.

79. *Boieldieu Bridge, Rouen, damp
weather*, 1896.
Oil on canvas. 73.7 × 91.4cm.
P&V 948.
Art Gallery of Ontario,
Toronto, Gift of Reuben Wells
Leonard Estate, 1937. Fig.136.

80. *Boieldieu Bridge, Rouen, sunset*,
1896.
Oil on canvas. 72.4 × 91.4cm.
P&V 952.
Birmingham Museum and Art
Gallery. Fig.137.

81. *Rouen, Misty Morning*, 1896.
Oil on canvas. 57.1 × 73.5cm.
P&V 960.

Hunterian Art Gallery,
University of Glasgow.
Fig.138.

82. *Sunset, Port of Rouen, (smoke)*,
1898.
Oil on canvas. 65 × 81cm.
P&V 1039.
National Museum of Wales,
Cardiff [Glasgow only].
Fig.139.

83. *Hay Harvest at Eragny*, 1901.
Oil on canvas. 54 × 65cm.
P&V 1207.
National Gallery of Canada,
Ottawa. Fig.116.

84. *Hay Harvest at Eragny*, c.1901.
Pen and indian ink with
chinese white over pencil on
tracing paper laid down on
card. 14.1 × 14.9cm.
B/L 335.
Visitors of the Ashmolean
Museum, Oxford. Fig.117.

Lenders

Basel, Kunstmuseum,
Öffentliche Kunstsammlung 25
Dr H.C. Emile Dreyfus Foundation 45
Bennington Museum, Vermont 30, 34
University of Birmingham, The Barber Institute
of Fine Arts 19
Birmingham Museum and Art Gallery 80
Boston, Museum of Fine Arts 38, 71, 77
Cardiff, National Museum of Wales 82
Chicago, The Art Institute of Chicago 28
Edinburgh, National Gallery of Scotland 14
Glasgow Art Gallery and Museum, Kelvin-grove 2
University of Glasgow, Hunterian Art Gallery 81
Glasgow Museums and Art Galleries, The Burrell Collection 35
Ipswich Museums and Galleries 4
Earl of Jersey 6
Leeds City Art Galleries 40
London, JPL Fine Arts 15
London, The Trustees of the National Gallery 5, 24
London, The Trustees of the Tate Gallery 32
Manchester City Art Galleries 8
University of Manchester, Whitworth Art Gallery 37, 41, 52, 66
New Haven, Yale University Art Gallery 23
New York, Metropolitan Museum of Art 72
Ottawa, National Gallery of Canada 83
Otterlo, The Netherlands, Kröller-Müller Museum 59
Oxford, Visitors of the Ashmolean Museum 12, 17, 18, 26, 27, 29, 33, 36, 39, 42, 47, 48, 51, 53, 60, 61, 62, 64, 65, 67, 68, 69, 70, 73, 74, 75, 76, 78, 84
Paris, Musée du Louvre, Département des Arts Graphiques 55
Paris, Musée d'Orsay 10
Philadelphia Museum of Art 31, 44, 46
Pontoise, Musée Pissarro 3
Rotterdam, Boymans-van Beuningen Museum 21
Southampton City Art Gallery 7
Strasbourg, Musée d'Art Moderne 1
Stuttgart, Staatsgalerie 11
Toronto, Art Gallery of Ontario 79
Toronto, Yaneff Gallery 54
Williamstown, Mass., Sterling and Francine Clark Art Institute 16, 58
Private Collections 9, 13, 20, 22, 43, 49, 50, 56, 57, 63

Photographic Acknowledgements

Berlin (West), Staatliche Museen Preußischer Kulturbesitz, Nationalgalerie: 15
Boston, Museum of Fine Arts: 12, Bequest of John T. Spaulding; 58, Juliana Cheney Edwards Collection, Bequest of Hannah Marcy Edwards in memory of her mother; 98, John Pickering Lyman Collection; 104, Gift of Mr and Mrs Benjamin A. Trustman
Cambridge, reproduced by permission of the Syndics of the Fitzwilliam Museum: 2, 56
Cambridge, Mass., Harvard University, Fogg Art Museum: 85, Bequest of Grenville L. Winthrop
Chicago, The Art Institute of Chicago, © 1988, All Rights Reserved: 65, Potter Palmer Collection, 1922
Cliché des Musées Nationaux, Paris: 10, 19, 59, 73, 74, 130
Cliché Musées de la Ville de Paris: 61
Colorphoto Hans Hinz: 70
Detroit Institute of Arts: 43, Bequest of Edward E. Rothman
Glasgow Museums and Art Galleries, The Burrell Collection: 84
London, reproduced by courtesy of the Trustees, The National Gallery: 8, 30, 39
London, reproduced by permission of the Trustees of the Wallace Collection: 49
Manchester, Whitworth Art Gallery, University of Manchester: 35, 57, 67, 90, 95
New Haven, Yale University Art Gallery: 37, Gift of Helen G. Altschul, widow of Frank Altschul, BA 1908; 100, Everett V. Meeks Fund
New York, Metropolitan Museum of Art: 9, Bequest of Emma A. Sheafer, 1974. The Lesley and Emma Sheafer Collection (1974.356.32); 24, Bequest of William Church Osborn, 1951 (51.30.2); 105, Harris Brisbane Dick Fund, 1947 (47.90.3); 109, Bequest of Mrs H.O. Havemeyer, 1929. The H.O. Havemeyer Collection (29.100.126)
Otterlo, The Netherlands, Kröller-Müller Museum: 38, 96
Oxford, Visitors of the Ashmolean Museum: 29, 40, 41, 45, 46, 54, 60, 64, 68, 79, 83, 88, 89, 91, 92, 93, 94, 99, 101, 102, 107, 111, 112, 114, 117, 119, 120, 121, 122, 126, 128, 129
Philadelphia Museum of Art: 72, The Henry P. McIlhenny Collection in memory of Frances P. McIlhenny; 75, George W. Elkins Collection; 133, Bequest of Charlotte Dorrance Wright; 134, John G. Johnson Collection of Philadelphia
Sheffield City Art Galleries: 115
Toronto, Art Gallery of Ontario: 113, Gift of Messrs Heintzman and Knoedler, 1927; 136, Gift of Reuben Wells Leonard Estate, 1937
Toronto, Yaneff Gallery: 125
Washington DC, National Gallery of Art: 81, Collection of Mr and Mrs Paul Mellon
Williamstown, Mass., Sterling and Francine Clark Art Institute: 27, 44, 97; 55, Gift of Mr and Mrs Norman Hirschl

Other photographic acknowledgements are given in the captions to the illustrations.